# HOW TO
# DRAW
# AND PAINT
# VAMPIRES

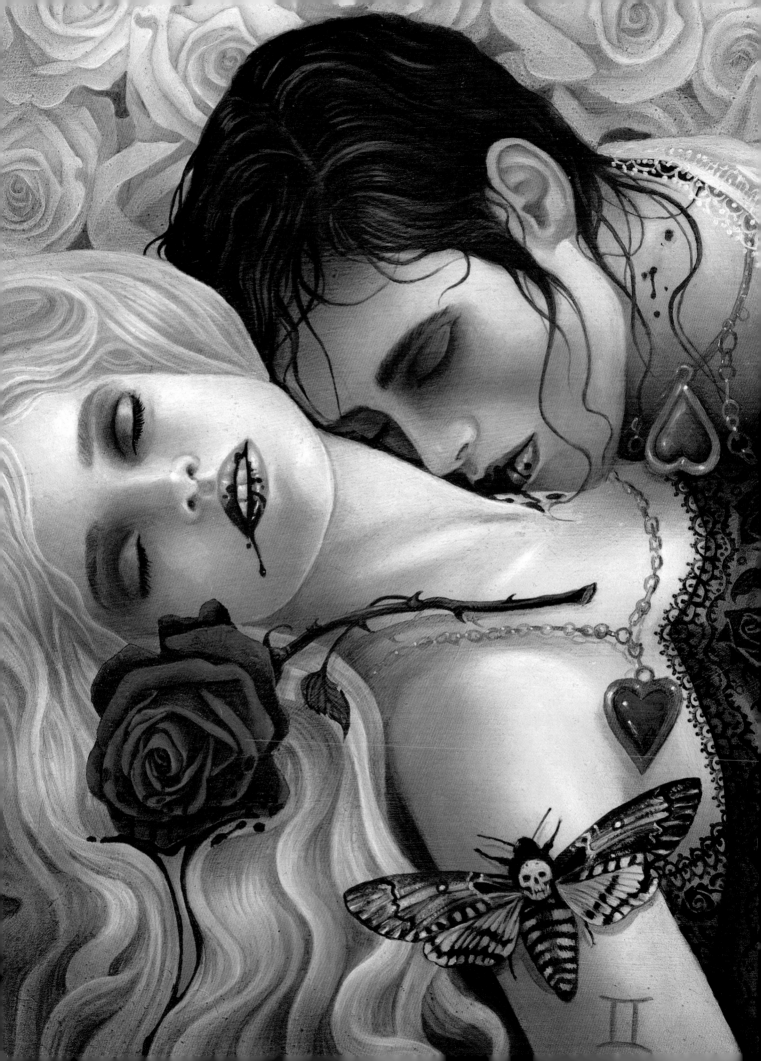

# HOW TO
# DRAW
# AND PAINT
# VAMPIRES

## Ian Daniels

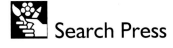
Search Press

A QUARTO BOOK

Copyright © 2010 Quarto plc

Published in 2011 by Search Press Ltd
Wellwood
North Farm Rd
Tunbridge Wells
Kent TN2 3DR

ISBN: 978-1-84448-615-1

Conceived, designed and produced by
Quarto Publishing plc
The Old Brewery
6 Blundell Street
London
N7 9BH

QUAR.DPVG

Senior editor: Katie Crous
Copy editor: Liz Dalby
Art director: Caroline Guest
Art editor: Emma Clayton
Designer: Austin Taylor
Additional illustrations: Rafi Adrian Zulkarnain
Picture research: Sarah Bell
Creative director: Moira Clinch
Publisher: Paul Carslake

Colour separation by PICA Digital Pte Ltd,
Singapore
Printed in Singapore by Star Standard Pte Ltd

10 9 8 7 6 5 4 3 2 1

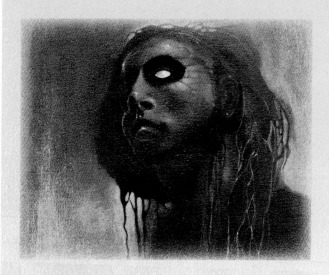

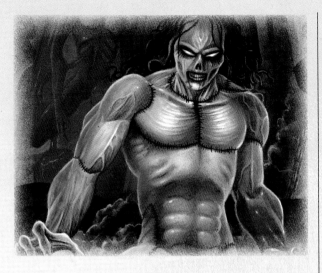

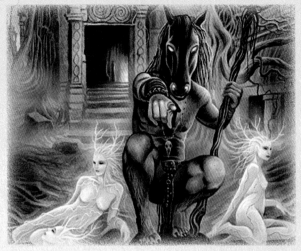

# INTRODUCTION

Vampires are the embodiment of 'Gothic', whether they be mysterious nobles shrouded in eerie mists and dark cloaks, sinister nocturnal creatures lurking in deep forests or beautiful supernatural females. The vampire myth – known throughout the world – explores great themes of human existence, such as death, resurrection, immortality, passion, hunger, love, loss and the supernatural, all of which are excellent themes to explore as an artist.

This book aims to guide you through the various stages of creating, from the initial inspiration and developing ideas to the completion of your own vampire and Gothic paintings. It is divided into three main chapters, the first dealing with technical information, such as tools and materials, colour mixing and themed Gothic palettes. The second chapter looks at anatomy and is designed to teach you how to create mood and expressions, draw different Gothic poses and design costumes for your vampires. A design directory of different types of vampires follows, with lessons in design, conceptualization, creating key elements and figure rotational views. The third chapter is devoted to the methods used to conceive and create haunting and mysterious Gothic environments for your figures to inhabit.

The most important element when creating exciting vampire art is to enjoy yourself. If you are enthusiastic in your creativity, the technical skills will develop naturally.

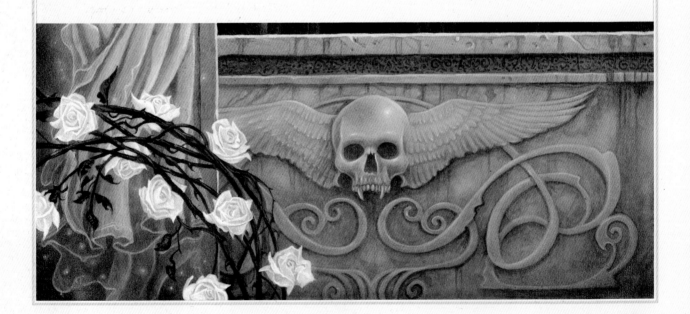

# ABOUT THIS BOOK

THIS BOOK IS SPLIT INTO THREE CHAPTERS THAT WILL GUIDE YOU THROUGH THE
PROCESS OF CREATING YOUR OWN GOTHIC PAINTINGS AND DRAWINGS.

## PRINCIPLES AND PRACTICE

Pages 8–50 take an informative look at the basics of painting and drawing – which medium to use, gathering inspiration and developing your knowledge of fundmental principles such as composition and colour palettes – and applying them all to the Gothic world of vampires.

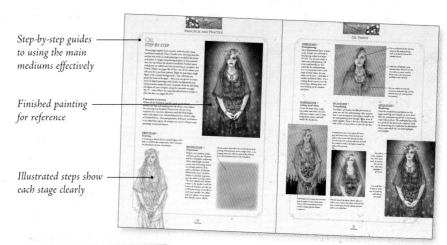

*Step-by-step guides to using the main mediums effectively*

*Finished painting for reference*

*Illustrated steps show each stage clearly*

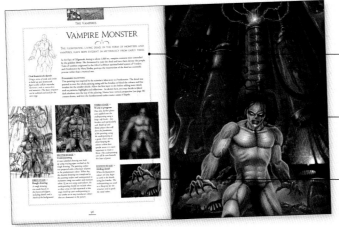

*Background information provides additional inspiration*

*Full-page picture of the character shows detail*

*Illustrated stages with clear instructions and suggestions*

## THE VAMPIRES

The characters you draw or paint will be the focus of your art, and on pages 54–100 you'll find advice on accurate face and figure drawing, expressions and costumes, and finally the creatures of the night you can use as reference or as inspiration for your own gruesome vampires.

## GOTHIC ENVIRONMENTS

You will need to develop an underworld in which your creatures can dwell – pages 102–113 have plenty of dark ideas to lead you through your decision making.

## GOTHIC CHARACTER TEMPLATES

Turn to pages 114–125 for line-drawn figures you can copy or experiment with.

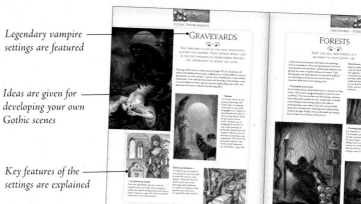

*Legendary vampire settings are featured*

*Ideas are given for developing your own Gothic scenes*

*Key features of the settings are explained*

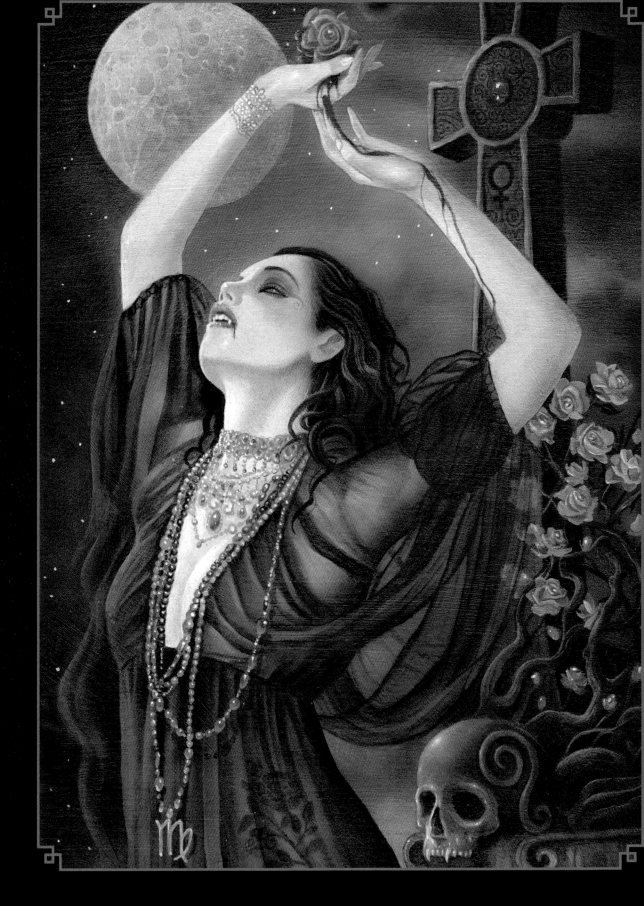

# CHAPTER I

# PRINCIPLES AND PRACTICE

THIS SECTION GUIDES YOU THROUGH ALL OF THE
IMPORTANT DECISIONS, FROM CHOOSING THE MOST
APPROPRIATE MEDIUM AND COLOURS TO
SOURCING THE SUBJECT ITSELF.

# Drawing and Painting Surfaces

THE CHOICE OF PAPER IS IMPORTANT BECAUSE THE SURFACE TEXTURE
WILL HAVE A STRONG INFLUENCE ON THE FINISHED EFFECT.

All papers are sold in loose sheets of various sizes as well as in sketchbooks in both landscape and portrait formats. Ultimately your choice of surface depends on the kind of work you intend to do.

## Pencils and pastels
The most commonly used paper for pencil and coloured-pencil drawings is white multi-purpose paper of the kind you might use in a printer, but some artists prefer to work on a more heavily textured paper such as those intended for watercolours and pastels. A wealth of paper types is available. Experiment with various tinted and textured papers.

You could even try working on some of the beautiful handmade papers available, containing seed husks, grasses and fibres.

## Watercolour papers
For watercolour, you can buy a variety of handmade papers, but most artists use the widely available machine-made type. Machine-made papers are the best to start with; you can experiment with more exotic papers later if you wish. They come in different surfaces, of which there are three main categories: smooth (hot-pressed, or HP for short); medium (sometimes called cold-pressed, CP, or not, for 'not hot-pressed'); and rough (also cold-pressed, but with a much more pronounced texture). Although some artists choose smooth or rough paper for special effects, the all-around favourite is the 'not' type, which has enough texture to hold the paint but not enough to interfere with colour and detail.

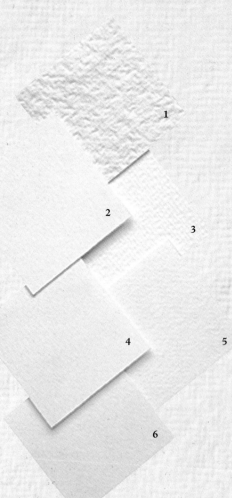

*If you want to experiment with textures and effects on watercolour paper, use a good, heavy paper or watercolour board. It should be able to soak up a lot of water without disintegrating and shouldn't require stretching.*

1 Handmade paper
2 Cold-pressed (not) paper
3 Extra rough mould-made artists' board
4 Hot-pressed (smooth) machine-made paper
5 Rough machine-made paper
6 Rough paper

### OIL- AND ACRYLIC-PAINTING SURFACES

There is a wide range of different surfaces you can use for oil and acrylic paintings. Your choice will depend on your desired visual effect for your painting.

### Linen canvas

The fibres of the flax plant are developed into yarns or threads that are then made into linen canvas. Individual fibres are huge and moderately strong and make for an extremely attractive and hard-wearing oil painting support. Paintings executed on this surface have endured the test of time, and it is for this reason that linen canvas is a preferred surface among expert oil painters. Different kinds of linen canvas are available, from rolled to pre-stretched. They come prepared for acrylic and oils, and are also available unprimed.

### Cotton canvas

Cotton canvas is the best support for novice oil painters. It is a comparatively strong material and much more reasonably priced than linen. It has an extremely even and perfunctory weave. If you are worried about the sturdiness of cotton, purchase a 'profound grade' cotton canvas and try widening it yourself. Cotton canvas is obtainable in rolls or in pre-stretched, primed or unprimed form.

### Canvas pads

If you are on a tight budget but desire a good-quality surface for oil paintings, canvas pads are a superior choice. Canvas pads come in a range of sizes and are great for beginner oil painters, for practice, or for doing studies. Make sure you get a heavyweight canvas pad intended to hold oil paint.

### Canvas boards

Canvas boards or panels are sheets of cardboard covered with inexpensive, white-painted cloth. These are available in many different sizes, from several centimetres to 1.25 m (4 ft) or more. They are very popular because they are generally inexpensive, easy to store and easy to transport, being less bulky than frame-stretched canvases. Different qualities are also available, so choose the one that best suits your needs – if, for example, you just want a surface to make oil painting sketches then a relatively inexpensive board is ideal. Good results can also be obtained from untempered Masonite or 3-ply chipboard prepared with two coats of white gesso primer on the front and one coat on the back to prevent warping.

1 Canvas board
2 Double-sided art board: toned side
3 Double-sided art board: white side
4 Hardboard: rough side
5 Hardboard: smooth side
6 Stretched canvas

# BLACK-AND-WHITE MEDIA

USE OF BLACK AND WHITE CAN GIVE YOUR DRAWINGS AND PAINTINGS
A STARKNESS AND PURITY, ENHANCING THE DARK, POETIC
OR BROODING NATURE OF THE SUBJECT MATTER.

### PENCILS AND GRAPHITE

Pencil 'leads' are made from graphite, a soft crystalline form of carbon, which is mixed with clay and fired in a kiln. The more graphite a pencil lead contains, the softer and blacker the mark it will make, while a higher clay content makes the mark paler. The lead is encased in wood, usually cedar, which is marked on the side with a number and letter classification. 'B' stands for black, containing more graphite; 'H' stands for hard, with more clay. The higher the number, the softer or harder the pencil, so for example, 9B is extremely soft.

Graphite sticks are shaped like thick pencils without the covering of wood and are also graded; 2B is a useful starting point. Some sticks are lacquered for clean use, so scrape them down if you wish to make broad marks, and wrap uncoated sticks in aluminium foil. Graded leads are made for some technical, or 'propelling', pencils. These are good for making clean, sharp lines, for detail and for construction drawings. Office pencils are usually graded HB or B, and the ones that make the blackest marks are best for drawing. Use a sharp craft knife to sharpen them.

### Using pencils and graphite

Try out the different grades of pencil to see the effects and compare all the marks together. The dark mark made by a soft pencil reduces the silvery tone of a harder grade of pencil almost to insignificance when the two are placed alongside each other. These different effects can broaden your creative horizons, but bear in mind that mixing grades may lead to problems with rendering light and shade. Choose the right grade of pencil for your drawings and you will need only one, because this medium is so subtle and responsive.

Your first consideration should be the size of your drawing. Large vampire artworks are usually viewed from a distance and may lack impact unless a very soft grade is used – and still may not have the drama of charcoal (see page 13), which is ideal for large drawings. Soft pencils may be used for work of any size, but hard ones should be reserved for small drawings where the paler marks will be seen close up. Time is another factor: because pencil is a linear medium it takes a while to build up density, so a softer grade may speed up the results.

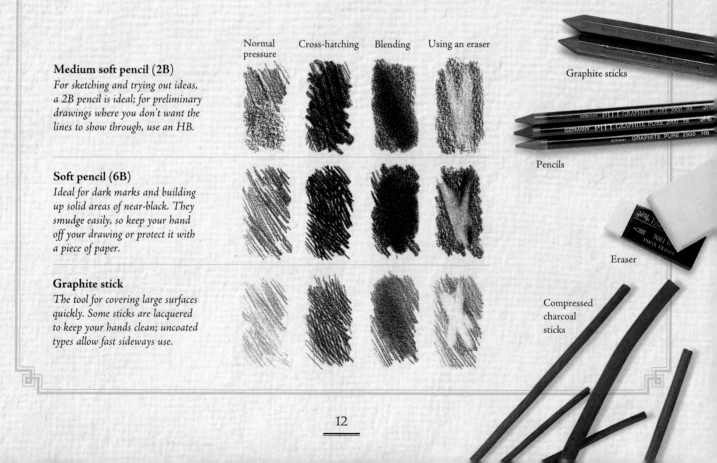

| | Normal pressure | Cross-hatching | Blending | Using an eraser |
|---|---|---|---|---|

**Medium soft pencil (2B)**
*For sketching and trying out ideas, a 2B pencil is ideal; for preliminary drawings where you don't want the lines to show through, use an HB.*

Graphite sticks

**Soft pencil (6B)**
*Ideal for dark marks and building up solid areas of near-black. They smudge easily, so keep your hand off your drawing or protect it with a piece of paper.*

Pencils

**Graphite stick**
*The tool for covering large surfaces quickly. Some sticks are lacquered to keep your hands clean; uncoated types allow fast sideways use.*

Eraser

Compressed charcoal sticks

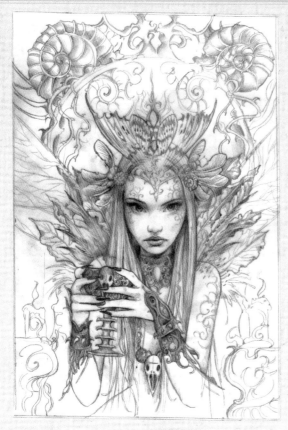

**Sketching** ⋀

*Begin your drawings by sketching out the basic shapes and forms. Try to work on the picture as a whole, gradually building up the tones from light to dark.*

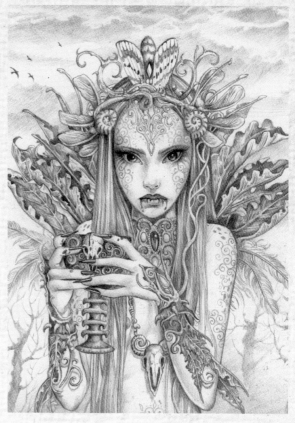

**Fine detail** ⋀

*Add the fine detail towards the end, using a sharpened pencil or a fine propelling one. This finely detailed drawing has been worked up from the previous sketch. The amount of detail you include is a personal choice; often a less detailed drawing or one that has a focus of detail can be more effective.*

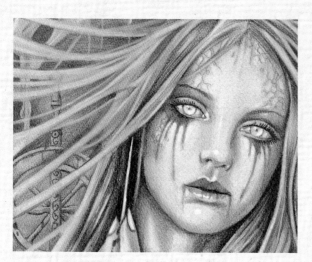

**Tinted papers** ⋀

*You can use tinted papers to add mood and interest to your drawings. Use a white pastel pencil to create highlights and give your drawings more tonal depth.*

## CHARCOAL

Charcoal sticks can be messy to use, but if you don't mind dirty hands, this is an attractive medium for the Gothic artist. Charcoal sticks are made in lengths up to 15 cm (6 in) and are usually graded according to diameter. The charcoal is also graded as soft, medium or hard. Large rectangular blocks and thicker sticks known as 'scene-painters' charcoal' are ideal for working on large areas.

Charcoal is easy to remove prior to fixing – lightly wiping the area with a rag will remove most of an unwanted mark.

Compressed charcoal, sometimes known as Siberian charcoal, is made from powdered charcoal dust mixed with a binder and pressed into short sticks. These are stronger than stick charcoal. Several manufacturers grade their sticks according to hardness, from the hardest (3H) to the softest (HB), and by blackness, from the blackest (4B) to the lightest (2B). Compressed charcoal sticks can also be found in a range of greys.

# COLOURED PENCILS

COLOURED PENCILS MAKE A WIDE VARIETY OF
COLOUR TECHNIQUES POSSIBLE AND ARE AVAILABLE
IN A RANGE OF QUALITIES.

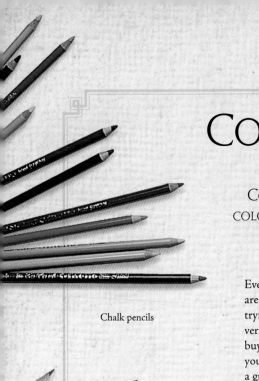

Chalk pencils

Every brand of pencils has its own handling qualities – pencils
are usually sold individually as well as in sets, so it is worth
trying out a few different styles. You should keep in mind the
versatility of the palette for your intentions if you decide to
buy an expensive boxed set. The surface finish of the paper
you use will also affect the pencil application. Some artists like
a grainy paper with a rough tooth that breaks up the colour;
others prefer a smoothed-out finish that leaves all the textural
qualities dependent on the way the marks are made. If you
want to create a special effect, check out the variety of papers
sold primarily for watercolour and pastel work.

Wax pencils in
the softest grade

## USING COLOURED PENCILS

Although coloured pencil is naturally a line medium, there are
many ways of building up areas of solid and mixed colour.

Water-soluble
pencils

### Hatching ➤

*Hatching creates effects of continuous tone using linear marks. With a colour
medium, this technique can also enable the artist to integrate two or more hues and
produce colour changes within a given area. Hatching consists of roughly parallel lines,
closely or widely spaced, and with even or irregular spacing. In monochrome drawing,
the black lines and white spaces read from a distance as grey – a dark grey if the lines
are thick and closely spaced, and a pale shade if the hatching is finer and more open.
The effect is similar with coloured lines, the overall effect being an interaction between
the lines and the paper colour showing through.*

### ◄ Cross-hatching

*Cross-hatching lines are hatched
one over another in different
directions, producing a mesh-
like or basket-weave texture.
An area of dense cross-hatching
can read as a continuous tone
or colour.*

Hard pencils
with fine leads

### Blending ➤

*The blending method you use will depend on
whether you want to achieve smooth gradations
of colour and tone, a layered effect built up by
overlaying colours, or an optical mixture created
by massing linear strokes to produce overall colour
blends. By using solvent, you can obtain effects
closer to the fluid colour blends typical of paint
mediums, while burnishing heightens the effect of
graded and overlaid colours. Dip your coloured
pencils into different solvents to sample their
different surface qualities.*

# COLOURED INKS AND PENS

Waterproof inks

ACCORDING TO A CHINESE SAYING, 'IN INK ARE ALL COLOURS',
HIGHLIGHTING THE WIDE RANGE OF TONAL POSSIBILITIES.

Ink is a wonderfully flexible medium that has been popular for centuries. It does not have to be a monochrome medium, as there are now many coloured inks available. These are perhaps less widely used than traditional blue, black and sepia inks, but they can add substantial interest to a Gothic drawing. They come in water-soluble and waterproof versions, and the latter can be used very much like watercolour (see pages 16–19) and diluted with water to produce lighter tones. Acrylic inks can also be diluted with water, becoming waterproof when dry, and can be mixed together to achieve many colour variations.

### MARKERS, INKS AND FIBRE-TIP PENS

The only drawback of marker, ink and fibre-tip pens is that the marks they make may fade over time. However, they are excellent for preliminary work and for drawings that won't be exposed to the light, such as sketchbook studies.

Markers are divided into water-based and solvent-based varieties, and both are available with varied nibs – such as wedge-shaped, chisel-shaped or pointed –

providing opportunities for striking line and colour work. Different brands of markers can be mixed with one another to produce a surprising range of interesting effects and colour combinations.

### Using inks and pens

As a medium, ink demands concentration and a decisive hand, but once you have mastered it, you will find it is one of the most spontaneous and exciting mediums available.

Try to make your marks as confidently as you can, even if this means throwing away a drawing and starting again. In this way, you will begin to learn the technical aspects of the medium; for example, it is vital to know when to reload a pen or brush in order to achieve a flowing unbroken line, and this knowledge can only come through experience. One tip for beginners is to make a light drawing in soft pencil or charcoal as a guide for the pen work, and another is to practise making the line on a spare piece of paper before making it on the actual drawing.

Fibre-tip pens

Marker pens

**Dip pen**
*The dip pen's capacity to accept a wide range of nibs makes it versatile.*

**Art pen**
*Art pens are quick and clean to use, making them ideal for sketching.*

**Marker pen**
*Use the different shapes and sizes to produce a wide variety of marks.*

**Bamboo pen**
*This pen needs plenty of ink; it can feel dry and stiff on the paper surface.*

**Technical pen**
*The line made by this pen is of uniform width. Work on a smooth surface.*

**Brush pen**
*Brush-pen marks vary in thickness, according to the pressure applied.*

**Quill**
*The natural feather quill makes a range of unique marks.*

**Ballpoint pen**
*Ballpoint pens produce defined lines of uniform width.*

**Oriental brush**
*Made for drawing with ink, this brush creates expressive marks.*

Fibre-tip pen set

Rollerball pens

# WATERCOLOURS

WATERCOLOUR PAINTS ARE SOLD IN TUBES, PANS AND HALF-PANS,
WITH BOTH OF THE LATTER DESIGNED TO FIT INTO A PAINT BOX.

You can buy paint boxes complete with around twelve colours – or sometimes fewer – but many Gothic artists prefer to choose their own. This allows you to start with a smaller range and build up gradually. Whether you choose pans or tubes will depend on your style and subject matter. Pans can be more convenient, because the paint boxes include wells for mixing paint, and you can fold up the box on completion of the session. Tubes necessitate a separate palette, which can get messy and require cleaning. But for any large-scale paintings, tubes are best because you can mix large quantities and strong colours more easily.

## BRUSHES

Probably the best brushes to use for watercolour work are sables. However, sables are expensive, and there are many excellent synthetic brushes and sable-and-synthetic mixtures that are adequate for most purposes.

A good brush has a certain resilience. Test the spring of your brush by wetting it into a point and dragging it lightly over your thumbnail. It should spring back, not droop. You also need brushes that hold a good quantity of water – you can test this by moistening it with your mouth. Don't try this with a paint-loaded brush, however, as trace elements from paint can be retained in the body.

**Brush sizes**
*The larger the brush head, the more water it will hold, so have one large, one medium and one small available to maximize your options.*

**Chinese brushes**
*A less expensive option than sable brushes, Chinese brushes create a wide variety of marks.*

**Straight lines**
*Riggers are long-haired sables that taper to a point, so they can be used to create long, straight lines.*

Medium rigger

Large rigger

Shaped rigger

**Broad lines**
*Flats are chisel-edged and held in flat ferrules. Short flats are suitable for applying dabs of colour; long flats hold enough colour for one stroke across your paper.*

Small flat

Medium long-haired flat

Large long-haired flat

## BUY THE BEST

Tubes of watercolour are made in a standard size, which may look small in comparison to tubes of oil or acrylic, but they actually last a very long time. Look for the label 'artists' watercolour', and don't be tempted to buy the less expensive paints, known as 'students' colours', as these contain less pure pigment and may lead to disappointing results. This advice also applies to pans of watercolour paint.

### USING WATERCOLOURS

It is best to practise mixing from a small range of colours to discover what you can achieve satisfactorily. The vampire artist's first requirement is at least two of each of the primaries – red, yellow and blue. Lemon yellow, for example, is more acid and 'cooler' than cadmium yellow; cadmium red is a brilliant, pure hue, while alizarin crimson tends towards blue; ultramarine is a strong, 'warm' blue, whilst both cerulean blue and Windsor blue are cooler and greener. Start with a warm and a cool of each primary, but it is useful to also have at least one green and a few browns.

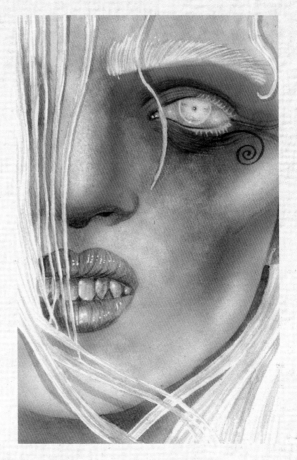

**Watercolour masking fluid ➤**
*The hair, eyebrows and highlights of the eye and lips were masked. When the paint is dry, peel off the masking and add detail to those areas.*

### TECHNIQUES

Many of the watercolour techniques, such as wet-into-wet and lifting out, are the same as those shown for inks on page 15, but do remember that watercolour remains soluble even when dry, so too many layers can stir up the colours beneath and result in a muddy effect.

**Granulation**
*Some watercolour pigments do not fully dissolve in water, creating a grainy texture that may be useful.*

**Impressing**
*A natural texture effect can be obtained by pressing several tissues hard on a partially dried area of colour.*

**Blotting with a brush**
*By blotting out spattered areas of paint with a brush, an interesting outline effect can be achieved.*

**Cloudy effects**
*Amorphous shapes can be created by brushing on an area of flat colour and, once dry, going over it with clean water before dabbing off the paint.*

**Controlled wet-on-wet**
*For soft colour transitions within a controlled area, lay a colour and then drop in more paint while still wet as it won't spread onto the dry paper.*

**Fine spattering**
*For a fine, easily controlled spray, load a toothbrush with paint and then drag a paintbrush or ruler over the bristles.*

# WATERCOLOUR
## STEP-BY-STEP

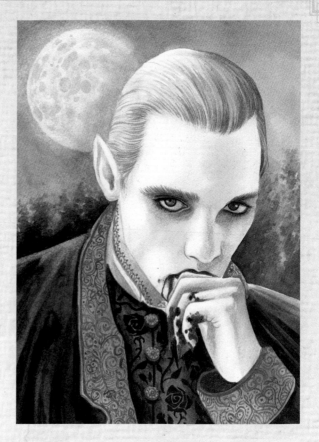

Watercolours are a transparent medium that have a quality of spontaneity about them. Some people are discouraged by using watercolours as they can be unpredictable, and it can be difficult to make corrections or changes. Watercolours sometimes have a mind of their own, blending and bleeding, seemingly indeterminately. However, this unpredictability can be their advantage; their element of randomness creates interesting results. By learning to guide their flow, you can create exciting, light-filled artwork. Watercolours reflect light beautifully and allow for layers of colour to be overlaid onto each other with a jewel-like quality.

### FINISHED PAINTING
Add elaborate designs to your vampire's clothing by using a fine brush to paint over the already dry under layer. The final touches were made to the face, hair, hands and background. See Gothic Palettes on pages 50–53 for sample blood and skin-tone colour mixes.

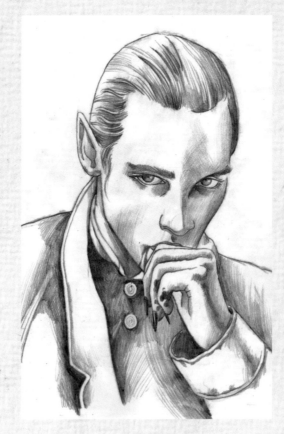

**FIRST STAGE ➤**
**Initial drawing**
*If you haven't used watercolours before, start with a simple face or figure with a simple wash background. Turn to the relevant tutorials on pages 56–81 and follow the stages described to create your initial drawing. As you become more skilled in this medium, you can paint evocative Gothic environments (see Chapter 3).*

**SECOND STAGE ▲**
**Preparation**
*Stretch the watercolour paper. When dry, cover the paper in a thin wash of colour by loading a large, soft brush with plenty of water and a little pigment. Smooth this wash over the paper. Use either a light warm colour such as yellow ochre, as used here, or a colour reflecting the overall scheme of the painting. When dry, transfer your drawing to the painting surface.*

### THIRD STAGE ➤
## Colour washes

*Use a medium-sized round watercolour brush loaded with water and pigment for each area, starting with the background colour. Mix a cool green from yellow ochre and cerulean blue, and a deep hue made up for the darker areas by adding raw umber and ultramarine. First moisten the area with water, then wash over it with your lighter hue. While the paint is still wet, add darker hues and other colours so that they merge into each other – this is known as 'wet-on-wet'. Experiment with various proportions of water and pigment to create variations in tone value. Use this technique on the different basic areas of colour; don't worry if the colours bleed into each other, as this creates interesting effects, and the areas can be defined later.*

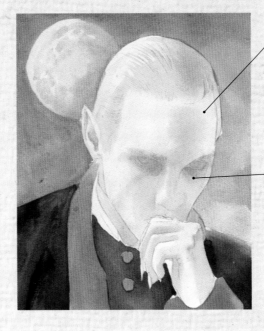

Create the skin using a diluted yellow ochre and alizarin crimson wash, followed by a less diluted wash of the same colours, painted wet-on-wet for the shaded areas.

Use the same technique for the darker shadows of the eye sockets, adding a little more crimson. With practice, you will learn to make evenly graduated washes by varying the ratio of water to pigment or blending colours.

### FOURTH STAGE ▼
## Light and form

*Lighten areas by lifting colour. Use a medium or large brush loaded with water. Wet the area, then, after drying the brush, rub the area gently to lift some of the pigment. Repeat this process until you are happy with the result.*

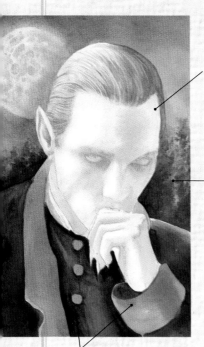

Highlight the right side of the vampire's face, as well as his nose, eyes and hand.

Use a cool green made from Prussian blue, cadmium yellow and a touch of cadmium red to paint the trees. Notice how this defines the face.

Add detail to the hair, shirt and cuff by mixing darker versions of the base colours and lightly overpainting new layers of colour.

### ◄ FIFTH STAGE
## Rendering

*Continue to render your painting by adding new layers of tones and colours as they dry. Give more depth to the hair, face, hand and costume.*

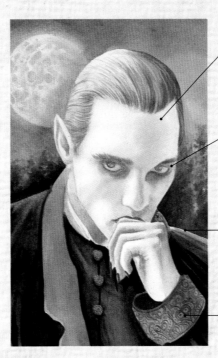

Work on the facial features and add a pink tint around the eyes. For a graduating tint, first wet the area. Brush very diluted colour over the surface and blend the edges with water.

You may also want to lift more colour at this stage. Notice how the colour on the left shoulder has been lifted to reflect the moonlight.

Start adding details to your painting, such as the designs on the Count's cuff.

Use small watercolour brushes to add strokes of paint for details of the eyelashes, eyebrows and other facial features.

# ACRYLICS

ACRYLIC PAINTS ARE HIGHLY VERSATILE; THEY ARE BY-PRODUCTS OF
THE PLASTIC INDUSTRY, JUST LIKE THE PAINT ON YOUR WALLS.

The pigments used for acrylics, with a few exceptions, are the same as those used for oils, watercolours and pastels; what makes them different is the binder, which is a polymer resin. This, once dry, acts as a form of plastic coating that cannot be removed.

Because acrylic paints are water-based, they are thinned by mixing with water or with a combination of water and one of the many mediums specially made for the purpose. With acrylics, you can paint in any consistency you like – use them in thin washes resembling watercolour, or apply colours with a knife in thick slabs. You can use thick paint in one part of a picture and thin in another, building up a variety of textures.

*Acrylics come in pots and tubes (above). Pots tend to be more fluid than tubes, so they are useful for large-scale projects.*

## BRUSHES

To a large extent, your choice of brushes will be dictated by the way you work as an artist – whether you apply the paint thickly or like to build it up in thin layers. For thick applications and impasto work, bristle brushes made for oil painting are the best choice; if you paint in a similar style to watercolour (see page 16) or with thin glazes, you would probably choose soft watercolour brushes.

Probably the best brushes are those that are made specifically for acrylic painting: they are versatile, combine the characteristics of both oil and watercolour brushes, and can also be used for medium to thick applications.

*Soft brushes were used here to build up thin layers of colour and to create an overall soft effect.*

**Types of brushes**
1 Small round nylon
2 Small flat nylon
3 Medium round nylon
4 Medium flat nylon
5 Large flat nylon
6 Medium bristle
7 Medium-large bristle
8 Large bristle
9 Small bristle

5

4

3

8

6

7

9

1

2

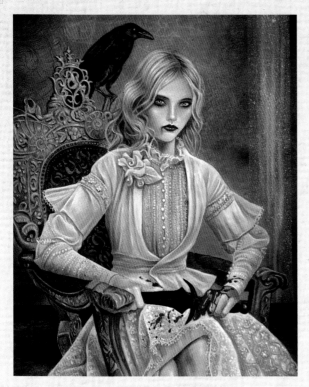

*The lace detail on this dress was added over the fast-drying underpainting of the fabric.*

## USING ACRYLICS

Acrylic paint can behave in similar ways to watercolours or oil paints, but don't consider it as a poor version of either. Acrylic is an important medium in its own right.

Although flat and graded acrylic washes are made in the same way as watercolour washes and are worked dark over light, they allow for more layers and more variations in the paint consistency than watercolour. Once the paint is dry, there is no danger that overpainted washes will disturb or move previous washes.

When used straight from the tube, acrylic paint has a buttery consistency. It can be moved and manipulated easily by brush or knife, and its character can be altered by the addition of various acrylic mediums. Paint of this consistency is perfect for direct approaches, with even relatively thick paint drying within one hour. Gel medium may be added to preserve brush and textural marks. Blending, scumbling and broken-colour techniques all work well with paint of this consistency. For impasto work, use tube acrylic paint extended with a heavy gel, or with a texture medium or paste. Alternatively, you can create your own texture medium using additives such as clean sand or sawdust.

## USING THIN PAINT

**Thin wash** Dilution with water or flow medium gives a transparent wash.

**Granulation** As in watercolour, some colours granulate when water is applied.

**Graded wash** Adding water to the mix after each stroke creates a graded wash.

**Adding white** The addition of white to the thin paint gives it a gouache-like quality.

**Dark over light** The application of dark paint over dry, light paint results in a watercolour-like effect.

**Glazing** Acrylic paint is ideal for glazing; its quick-drying capacity enables the completion of painting in one sitting.

## USING THICK PAINT

**Direct painting** Acrylic paint of a buttery consistency is perfect for rapid applications.

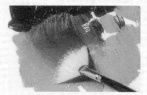

**Blending** Acrylic paint must be blended fairly quickly, before it begins to dry.

**Broken colour** Areas of broken colour can be built up easily.

**Scumbling** In this technique, a layer of wet paint is brushed over a dry, textured layer.

# ACRYLIC
## STEP-BY-STEP

Acrylics dry much faster than oils. This means that you will have to blend colours more quickly, before they dry. Faster drying can also be an advantage however, as it means that layers of paint and glazes can be worked over almost immediately. The quick-drying nature of acrylics means that glazes can be built up in any number of hues and colours. They are more opaque than watercolours, allowing for deeper colours and tones in higher contrast.

### FINISHED PAINTING

The finishing touches were added once the previous layers of paint are dry – in this example, the feathered totems hanging from the staff. A mysterious green glow was created around the gem on the staff by blending colour onto the already dry sky. As the glow faded, more water was added to dilute the strength of the colour until it was transparent. Finally, the splashes and trickles of blood were painted.

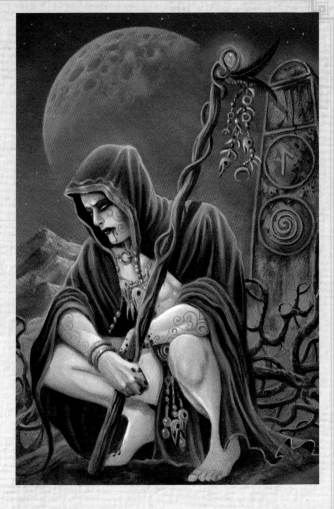

Here, a crouching figure was drawn using the framework figure technique described on page 41. He was then clothed.

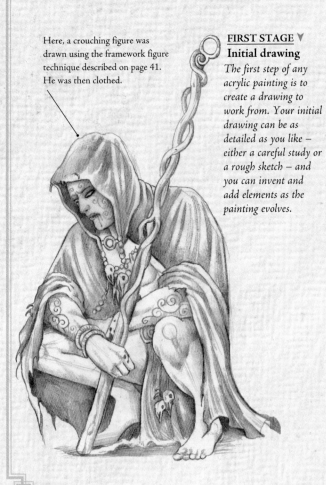

### FIRST STAGE ▼
**Initial drawing**

*The first step of any acrylic painting is to create a drawing to work from. Your initial drawing can be as detailed as you like – either a careful study or a rough sketch – and you can invent and add elements as the painting evolves.*

### SECOND STAGE ▼
**Preparation**

*Paint on watercolour paper or cartridge paper, or on panels designed for oil paints or primed hardboard. If you stretch your own paper, you will need to paint on a layer of gesso primer and let it dry before painting. Most shop-bought panels and boards for painting are already primed. Begin by painting a thin layer of acrylic paint (diluted with water) with a broad soft brush. Use colours that reflect the overall colour scheme of the painting.*

Use a light grey-blue to create a base colour for the cool moonlight and ghostly pale skin. This thin layer may be a single colour or blended colours for different parts of the painting. Let this layer dry completely – within an hour, you should be ready to start your underpainting.

# ACRYLICS

**THIRD STAGE** ▼
## Underpainting

*Transfer your initial drawing onto your painting surface. You may need to enlarge it so that it fits your painting area (see Transferring Imagery, pages 42–43). Traditionally, raw sienna or burnt sienna are used for the underpainting, but use any colour with a good tonal range. Experiment by using a colour that reflects the overall scheme of your painting, such as dark blue, purple or deep red.*

**FOURTH STAGE** ▼
## Adding colour

*When your underpainting is touch-dry, mix the colours you want to include in the background (see Gothic Palettes on pages 50–53). Using medium and large soft brushes, paint in the different coloured areas of the background, blending as you go. You can also mix new colours and blends on the painting surface and merge them together using a large dry soft or fan brush. Mix lighter hues at the horizon, merging them into the existing colours.*

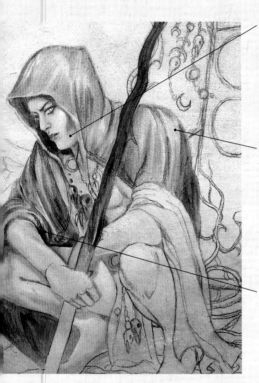

Paint the facial features in monotone, and blend the skin with titanium white to give it form. Paint the highlights with white, so that layers of colour can be added at a later stage.

Use raw sienna, along with titanium white for the highlights. Blend the colours to create shapes and areas emerging from shadow and to define forms.

Paint the darker areas of the painting, such as the inside of the cloak, in a dark tone; lighten the highlighted areas on the shoulders and hood with touches of white.

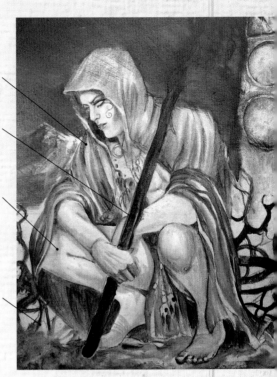

Create folds of material by blending highlights and shadows.

Simulate metal and wood by mottling dryer paint to build up texture and colour.

Blend a pallid skin colour over the underpainting in semi-opaque paint, just transparent enough to allow the underpainting to show through.

Paint finer details, such as the tree formations, with a smaller brush. Blend the colours by feathering the edges with a fan brush.

◄ **FIFTH STAGE**
## Rendering

*Once the previous stage is dry, start rendering your acrylic painting in more detail. Use small and medium soft brushes to add highlights and shadows to the surfaces of the areas of colours. You should just be able to see your original underpainting, which will act as a foundation for your rendering. Pay particular attention to where the main sources of light fall on your figure.*

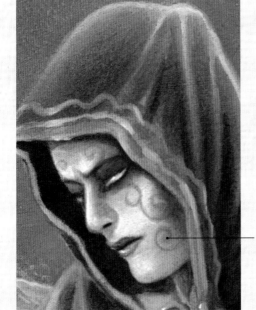

Darken the shadows and overpaint the details of the face. Mix light and dark tones from the base colours painted in the previous step, then blend into the existing dry colour to create form.

Add touches of cadmium yellow, ultramarine and alizarin crimson to white acrylic for a pale skin tone. Darken with more of the colours and raw umber or black. Add highlights using white tinted with the predominant colour of the environmental light.

# OIL PAINTS

WHILE ALTERNATIVE MEDIUMS HAVE BECOME MORE COMMONLY USED THAN OIL IN GOTHIC ART, OIL IS STILL A REWARDING PAINT WITH WHICH TO WORK.

As with watercolour and acrylic, oil is available in 'artist' and 'student' versions. There is no reason why you should not begin with students' colours to get the feel of the paint, but as you become more experienced, you should consider moving up the scale to artists' quality, because the colours are purer and brighter. They also have more tinting power than the cheaper paints, which contain less pigment and are bulked out with thinners, so you will end up using less of them.

Start off with a small range of colours and avoid buying a boxed set of paints, as these often contain colours you will never use. All oil paints can be purchased individually in standard-sized tubes, so you can add more as you need them.

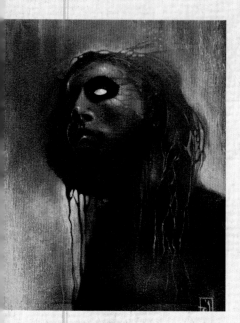

*A palette knife was used for the textured background, bristle brushes for the figure and softer brushes for the finer blending and detail.*

## BRUSHES

Bristle brushes (usually made of hogs' hair) are specifically designed for oil painting. They have long handles, unlike the brushes sold for watercolour, allowing you to stand away from the painting surface, and are made in a variety of shapes and sizes. The three main shapes are flats, rounds and filberts, all of which make distinctive marks, as shown below. Most artists also have one or two small round sable or sable-substitute brushes, which are useful for preliminary drawings and for adding fine detail in the final stages.

You don't have to use bristle brushes if they don't suit your painting style, however. They are ideal for work in which the marks of the brush play an important part, but some artists like smoother effects, so they prefer brushes made for watercolour and acrylic. Start with a small range of brushes until you discover which kind suits you best.

**Rounds:** When held vertically, rounds are ideal for stippling. They can also deliver long, continuous strokes.

**Flats:** Ideal for making distinctive square or rectangular marks.

**Filberts:** These brushes can leave rounded dabs of paint or can be twisted during a stroke to create marks of varying thickness.

### Palette knife

*An essential tool in your kit, a palette knife can be used to clean up the palette, mix large quantities of paint, and apply paint – squash the paint onto the surface so that it mixes with the colour below to create a streaky, ridged effect.*

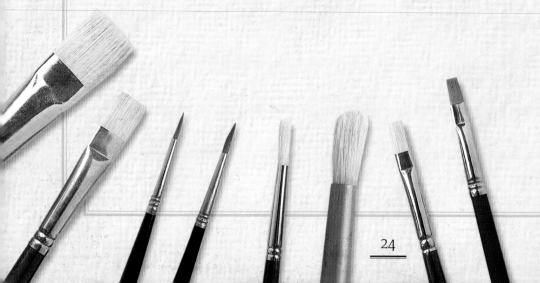

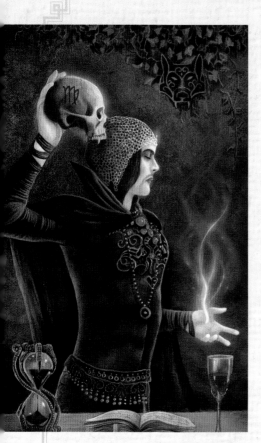

## USING OIL PAINTS

You can apply oil paint straight from the tube, but it is customary to mix it with a painting medium. The two commonest mediums are linseed oil (also used in the manufacture of paint) and turpentine. The latter thins the paint and makes it dry faster, and it is normally used in the early stages of a painting, before being mixed with greater quantities of oil as the work progresses. White spirit is sometimes thought to be an alternative, but is not recommended as it has no oil content and makes the paint look very dull; save this for its main task of washing brushes. For those who are allergic to turpentine or dislike its strong smell, special odourless and non-toxic thinners provide an alternative.

There are many other mediums sold for bulking out the paint for impasto work, making it more transparent for glazing methods and varnishing when the painting is complete and fully dry.

*Layers of colour were thinned for this painting using artist's turpentine. Paint mixed with linseed oil created the colour glazes that were laid on top.*

*With all mix mediums, read the manufacturer's instructions carefully before using.*

### Basic palette

*You will need two versions of each of the primary colours – red, blue and yellow – because even these vary in hue. As you can see from the swatches here, there is a 'warm' and a 'cool' version of each one, and this colour temperature affects the kind of mixtures you make. Six primaries, a green and one or two earth colours such as yellow ochre, raw sienna, burnt sienna and raw umber – and white, of course – will facilitate a wide range of mixtures.*

Cadmium yellow

Cadmium red

Ultramarine

Lemon yellow

Alizarin crimson

Cerulean blue

Viridian

Yellow ochre

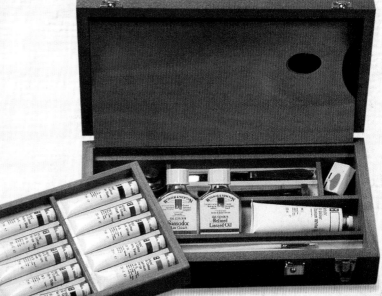

# OIL
## STEP-BY-STEP

These pages explain how to paint with oil paint using traditional methods. First, transfer your drawing onto the surface and make an underpainting to establish the forms and tones. A rough overpainting or glaze is then painted over the top before the detail is rendered. Further layers and glazes are added until the oil painting is complete. See Colour Palette on pages 46–47 for a list of oil colours you will need for your basic palette. Begin by painting a single figure with a simple background – this will help you grasp the basic techniques – then you can go on to create more in-depth paintings with Gothic backgrounds and environments, using the same methods. Start by sketching the figure of your vampire using the tutorials on pages 56–77 – then follow the steps described here to render it. (For the face, see pages 56–63.)

### FINISHED PAINTING

When all the finishing touches, such as the blood around the lips and seeping into the dress, were added, the painting was finished. Notice how the painting retained very romantic elements until the final stages, where this aspect was counterbalanced by a darker edge of Gothic horror. This juxtaposition of beauty and horror is an important aspect of vampire art, and it will give your paintings emotional impact.

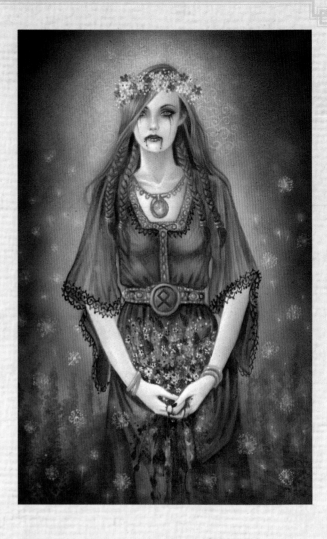

### FIRST STAGE ▽
**Drawing**

*A drawing or sketch of your vampire figure will help to establish the composition, and it becomes the foundation of your oil painting.*

### SECOND STAGE ▽
**Preparation**

*Prepare your painting surface with gesso primer for oil paints and let it dry before continuing. (Most shop-bought stretched canvas and oil painting boards are already primed.) Next, paint a thin layer of oil paint, diluted with artist's oil paint thinner or distilled turpentine, over the whole painting surface. The more diluted with thinners a layer is, the quicker it will dry. Layers of oil paints can take up to 48 hours to dry; if you like to work more quickly, mix alkyds with your paints, or use paints that already contain alkyds.*

Choose colours that reflect the overall scheme of the painting. This thin layer can be a single colour, or try merging colours for different areas of the painting. Leave this foundation layer to dry completely.

# OIL PAINTS

### THIRD STAGE ▶
### Underpainting

*Once the foundation layer of paint is dry, transfer your drawing to the painting surface (see pages 42–43). You are now ready to make your underpainting. Oil artists traditionally use raw umber for the underpainting, as it is a warm hue with a wide range of tonal values, but any colour can be used – dark blue is another traditional choice. Use a medium brush to paint over the pencil lines, defining them, and start building up the shadows and forms.*

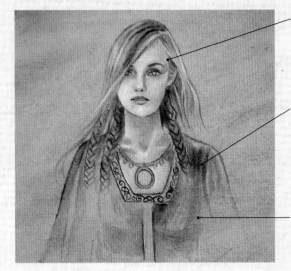

Use a smaller brush for the finer details of the underpainting, such as the facial features and costume details.

Add areas of highlight using titanium white, blended into the raw umber to create rounded forms, such as the head, arms and folds in the material.

Use raw umber to create the monotone underpainting, starting with the face and working down the painting.

### FOURTH STAGE ▼
### Adding tonal values

*Create the tonal values using raw umber and white oil paint. Add more colours, such as some background colours, and add details like the flowers.*

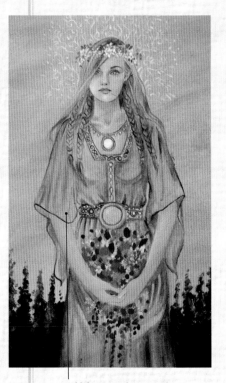

Add designs and textures that you may want to appear as semi-transparent. These could be interesting textures, costume designs, ghostly shapes or patterns.

### FIFTH STAGE ▼
### Overpainting

*Use larger soft brushes and flat fan brushes to paint over the dry underpainting. Mix up paint that is semi-transparent and opaque enough to let the underpainting show through. Blend areas of colour together. Paint a thin layer of white mixed with a little red and yellow or ochre for the skin.*

Overpaint the dress with a glaze of Payne's gray and burnt sienna. Paint the belt with yellow ochre mixed with ultramarine blue. Use the dress mix to darken the eyes, and add ivory black to create a dark glaze around the edges of the painting.

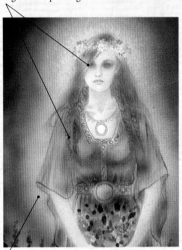

Directly around the figure, blend a glaze of yellow, burnt umber and white; surround this with a cooler green hue by adding cadmium yellow and cobalt blue.

### SIXTH STAGE ▼
### Rendering

*Once the overpainting and glazes are dry, begin rendering your vampire in more detail. Both the underpainting and the overpainting stages help you here. The underpainting works as a guide for the detail to be rendered, while the overpainting has established the foundation colours onto which you can build highlights and lowlights.*

Mix yellow ochre, cadmium red, white and a touch of cerulean blue for the skin. Add white highlights to give form.

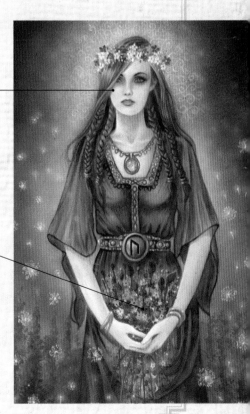

Use small, fine brushes to work into the painting and build up the details.

# Colouring Digitally

Colouring images digitally allows you to apply colour
without damaging the original drawing. It is also
easier to correct mistakes and alter colour schemes.

The following sequence describes a basic procedure for
colouring digitally using Adobe Photoshop, but the same
principles can be applied to other programs. Refer to a manual
or online help for more information on your particular software.

**Toolbar**

Marquee

Lasso — Magic Wand

Brush

Paint Bucket

Eraser

Dodge and Burn

Eyedropper

## LAYERS

Most image-editing programs allow you to put different
elements on different layers. The layers are independent
of each other, so you can work on each layer individually
without affecting the others. This allows you to experiment
with different colours and compositions more easily. You can
switch the visibility of each layer on or off, reorder the layers,
apply different digital effects to each one, adjust the opacity and
transparency of each layer, and so on.

Try to get into the habit of naming and organizing layers in
groupings that make sense to you. Being able to find what you
need easily and being able to change layer orders quickly are
important to your workflow. For example, you can allocate one
layer per colour, or one layer per object. Assigning a colour to
its own layer makes it easier to alter that colour at a later stage.
On the other hand, if you want to add effects to a particular
object, assigning it to its own layer will help. The method you
choose will depend on how you like to work and may change
from one painting to the next.

Make sure that you save a copy of the image in a
format that retains the layers, so that you can edit it later
if necessary.

▼ **1** Duplicate the Background
layer and label it 'Line Art' or
something similar. Switch off (but
do not delete) the background layer
with the original drawing on it, so
that you cannot see it but can go back
to it if necessary.

▼ **2** Select the appropriate colour mode
– CMYK if you plan to print the artwork;
RGB if it is for screen only. Then make
the 'Line Art' layer transparent by choosing
'Multiply' at the top of the Layers palette.
This makes all the white areas of the image
transparent and will allow you to see the line
drawing through the layers of colour.

▼ **3** Lay down the base colours, grouping
each colour or type of item together on
separate layers. To colour an area of your
artwork, first select it (the selected area is
defined by a dotted line). There are several
tools on the toolbar that you can see. The
Marquee tool is useful for selecting simple
geometric shapes; the Lasso tool for drawing
around an area manually; and the Magic
Wand for selecting areas where the colour
or tone is distinct.

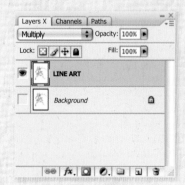

# COLOURING DIGITALLY

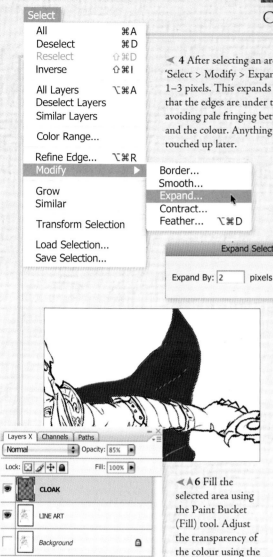

**Select**

| | |
|---|---|
| All | ⌘A |
| Deselect | ⌘D |
| Reselect | ⇧⌘D |
| Inverse | ⇧⌘I |
| All Layers | ⌥⌘A |
| Deselect Layers | |
| Similar Layers | |
| Color Range... | |
| Refine Edge... | ⌥⌘R |
| Modify ▶ | |
| Grow | |
| Similar | |
| Transform Selection | |
| Load Selection... | |
| Save Selection... | |

Modify submenu:
Border...
Smooth...
Expand...
Contract...
Feather...  ⌥⌘D

**Expand Selection**
Expand By: 2 pixels
OK
Cancel

◄ **4** After selecting an area, choose 'Select > Modify > Expand' by value 1–3 pixels. This expands the area so that the edges are under the linework, avoiding pale fringing between the lines and the colour. Anything missed can be touched up later.

▼ **5** Create a new layer for the colour. Either select a colour from a palette or create your own. It is also easy to match an existing colour in your work by clicking the Eyedropper tool, then clicking on the colour you wish to match.

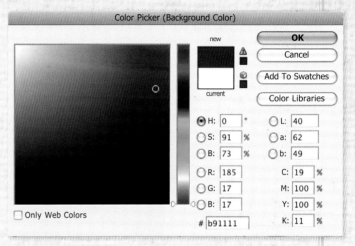

**Color Picker (Background Color)**

new
current

OK
Cancel
Add To Swatches
Color Libraries

H: 0 °     L: 40
S: 91 %    a: 62
B: 73 %    b: 49
R: 185     C: 19 %
G: 17      M: 100 %
B: 17      Y: 100 %
# b91111   K: 11 %

☐ Only Web Colors

**Layers X** | Channels | Paths

Normal    Opacity: 85%
Lock: ☐ ✎ ✚ 🔒    Fill: 100%

👁 CLOAK
👁 LINE ART
☐ Background 🔒

◄▲ **6** Fill the selected area using the Paint Bucket (Fill) tool. Adjust the transparency of the colour using the opacity percentage slider.

**7** Use a brush to paint darker ➤ shadows and lighter highlights on separate layers. A useful technique is to select the area to be coloured (Step 3), then click on the layer you wish to paint on. Use a large brush to paint the area quickly; the area selection creates a mask that will keep the colour contained within the edges. Make tonal adjustments for highlights and shadows using the Dodge tool to lighten areas, or the Burn tool to darken them.

**8** Continue building up texture and colour. Switch off the linework layer now and again so that you can see if you have missed any areas or little spots. If you need to touch up any missed areas, make sure that you do the retouching on the correct layer.

## THE PATH TO SUCCESSFUL DIGITAL COLOURING

It is well worth spending some time exploring the various options available in your particular paint program – interesting effects can be discovered through making basic mistakes.

### Special effects
Most paint programs provide lots of filters and effects to enhance your images. Use them with discretion, rather than just because they are there, but do be adventurous. The History palette will help you repeat an effect.

### Adding texture
Texture creates interest and realism. Make marks with real objects, such as a toothbrush or sponge, using black paint on white paper, and scan the results. Most paint packages will allow you to create custom brushes from your scanned marks, or the scan can be overlaid onto the painting.

### Coloured lines
Although a black ink outline is standard in comic-book art, you do not have to keep it like that. Try colourizing the line drawing (use the Hue and Saturation panel in Photoshop).

### Canvas ground
Adding a canvas ground can affect the impression and style of your art. If you can scan something, it can be used as a ground – textured paper or canvas, for example. Simply lay the scan, multiplied (transparent), over the painting. The texture will establish the colour and textural harmony of the piece.

# HOW TO GATHER INSPIRATION

INSPIRATION CAN COME FROM ANYWHERE. HOWEVER, WE EACH HAVE AN
IMAGINATION THAT IS STIMULATED IN A UNIQUE WAY, SO IT IS IMPORTANT
TO UNDERSTAND AND CULTIVATE WHAT INSPIRES YOU PERSONALLY.

Inspiration is a purely natural process; it is the act of having our
imagination, enthusiasm or emotions stimulated. This stimulation urges
us to explore, discover, invent and create with natural exuberance. You
should seek out things with a Gothic undercurrent; draw inspiration from
nature, Gothic architecture, graveyards, art, myths, books and films, or
from anything that stimulates excitement, interest or feelings of Gothic
ambience in general. You should also cultivate inspiration from other
subjects, not only Gothic, but anything that sparks an idea. Find
inspiration in biology books, antique devices, fossils, feathers, the
landscape, old photos, jewellery or costumes, museums, art galleries,
sculpture, poetry, music, fashion or magazines. A leaf texture can become
a phantom's gown; a twisted root may become the face of a weeping ghost.

## JOURNALS, SKETCHBOOKS AND SCRAPBOOKS

Keep a journal or sketchbook to record your
thoughts and any inspiring imagery – sketch things
that inspire you while out and about and take
photographs of anything that stimulates your
imagination. It's a good idea to keep a scrapbook in
which you can store cuttings from magazines and
newspapers; natural materials such as leaves and
feathers; and textured papers, articles, poetry and
colour/mood ideas. You can browse back through
the pages when you start a new work of art.

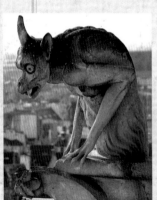

**Gothic architecture**
◄ Draw inspiration
from ancient Gothic
buildings such as
churches, castles and
monasteries. Record
details of structural
design, archways,
architectural details,
gargoyles, fountains
and stairways.

**Nature ►**
The natural world is teeming with inspiration.
Draw details such as textures of tree bark and
fossils, insects, shells and seeds; or capture
bigger things – the anatomy of large animals,
waterfalls, caverns, forests or stormy landscapes.

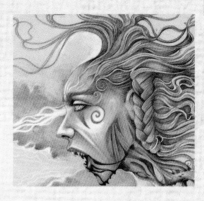

## Myths ➤

Look to myths and legends for inspiration. The vampire myth abounds in cultures from around the world, appearing in many weird and wonderful forms, from the deadly Rakshasa of India to the screeching Penanggal of Malaysia (right).

## Graveyards ◀

You will find a wealth of inspiration around old graveyards. Pay particular attention to details like the carved designs of tombstones, overgrown graves and crumbling stonework. Graveyard statues can be a fantastic source of reference.

## Film ▽

Another source of inspiration is film – from the early vampire films such as *Nosferatu* (below), to the Hammer House features of the 1960s and 1970s, and modern films with a Gothic theme such as the *Blade* trilogy.

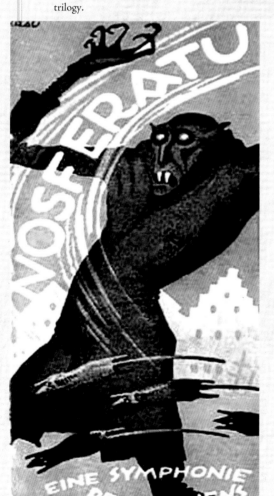

## Art ▽

Many art movements and periods have explored a Gothic theme – from the bizarre works of Hieronymus Bosch, to the Romantics, the Pre-Raphaelites, and the Symbolists – such as Fernand Khnopff (*The Blood of Medusa* is shown below), and the Surrealists. Also look to modern Gothic artists, conceptual art, graphic novels and photography.

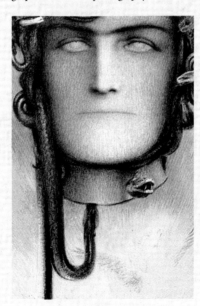

## Books ▲

Immerse yourself in works of fiction about vampires and Gothic horror, both contemporary and traditional – *Dracula* is the most widely known, thought to be based on the historical figure Vlad Tepes, shown above. Edgar Allan Poe, H.P. Lovecraft and Mary Shelley are just some of the authors to seek out.

# IDEAS AND IMAGINATION

THE PREVIOUS PAGES EXPLAINED HOW TO CULTIVATE AND GATHER INSPIRATION;
NOW EXPLORE HOW TO TRANSFORM THAT INSPIRATION INTO IDEAS AND CONCEPTS
THAT WILL BE THE FOUNDATION FOR YOUR PAINTINGS AND DRAWINGS.

Painting can be a way to express our emotions, thoughts, ideas, dreams and nightmares. The vampire myths explore universal themes relating to life and death, love, beauty, sorrow, decay, immortality and eternal sleep, loss and resurrection. They tap into our primal fears, hopes and spiritual hunger – all subjects worthy of our contemplation and creativity.

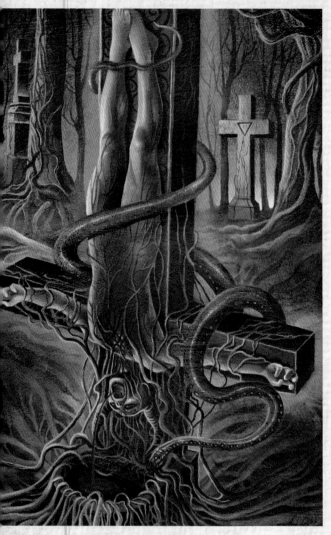

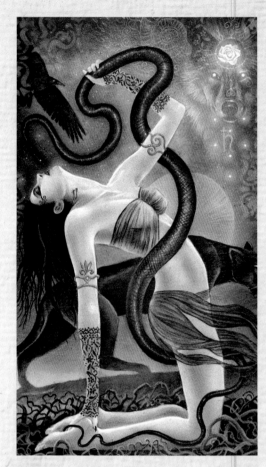

**Imagination ➤**

Following the spark of inspiration, imagination is the next step in the creation of anything. When we imagine, we are taking the first step towards making the impossible possible. Without dreaming that something is possible, nothing would occur; nothing new would be created. Imagination opens the gateway to your unique creativity. Rather than recreating art and ideas you have seen before, try to surprise yourself by dreaming up new and wondrous concepts and combinations of ideas and imagery. Make notes and sketches in your journal before developing concepts and ideas.

**➤ Innovation**

Invent innovative vampire characters and creatures by combining multiple elements and ideas. This drawing of a chupacabra (a vampire creature of Mexican myth) was created by combining various animal and human body parts.

**▲ Drama**

Use narrative and symbolism to enhance dramatic effect. Here, the theme of sacrifice is dramatized.

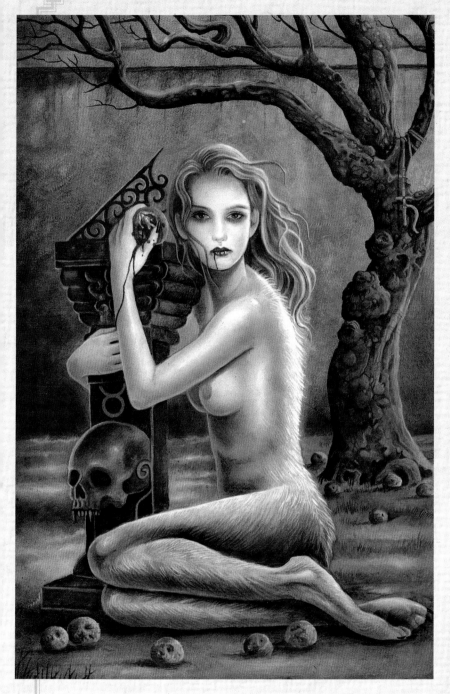

## Ideas ▽

Once we know what it is we want to say, we can begin to formulate our ideas in order to communicate our message in the most powerful way. The concept begins to take shape. How can you best express the feelings and themes involved? What objects can you utilize? What environment (see pages 50–53) would best portray the message? How are the figures interacting with the objects and the environment around them? What are their expressions and poses saying about their feelings? Gather your ideas in note form and make sketches; play with them until you build a structure of ideas with which you are happy. The tokoloshe below is a vampire entity from African mythology. In order to portray the African elements, skin and fur of African animals were included – the coarse hair of a baboon and the markings of a leopard.

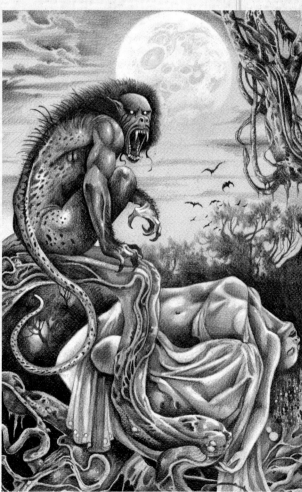

## Concepts △

Developing a concept engages our mental skills. This is where we conceive the vision – using symbolism (see page 34), interaction of elements and association of ideas. This painting, called 'Forbidden Fruit', explores the theme of time and mortality and how new life is drawn from the old (the fruit) in order for regeneration to happen. Notice how the female vampire clings to the sundial (representing time) while sucking the life essence from the fallen blood-fruit. The dying tree, her sorrowful expression and the sexual undertones add more layers of conceptual meaning.

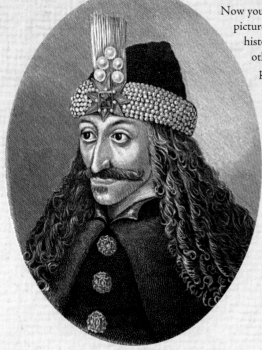

### RESEARCH AND REFERENCE

Now you are ready to turn your attention to the more practical side of picture making. Do your research: This could include exploring historical details, costume designs and architecture, and investigating other elements of the painting. You may want to look at photographs of snakeskin for the skin of your vampire, or the head and hind legs of a wolf for a hybrid vampire. Perhaps you need to research Celtic folklore, or gather images of root-covered ruins. Libraries and the Internet are great sources of information. This original image of Vlad Tepes (left) formed the basis of the portrait of Dracula on page 31.

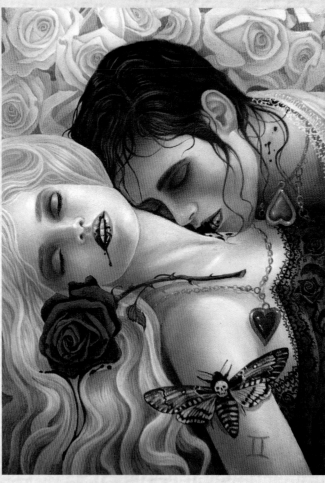

### Photographs ▽

Photography is an invaluable tool for the Gothic artist. Take shots for research and reference, from landscapes, graveyards and ruins, to twisted trees, cave entrances and crumbling cliff faces. You can also take photographs to use as the basis for figures in your painting. This pose and costume were inspired by Gothic belly dancing, and formed the basis for a vampire painting.

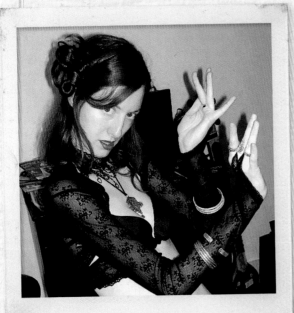

### Symbolism ▲

The practice of representing meanings through symbols is known as symbolism. It is believed that each of us has a subconscious 'map' of symbolic imagery that we have gathered consciously or unconsciously, as well as being inherited at a deeper level – known as the 'collective unconscious'. Blood is symbolic of life energy, so spilt blood represents loss of life and fear of death. The red rose above is used as a symbol of love – but blood is spilling from its centre, conjuring up meanings that blend love, life and death. The death-hawk moth features here as a more cryptic symbol of duality, death and transformation. The red and green heart lockets add more layers of meaning.

### The macabre ▼

Vampire legends are steeped in gruesome and horrifying imagery. You may want to explore the ghastly or bizarre aspects of the Gothic genre – or perhaps the romance and beauty are of more interest to you. A blend of these different elements within one painting can give your art a certain potency. Often, a gruesome image can be made to seem even more macabre when a sense of beauty is present, or a romantic image becomes darkly poetic when a bizarre, ugly or mournful element, such as a skull, is included.

### Fantasy ➤

To engage with the imagination of your audience, you may like to include elements of fantasy or dreamlike aspects. Fantasy is the extravagant and unrestrained forming of mental images, especially the strange, wondrous or fanciful. When applied to works of Gothic horror, fantasy focuses primarily on the supernatural, spiritual, demonic or unnatural. Here, descriptions of the cherubim and seraphim from Hebrew myth were used to create this fantasy painting of fallen angels.

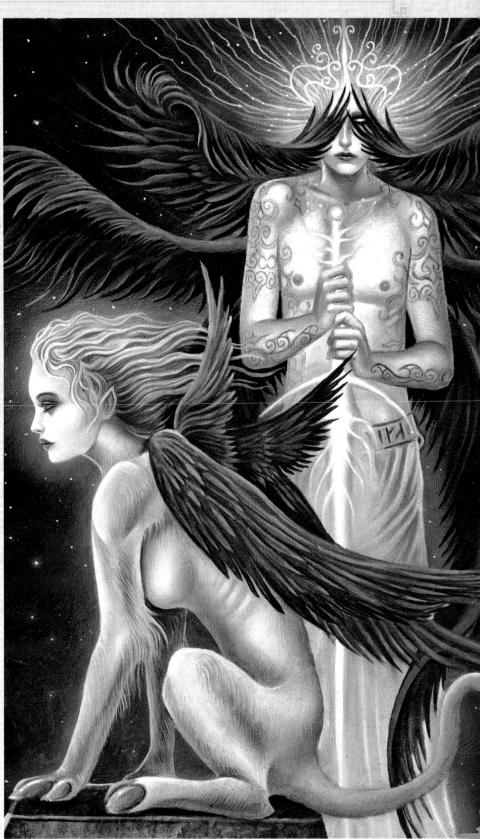

# PERSPECTIVE

TO CREATE CONVINCING ENVIRONMENTS FOR YOUR VAMPIRES AND GOTHIC CHARACTERS, YOU NEED TO MAKE THEM LOOK AS REAL AS POSSIBLE. PERSPECTIVE WILL GIVE YOUR DRAWINGS AND PAINTINGS A TRUE SENSE OF DEPTH AND DISTANCE.

The term 'perspective' refers to a set of rules that help to create a convincing sense of depth in a flat image. Perspective drawing is a technique used to represent three-dimensional images on a two-dimensional picture plane (PP). Objects appear to get smaller and closer together the further away they are. If you look along a straight corridor, the parallel walls and edges of the floor appear to meet at a point in the distance, called the vanishing point (VP), is used to enhance realism. The viewer's eye level is called the horizon line (HL) and represents the height at which the viewer of the picture is standing. This line, directly opposite the viewer's eye, represents objects infinitely far away – they have diminished in size, to the thickness of a line. The HL is shown in these drawings as a white line. Any perspective representation of a scene that includes parallel lines will have one or more vanishing points – shown in these examples by a black cross.

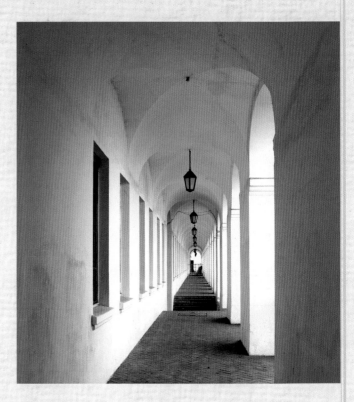

## ONE-POINT PERSPECTIVE

'One-point perspective' means that the picture has a single VP. All lines parallel to the viewer's line of sight recede towards this VP. One VP, typically used for pathways, tracks, hallways or buildings, shows the front directly facing the viewer. Any objects that are made up of lines either directly parallel with the viewer's line of sight or perpendicular to it can be represented with one-point perspective. This not only applies to buildings and pathways but also natural objects such as trees and cliff faces. In one-point perspective, the VP is always on the HL. To begin drawing in perspective, draw an HL and mark the VP at the centre. Lines that are parallel in real life are drawn intersecting at the VP. As things get closer to the VP they grow smaller and smaller until they appear to vanish. You can see the top of an object if it is below the HL, but if an object is above it you cannot see its top. One-point perspective draws the eye towards the VP, making a natural focal point. Notice how lines above the HL slope down, while those below slope up.

**Lower horizon line** ➤

The HL represents the eye level of the viewer. The further the HL is towards the bottom of the picture, the lower the viewer is standing. Notice here how less of the chequered floor can be seen because the viewer is more on a level with that plane. Objects seem to tower above the viewer more, and the angles of receding walls and lines above the HL slope down towards the VP more steeply.

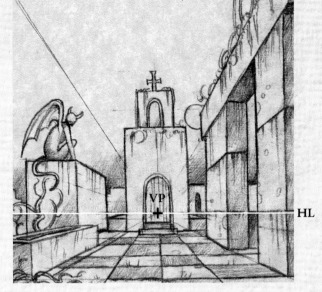

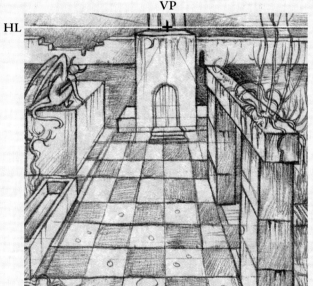

◀ **Higher horizon line**

If you would like the viewer to be higher above the scene, place the HL towards the top of the picture. Wherever the HL is, all lines that recede away from the viewer converge towards the VP. Here, the viewer is on a level with the window at the top of the chapel opposite. Notice how more of the floor and the tops of objects below the HL can be seen.

**Vanishing point** ➤

When the VP is placed on the HL, this is the direction in which the viewer is looking. Placing the VP towards the right or left leads the eye in that direction. Always place the VP where you would like the viewer to be looking – perhaps towards a point of interest in the picture. Notice how more of the left-side walls of the buildings and objects can be seen because the VP is towards the far right.

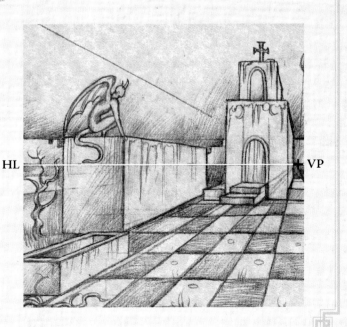

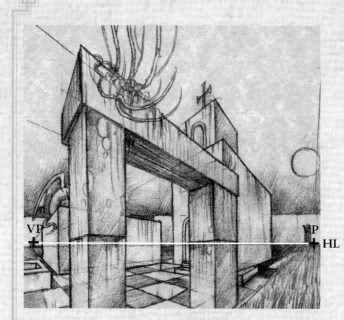

### ◄ TWO-POINT PERSPECTIVE

Two-point perspective is used to draw the same objects as one-point perspective, but rotated – looking at the corner of a house, for example. One VP represents one set of parallel lines, while the other VP represents another. In this example, the viewer is standing directly at the corner of the nearest stone column. Parallel lines recede towards the right VP on the right-hand side of the corner, and to the left VP on the left-hand side. Two-point perspective has one set of lines parallel to the picture plane and two sets oblique to it. It is often used when drawing buildings in the landscape or to represent hallways receding in different directions.

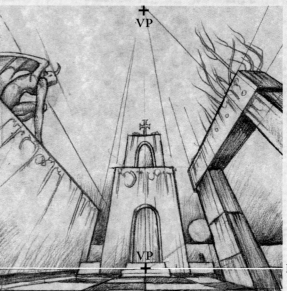

### ▲ VERTICAL PERSPECTIVE

To create the dramatic effect of looking up at objects towering above, use vertical perspective. The technique works best by having a very low HL, so that the viewer appears to be low on the ground. Place your VP on the HL, to which lines on the horizontal plane converge. At the top of your picture place another VP. All vertical lines should be drawn to converge towards this second VP, creating the illusion of looking up at looming structures, whether they be buildings, trees or cliffs. Here, as with all VPs, the VP does not need to be placed within the frame of the picture.

### ◄ Vertical perspective – downwards view

Vertical perspective can also apply if you want the viewer to be looking down into the depths below. Use the same technique as for vertical perspective, but place the second VP at the bottom of the picture or beyond its bottom edge. All vertical lines will recede into the distance below, as in this painting, where the vampire towers can be seen descending deep into the waters.

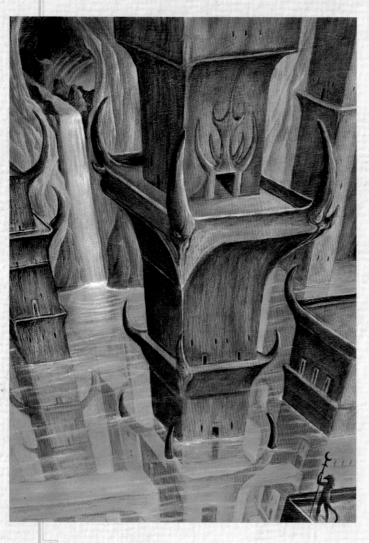

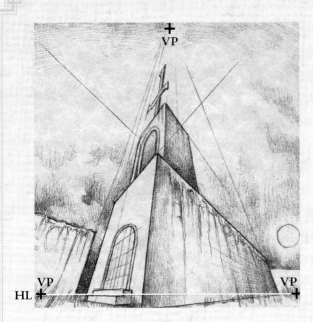

## THREE-POINT PERSPECTIVE

You can combine the rules of two-point perspective with vertical perspective to create three-point perspective. In this case, lines to the right recede to a right-hand VP, lines to the left converge to a left-hand VP, and vertical lines meet at a point above or below (see Vertical Perspective).

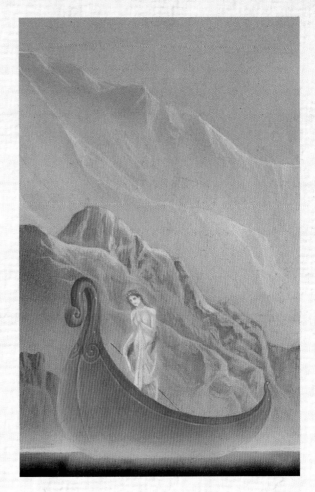

## AERIAL PERSPECTIVE ►

Aerial perspective is the visual effect of light passing through the atmosphere. The purpose of using aerial perspective is to give your drawings depth and a sense of realism. Features and objects appear lighter and less detailed as they recede into the distance. They also appear to lose colour, or saturation, as they fade into the background. Refraction in the atmosphere causes changes so that distant objects, like hills and mountains or distant buildings, appear more blue or 'colder' in colour. The focus is less sharp than foreground features, so that you cannot see much detail, and the tonal contrasts become muted, with little apparent difference between light and dark colours.

## FORESHORTENING

Foreshortening is an important concept in art where visual perspective is being depicted. It refers to the visual effect or optical illusion that means that an object or distance appears shorter than it actually is because it is angled towards the viewer, and objects closer to the viewer appear larger. You can recreate this effect by making things that are close to the front of your picture larger than the same-sized objects farther away. See page 96 – the Vampire Monster – and notice how the right hand, closer to the viewer, is significantly larger than the left one, which is further away. Notice, too, how the cylinders are foreshortened, appearing shorter than they actually are as they ascend into the darkness above.

# COMPOSITION

A DYNAMIC AND ALLURING VAMPIRE PAINTING WILL ALMOST ALWAYS HAVE A GOOD COMPOSITION. THE ARRANGEMENT OF THE COMPONENT PARTS OF YOUR PICTURE ARE ESSENTIAL FOR CREATING IMPACT – AND CAPTIVATING THE VIEWER.

A well-composed Gothic painting grabs your attention from a distance, even before you notice the details. Good composition results in the viewer remaining engaged long enough to look deeper into the artwork. Your pictures should form balanced and interesting arrangements.

The following examples show some traditional compositional picture structures. The components have been simplified to illustrate the basic dynamic of each structure. You could include more than one of these within a single painting.

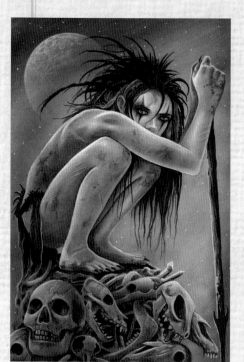

**Symmetrical** ▽

Symmetrical pictures have the same number of objects, shapes or focal points on both sides – each side acts like a mirror image of the other. All of the parts are equally important and there should be the same amount of visual interest or 'weight' on each side. The eye is drawn to both sides of the painting equally.

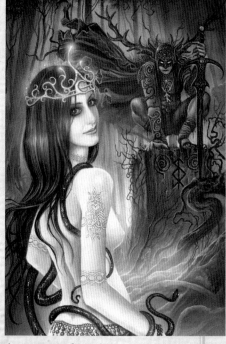

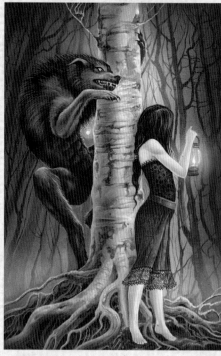

**Centralized** ▲

This composition is the simplest but can produce an extremely captivating image with direct impact. The main shape or focal point is centralized, somewhere in the middle of the picture, so that the eye is drawn towards it, with powerful effect.

**Asymmetrical** ▲

Asymmetrical composition positions the main focus or shape to one side of the picture. This is counterbalanced by components on the other side. The eye is first drawn to the main component then travels to the others. This kind of composition often relies on visual tension between the two sides of the picture.

### Rhythmic ▼

As with all artistic disciplines, rhythm is crucial to composition in the visual arts. Try to lead the viewer around the different components of your composition by creating shapes and lines that flow towards each other and follow the desired rhythm of the painting.

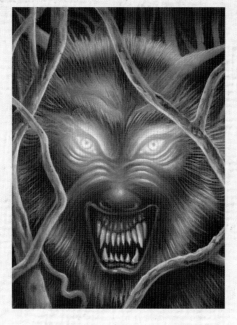

### Framed ◄

This compositional technique frames the main shape or focus within an outer frame. This has the effect of making the viewer peer into the picture, so it is perfect for creating a Gothic environment in which the viewer is looking into a deep forest or through an archway. And perhaps someone, or something, is peering out…

### Sequential (see below)

Sequential composition relies completely on the movement of the viewer's eye across the picture plane. Varying the shape, size and visual values of the painting's components creates an intriguing visual narrative. The eye flows from one object to the next, just as the changing notes lead a listener through a piece of music.

### COMPOSITIONAL STUDY

This painting, 'The Snow, The Crow and The Blood', illustrates many of the compositional techniques mentioned, along with a few others that will help you decide on a structure for your own paintings.

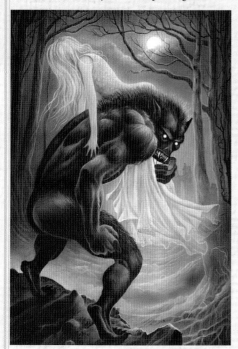

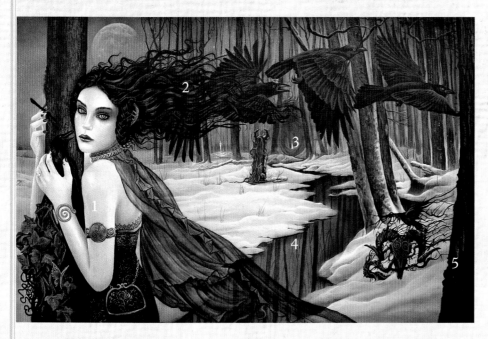

**1** The painting is composed using the sequential technique (see above), unfolding from left to right.
**2** The vampire's flowing hair, the crows emerging from it and her gown, all enhance the sequential effect and create a rhythmic composition.
**3** The second most important focal point is the blood-red tomb entrance. Attention is drawn to this by its centralized position and the vibrancy of its colour.
**4** The icy river entices the viewer deep into the painting, towards the tomb.
**5** The figure and the tree in the foreground on the far right form a frame (see Framed, above) for the unfolding story.

# TRANSFERRING IMAGERY

❧

WHEN YOU WANT TO COPY AN IMAGE, YOU'LL NEED TO REPRODUCE IT AS CLOSE
TO THE ORIGINAL AS POSSIBLE. THERE ARE TWO METHODS FOR TRANSFERRING
ACCURATE COPIES READY FOR PAINTING: TRACING AND USING A GRID.

**TRACING IMAGES**

Tracing is a simple way to produce accurate, same-size copies of your chosen images. Just place the tracing paper over the image you want to trace, secure it in place with small pieces of masking tape, and use an HB pencil to draw the main elements of the subject onto the tracing paper. Then you can transfer the tracing to your paper in one of the following ways.

**YOU WILL NEED**

+ Good quality tracing paper
+ Ready-coated graphite paper (To make your own, take a piece of copier paper and rub an HB graphite stick all over one side.

Re-coat after each use.)
+ Masking paper
+ HB and 4H pencils
+ Low-tack masking tape
+ Drawing paper

**Making an exact copy with graphite paper**

This easy method creates an almost exact copy of the image you wish to reproduce; in order to achieve the best results, remember to draw over your lines as accurately as possible, and keep an eye on the drawing as you progress to make sure that you have all of the lines traced out.

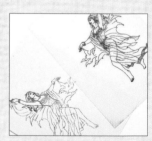

**1** Secure the image. Place the graphite sheet under the tracing paper and, with a sharp 4H pencil, draw over the original. If the graphite messes up the paper beneath, erase any fogging when the tracing is complete.

**2** Remember to lift the sheets to check your work every so often as you progress. If the image is very faint, it might help to go over some of the lines while you still have the paper secured.

**3** The copy should be almost the same as the original. When you are happy with your image, carefully remove the tracing sheet and graphite paper.

**Making a mirror image with masking paper**

As long as you remember to check your work as you progress, and draw over the existing lines carefully, this is a simple, effective method. Once you have traced your desired image onto your tracing paper with an HB pencil, begin to transfer it to your paper. There is no need to use graphite paper in this instance.

**1** Make sure that the tracing sheet is placed drawing-side down (i.e. the HB pencil lines are facing the paper surface). The image will appear reversed. After making sure that it is secured, use a 4H pencil to draw carefully over the image.

**2** Check the image often to ensure that you are transferring all of it. If you find the image too faint, go over the lines again while your tracing sheet is in place. It is difficult to re-align an image after you have finished.

**3** The end result will be a mirror image of the traced image. Remove the tracing paper very carefully and go over the image with your HB pencil (or a pen, if you prefer).

## USING A GRID

A grid is a handy way to reproduce images that you want to enlarge or reduce. Of course you can also use it to create same-size copies.

**1** Use the ruler and fine-line pen to draw a grid of 2.5-cm (1-in) squares large enough to cover the picture you want to reproduce onto an acetate sheet.

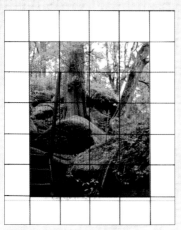

*Photograph with an acetate grid.*

**2** Secure the picture to a piece of paper or cardboard with small pieces of masking tape. Lay the acetate grid over it and secure that in place, too.

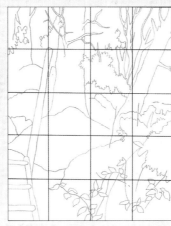

*Pencil sketch extrapolated from the gridded photograph.*

**3** On your drawing paper, use your HB pencil to lightly draw a faint grid with the same number of squares. For a same-size copy, use the same size squares. To enlarge the image use bigger squares, and to reduce it use smaller squares.

**4** Now copy the information in each square, one square at a time. As long as your grid lines are faint they will be covered by your paint. Any that remain outside the picture area can be erased carefully when the painting is complete.

*Using the grid method, draw as much detail (right) or as little (above) as you'd like.*

### YOU WILL NEED

- Sheet of clear acetate large enough to cover the image and overlap a little on each of the sides
- Black, permanent, fine-line pen
- Ruler
- HB pencil
- Drawing paper
- Spare sheet of paper
- Low-tack masking tape

### SOURCING IMAGES

There are plenty of images in this book for you to copy, including the templates on pages 114–125, or you might want to work from drawings in your sketchbook or photographs that you have taken.

# UNDERSTANDING COLOUR

THE ABILITY TO MIX COLOUR TO THE RIGHT SHADES COMES WITH EXPERIENCE AND PRACTICE, BUT KNOWING ABOUT THE PROPERTIES OF COLOURS WILL HELP YOU ACHIEVE SUCCESSFUL MIXTURES AND CREATE ATMOSPHERE IN YOUR PAINTINGS.

## PRIMARY AND SECONDARY COLOURS

Most of us know that red, yellow and blue are primary colours – so called because they can't be made by mixing other colours – and that mixtures of any two of these create a secondary colour – orange, green and violet. But there is more than one version of each primary colour, so for successful colour mixing you need six primaries, not just three.

Most artists have their own favourite colours that they would find it hard to do without, but for beginners it is best to start with a fairly small range and discover what colours can be mixed from them.

## Colour wheel

The colour wheel is an arrangement of colours that shows the basic aspects of colour theory. Between each of the primary colours is the secondary colour achieved by mixing them together. The colours opposite each other on the wheel are complementary pairs.

## COMPLEMENTARY COLOURS

Complementary colours are those opposite one another on the wheel. There are three pairs: red and green, blue and orange, and yellow and violet. Each pair consists of one primary and one secondary colour. When combining these, you are in effect mixing three primary colours (see Tertiary Colours, opposite). However, unlike some three-colour mixes, the complementaries cancel one another out, producing muted neutrals.

Conversely, complementary colours, when placed side by side as opposed to being mixed, produce vibrant contrasts. For example, a splash of red blood against olive skin will make the red more intense.

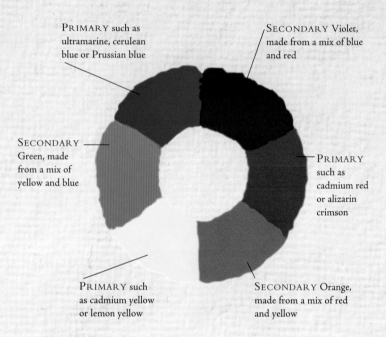

PRIMARY such as ultramarine, cerulean blue or Prussian blue

SECONDARY Violet, made from a mix of blue and red

SECONDARY Green, made from a mix of yellow and blue

PRIMARY such as cadmium red or alizarin crimson

PRIMARY such as cadmium yellow or lemon yellow

SECONDARY Orange, made from a mix of red and yellow

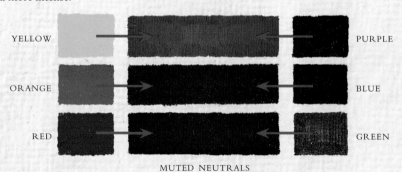

YELLOW      PURPLE

ORANGE      BLUE

RED      GREEN

MUTED NEUTRALS

## MODIFYING HUES

If a colour is very strong, it can look artificial and will not be ideal for using straight out of the tube. To give a more natural look, modify a hue that is too bright by adding small amounts of more subdued earth colours such as brown and ochre. You can also make colours subtler by adding touches of their complementary colour.

44

## ▼ TERTIARY COLOURS

Tertiary colours are produced by mixing a primary with a secondary. If a primary is mixed with the secondary next to it on the colour wheel, the result is usually a harmonious blend of the two colours. If a primary is mixed with the secondary opposite it on the wheel, a more neutral colour (brown or grey) is likely to result. As with the secondary colours, a huge range can be achieved by varying the proportions. Although most starter palettes contain two or three tertiary colours, it is good practice – and fun – to try mixing your own.

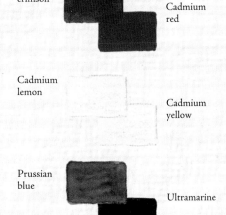

### Tertiary colour wheel

This wheel shows primary, secondary and tertiary colours of pigments. The tertiary colours are produced by mixing a primary colour with the secondary colour nearest to it on the wheel. The tertiary colours here are red-orange, yellow-orange, yellow-green, blue-green, blue-violet and red-violet.

## ▼ PRIMARY COLOUR MIXES

The most vivid secondary colours are made by mixing primaries that are inclined towards the temperature of secondary that you want to achieve. For example, cadmium red and cadmium yellow, which both have a warm bias, produce a warm, vivid orange, whereas alizarin crimson and lemon yellow, which both have a blue bias, produce a paler, muddier orange.

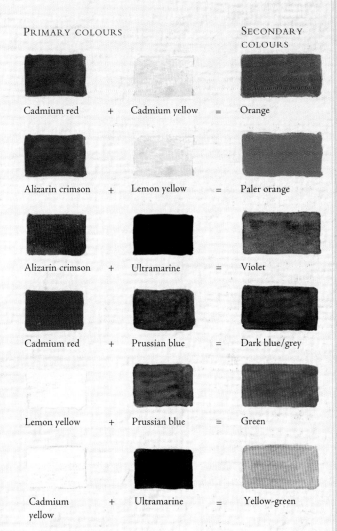

| PRIMARY COLOURS | | | SECONDARY COLOURS |
|---|---|---|---|
| Cadmium red | + Cadmium yellow | = | Orange |
| Alizarin crimson | + Lemon yellow | = | Paler orange |
| Alizarin crimson | + Ultramarine | = | Violet |
| Cadmium red | + Prussian blue | = | Dark blue/grey |
| Lemon yellow | + Prussian blue | = | Green |
| Cadmium yellow | + Ultramarine | = | Yellow-green |

## ◄ WARM AND COOL COLOURS

Colours are often described in terms of 'temperature', with blues and blue-greens described as cool and reds and oranges as warm. But each colour, including the primaries, secondaries and so-called neutral colours, has a warm and a cool version. The slightly blue alizarin crimson, for example, is cool in comparison with cadmium red, while ultramarine is warm in comparison with the greenish Prussian blue. The concept of warm and cool colours is important in painting, as it allows you to create depth. As objects become more distant, the colours become paler and cooler.

# COLOUR PALETTES

THE WORD 'PALETTE' HAS TWO MEANINGS: IT IS THE SURFACE ON WHICH YOU MIX YOUR PAINT, BUT IT IS ALSO A TERM USED TO DESCRIBE AN ARTIST'S CHOSEN RANGE OF COLOURS.

Although professional painters may have a palette of up to 20 colours, it is best to start with a small range initially, as this will give you valuable practice in colour mixing. You won't know what other colours you need until you have discovered what you can and can't do with a standard range, and new colours can be added gradually.

### STANDARD PALETTE

You will always need two versions of each of the primary colours – red, yellow and blue – because even these colours vary in hue. As you can see from these swatches, there is a 'warm' and 'cool' version of each one, and this 'colour temperature' affects the kind of mixtures you make. Your basic palette should include cadmium red, alizarin crimson, cadmium yellow, lemon yellow (or cadmium lemon), ultramarine and cerulean blue (or Prussian blue). You will also need a white, such as titanium white, and a black, such as ivory black or lamp black. With these eight pigments you will be able to mix any number of colours and hues.

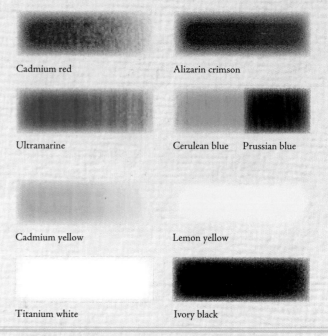

Cadmium red

Alizarin crimson

Ultramarine

Cerulean blue  Prussian blue

Cadmium yellow

Lemon yellow

Titanium white

Ivory black

### VAMPIRE COLOUR MIXES

The following swatches show which paints can be mixed to create palettes for specific vampire themes. Experiment with different combinations until you find your perfect colour. Try adding different colours to see the effects.

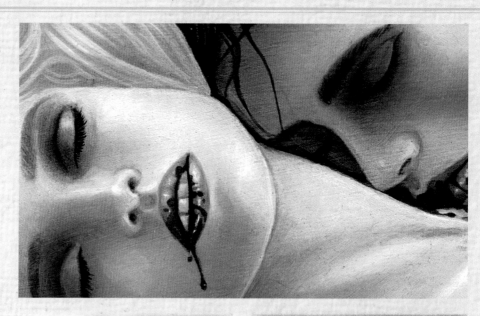

### Flesh and blood

*The lightest areas of the skin were created by mixing white with a little cadmium yellow, with cerulean blue and raw umber added for darker areas. For freshly spilled blood, mix the lighter paints listed.*

**Flesh** Titanium white, cadmium yellow, cadmium red, alizarin crimson, cerulean blue, raw umber

**Blood** Cadmium yellow, cadmium red, alizarin crimson, burnt umber, raw umber, ivory black

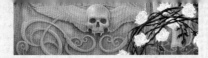

Raw umber

Sap green

Burnt umber

Cadmium orange

Yellow ochre

Purple lake

Raw sienna

Payne's gray

Viridian

A number of other colours will come in very useful, either to save time mixing from the primary colours or because they have other qualities that will be helpful and will increase your range of hues. You may want to add two or three earth colours, such as raw umber, burnt umber, yellow ochre or raw sienna. Raw umber is particularly useful as it is widely used for underpainting. A couple of greens will also prove useful, especially viridian and sap green. If you would like to add the other secondary colours to your palette, try cadmium orange and purple lake. Another useful pigment is Payne's gray, which can be used to dull down colours that are too intense.

This standard palette applies to any medium you are using. If you have trouble finding a particular colour, buy one that is similar in colour, temperature and hue; some colours are practically the same but have different names.

## PERSONAL PALETTE

The choice of colours is always, to some extent, personal. All artists have their favourites, and choice also depends on your style of Gothic art and subject matter. If, for example, you like to paint your vampires in natural settings, you will use more greens and earth colours; if you like to concentrate on portraits, you will be mixing more flesh tones.

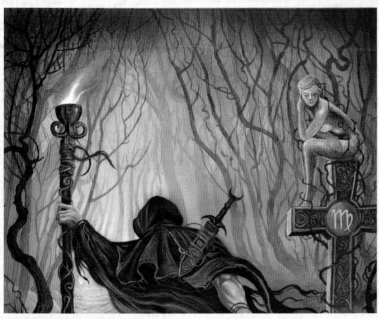

**Environment colours**
*A variety of different colour blends were used here to create the setting. Use the colours listed here to make your own palettes (see Gothic Palettes on pages 50–53).*

**Mist** Titanium white, cerulean blue, raw umber, ultramarine, cadmium yellow, alizarin crimson, sap green

**Earth** Lemon yellow, ultramarine, raw umber, burnt umber, burnt sienna, alizarin crimson

**Foliage** Titanium white, lemon yellow, cadmium yellow, sap green, yellow ochre, Prussian blue, viridian

**Stone** Titanium white, cerulean blue, cadmium red, yellow ochre, raw umber, ivory black

# LIGHT AND SHADOW

DRAMATIC TECHNIQUES SUCH AS UPLIGHTING, SILHOUETTE, AURAS AND DEEP
SHADOWS WILL ALL AID YOU IN CREATING CHILLING AND SUPERNATURAL SCENES.

### ◄ LIGHT AND FORM

The most fundamental purpose of light
and shadow in a painting is to create
form. Be aware of where the main source
of light is: All surfaces that face this light
source – figures and the surrounding
environment – should be highlighted,
while the surfaces that face away from the
light will be in increasing darkness. By
graduating from light to shadow, you will
create the three-dimensional solid form
that will make your subjects more
believable. The highlighted areas should
reflect the type and colour of the main
light source. If, for example, the scene is
set under hazy moonlight, use a cool,
eerie blue. If your subject is lit by stark
light, such as flames, make the highlights
sharper and more defined.

Notice here how the tops of
the gargoyles are bathed in the
moonlight from above, and their
undersides deepen into shadow to
create their forms.

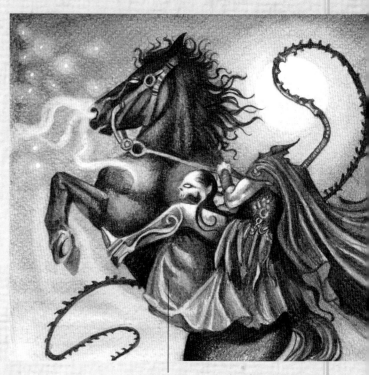

The tonal values of this headless
horseman create a silhouette
effect, while still retaining the finer
details within its dramatic shape.

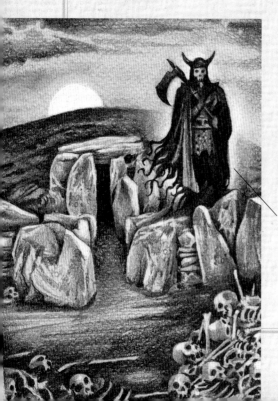

### ◄ Mystery

*Here, the half-hidden full moon acts
as a focal point, drawing the viewer
towards the centre of the image.
Its brightness contrasts with the
mysterious darkness of the burial
mound entrance. Note how the
forms of the bones and stones are
picked out with touches of moonlight.
When creating your artwork, try to
communicate your feelings through
your use of light and shadow.*

Surround your figures with
a mysterious glow for a mood
of ghostly otherworldliness.

### ▲ Silhouette effects

*By drawing attention to a subject's outline you can give
it heightened drama. Silhouetting your subject will
create more impact and is a technique used widely in
Gothic art.*

### TONAL CONTRAST

When composing your pictures, take time to
decide which areas are to be in light and which
are to be in shadow. Create a more dramatic
scene by dividing your subject into large areas
of tonal contrast. This will also create a well-
balanced composition and add realism to your
scenes. You can employ any of the compositional
arrangements shown on pages 40–41 to
construct your pictures, using areas of light and
shadow as the compositional elements.

## Dramatic lighting effects

*Once you have an understanding of light and shadow effects, you can employ different Gothic art techniques within a single image. In this monotone oil painting, the stormy background creates a mid-tone foundation, which emphasizes both the vampire's light skin and her dark dress. The primary light source falls on the right side of her face. A break in the cloud behind her head creates backlighting – which in turn silhouettes the cat, heightening the drama.*

The feline eyes glow like embers, adding a sinister element.

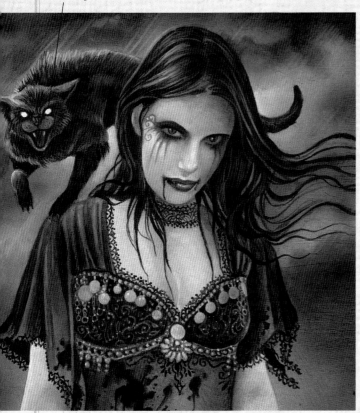

## THE DIRECTION OF LIGHT

When applied to the human face, lighting can help determine the temperament and feelings of a character. Also, whether the light source is soft or intense will alter the mood – a soft, diffused light will create a ghostly, otherworldly atmosphere, while a direct, hard light adds dramatic intensity to your character's persona. When working out your light sources, set up a lamp for the direction of light, then ask someone to pose for you, or use a mirror to see how the light illuminates your own face.

**Front side lighting**
*Front lighting can be very effective in Gothic art, especially when you want to focus attention on your vampire's features. You may like to try positioning the direction of light to one side, as illustrated here. This positioning gives more interest and form to the features. Notice how the left-hand light casts a shadow to the right, beneath the jaw line.*

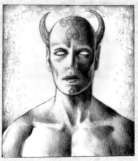

**Side lighting**
*Here, the light source comes from one side, resulting in a more sinister look. The side away from the light is in shadow, giving the face an enigmatic feel. Facial features and muscular forms appear more defined because of the stark effect of the lighting.*

## LIGHTING FIGURES

Deciding on the direction of your light source not only applies to faces but also to full figures. When adding form and muscle to your figures (see page 66) be aware of where the main light source is coming from. Sketch out tonal roughs, which you can refer to later. Here, the light falls from above, casting a deep shadow under the vampire's jaw line.

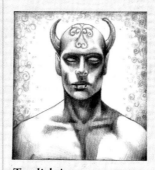

**Top lighting**
*By lighting your characters from above, you can achieve a look that is both menacing and chilling. Here, the cheekbones become more pronounced and the eyes are hidden in shadow. This suggests a harsher, less emotional mood for the character.*

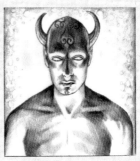

**Bottom lighting**
*Here, the brow and lower eyelids are highlighted. This strong lighting effect is often used both in Gothic art and film. It creates a surreal and spooky effect and is especially useful when a haunting or ritualistic feel is required.*

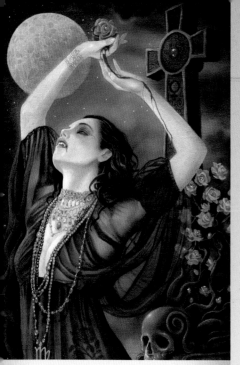

# GOTHIC PALETTES

THE FOLLOWING THEMED PALETTES WILL HELP YOU CREATE EXTENSIVE COLOUR SCHEMES FOR A NUMBER OF ENVIRONMENTS, ATMOSPHERES AND MOODS BASED ON TRADITIONAL VAMPIRE SETTINGS.

## STARRY SKIES

Vampires stalk in the night, lurking in the deep shadows, drifting like phantoms beneath the silent starlit skies, hunting their prey. Capture this spine-tingling world by using inky blacks, icy greys and mysterious purples in your backgrounds. Add hazy clouds and ghostly mists, and fill the sky with flickering stars. Skin should be pale.

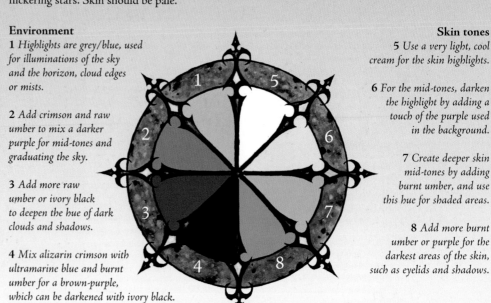

**Environment**

1 Highlights are grey/blue, used for illuminations of the sky and the horizon, cloud edges or mists.

2 Add crimson and raw umber to mix a darker purple for mid-tones and graduating the sky.

3 Add more raw umber or ivory black to deepen the hue of dark clouds and shadows.

4 Mix alizarin crimson with ultramarine blue and burnt umber for a brown-purple, which can be darkened with ivory black.

**Skin tones**

5 Use a very light, cool cream for the skin highlights.

6 For the mid-tones, darken the highlight by adding a touch of the purple used in the background.

7 Create deeper skin mid-tones by adding burnt umber, and use this hue for shaded areas.

8 Add more burnt umber or purple for the darkest areas of the skin, such as eyelids and shadows.

# NIGHT

## STORMY SKIES

Stormy night skies express perfectly the dark and often tempestuous nature of vampires. Use neutral and muted colours, varying from murky greys and browns to dusky blacks. You can include a highlight colour, depending on the mood you want to achieve – here, a dull blue-green is used but, for more fierce storms, add warmer colours.

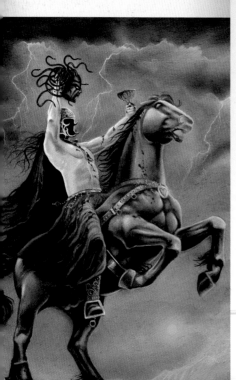

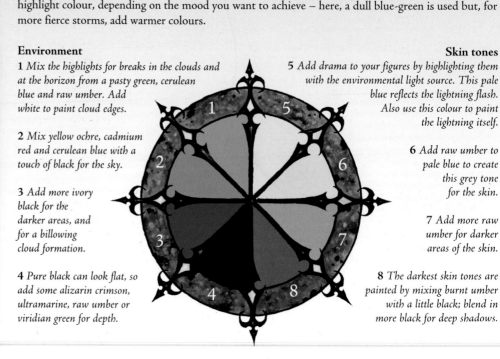

**Environment**

1 Mix the highlights for breaks in the clouds and at the horizon from a pasty green, cerulean blue and raw umber. Add white to paint cloud edges.

2 Mix yellow ochre, cadmium red and cerulean blue with a touch of black for the sky.

3 Add more ivory black for the darker areas, and for a billowing cloud formation.

4 Pure black can look flat, so add some alizarin crimson, ultramarine, raw umber or viridian green for depth.

**Skin tones**

5 Add drama to your figures by highlighting them with the environmental light source. This pale blue reflects the lightning flash. Also use this colour to paint the lightning itself.

6 Add raw umber to pale blue to create this grey tone for the skin.

7 Add more raw umber for darker areas of the skin.

8 The darkest skin tones are painted by mixing burnt umber with a little black; blend in more black for deep shadows.

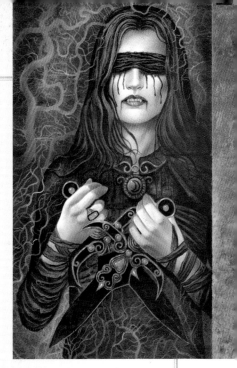

## CRYPTS

The vampire sleeps in deathly hibernation, cocooned in its cold crypt, awaiting its time of reawakening. Use a palette of earthy browns to paint root-woven Gothic crypts. Keep your tones dark, contrasting with the vampire's skin. You may want to add traces of blood by mixing alizarin crimson, cadmium red and ivory black or raw umber.

**Environment**

1 Create a colour for the stone crypt by blending burnt umber with ultramarine blue, then add some black. Add white to this mix to vary the hue.

2 Add yellow ochre or any green hue to make a colour for moss or vegetation.

3 For the darker areas of stone and for roots, add more black or brown to your stone colour.

4 For the deepest shadows, mix alizarin crimson, raw umber and black.

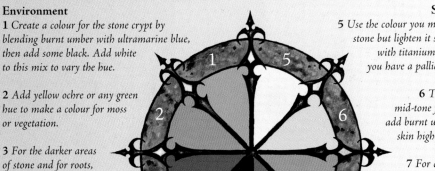

**Skin tones**

5 Use the colour you mixed for the stone but lighten it significantly with titanium white until you have a pallid flesh tone.

6 To create the mid-tone flesh colour, add burnt umber to the skin highlight colour.

7 For darker mid-tones, add a little raw umber and ivory black.

8 Make the darkest skin tones by blending raw and burnt umber with black.

# TOMBS

## GRAVEYARDS

Graveyards are possibly the most traditional haunting places of vampires. Crumbling tombstones, half-hidden statues and thick undergrowth all evoke fear of what may be lurking in this dwelling place of the dead, or of the undead.

**Environment**

1 For gravestones and statues, add touches of raw umber, alizarin crimson and cerulean blue to a base of titanium white.

2 Create a warm tan with yellow ochre and a touch of blue for dappled light beyond the trees, and to reflect on your stonework.

3 For the foliage, blend yellow and blue, or use viridian green mixed with cadmium red.

4 Use burnt umber for lowlights. Add green and black for deeper foliage, and to blend into the shadows.

**Skin tones**

5 Mix a warm, light flesh tone by adding small amounts of cadmium red and yellow ochre to titanium white.

6 Add more red and ochre to the light flesh hue for the mid-tones, along with touches of raw umber.

7 For the shading, add more raw umber and a touch of ultramarine blue to the flesh mid-tone.

8 The darkest skin tones can be made from burnt and raw umber, ultramarine and alizarin crimson. Mix with white to get your desired tone.

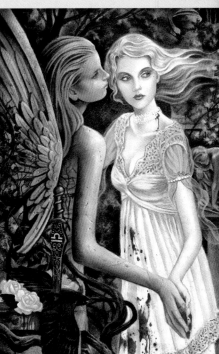

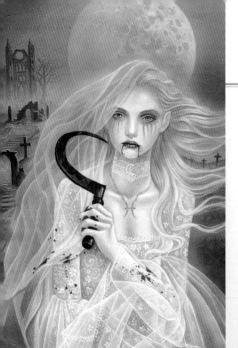

## FULL MOON

A landscape shrouded in moonlight takes on an eerie, supernatural glow. Capture this haunting effect by adding a soft silvery haze to pale skin and pools of cold light. Add cool muted blues and silvery greens to make skin whiter and colder. Try adding a low pallid mist or an eerie insipid glow towards the horizon.

### Environment

**1** *Use a cool silvery blue for the highlights on the moon, pools of light in the landscape and mist.*

**2** *For moon low lights and the light at the horizon, use a deeper greyish or greenish blue hue.*

**3** *Darken the colours with raw umber for the mid-tones and the distant shadows.*

**4** *Use a muted grey-brown for the deeper shadows; this can be darkened further for the deepest shadows.*

### Skin tones

**5** *Use a light creamy silver for the skin highlights; this should be slightly warmer than the moon, but still towards the cool end of the spectrum.*

**6** *For the mid-skin tones, reflect the colours in the moon and add a little yellow.*

**7** *Add a warmer tone such as burnt umber or red to create a warmer creamy hue for flesh low lights.*

**8** *Increase the warmth and depth of the skin further to paint the shadowed areas of the skin.*

# MOONLIGHT

## TWILIGHT

As day turns to night, a mysterious purple light bleeds into the landscape. To paint this magical aura, use muted pinks, purple and indigo. A warm, mid-grey or brown can be used in the shadow areas. The skin should have a shimmer of warm silver, deepening into purples and greys.

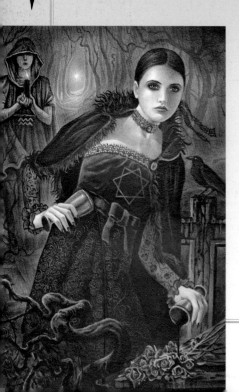

### Environment

**1** *Use a light lilac tone for brighter areas of sky and highlights. Blend in pink, and lighten this colour to paint light at the horizon.*

**2** *Mix a greyish muted purple for the sky and mid-tones of the scenery.*

**3** *Add blue to mid-tones to paint silhouettes in the distance and darker areas of sky and landscape.*

**4** *Use a deep, rich purple for the shadows, deepening into a dark, warm brown.*

### Skin tones

**5** *Mix an opaline shade of light grey for skin highlights to reflect glimmering starlight.*

**6** *Add a touch of purple or light brown to skin highlights to blend in to the mid-tones of the skin.*

**7** *Where the flesh darkens into shadow, mix in raw umber to create a warm, purple-brown.*

**8** *Darken the skin tones further by adding a blend of blue and red or dark brown.*

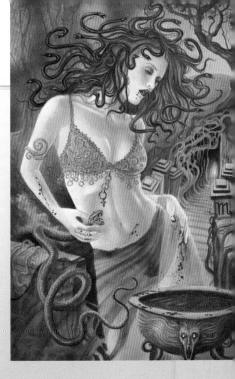

### Green poison

To create a painting that is seeping with toxic venom and malignancy, use a palette of acid yellows and noxious greens. Flesh tones should be pallid, so use creamy colours with a tinge of green. The overall painting should have a feel of anaemic fever and poisonous vapours.

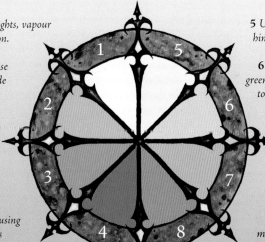

**Environment**

1 *Use acid yellow for highlights, vapour and glow beyond the horizon.*

2 *For sky and mid-tones, use a warm, lurid green. Include this hue in other elements of the painting.*

3 *Mix some blue in to mid-tones to create a cooler, duller green for low lights and distant features.*

4 *The darker objects and shadows should be created using olive green, merged towards black for deep shadows.*

**Skin tones**

5 *Use a pallid cream with a hint of green for highlights.*

6 *Add a touch of the olive green used in the background to the skin highlight colour for a darker, pasty flesh tone.*

7 *Blend dull, green-brown for shaded areas of flesh.*

8 *For skin shadows, use a muted olive green, made by adding a touch of white and raw umber to the environment shadows colour.*

# ATMOSPHERE

### Red passion

Passion is an emotion deeply connected with the vampire myth – use fiery reds and blazing oranges to inject energy and intensity into your paintings. Skin, foliage and structures should be glowing with warm hues, while the overall mood should be one of heated, tempestuous energy.

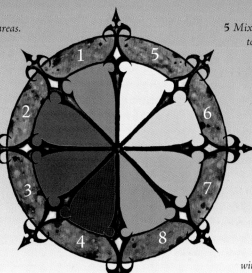

**Environment**

1 *Use orange for the brightest areas. To create fire, use light yellow surrounded by orange and then red.*

2 *Use bright reds and burnished oranges for maximum impact, infusing the painting with passionate energy.*

3 *Add burnt or raw umber for darker reds to make shadows and stormy or graduated skies.*

4 *Mix deep, warm browns and black mixed with red for dark areas and shadows.*

**Skin tones**

5 *Mix a warm, creamy colour to give the flesh radiance.*

6 *Add a touch of burnt umber to the highlight colour for blending skin tones towards shadows.*

7 *For mid-tones, mix red, yellow and a touch of blue and raw umber, lightening with white as required.*

8 *To achieve a darker skin tone for areas in shade, mix raw umber with your mid-tone colour.*

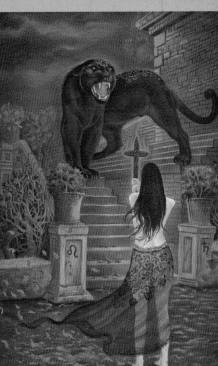

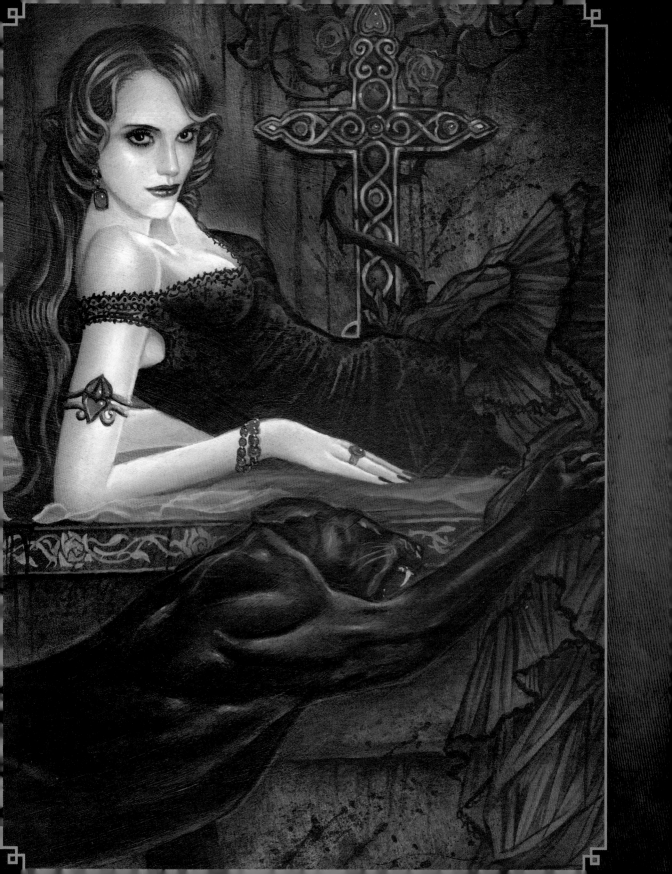

## CHAPTER 2

# THE VAMPIRES

NOW THAT YOU KNOW HOW TO GET STARTED, HERE IS EVERYTHING YOU WILL NEED TO DRAW OR PAINT YOUR VAMPIRES – FROM THE FACE AND FIGURE TO SOME CREEPY CHARACTERS FOR YOUR INSPIRATION.

# THE MALE FACE
## FRONT VIEW

THE FACE IS OFTEN THE FOCAL POINT OF YOUR PAINTINGS AND DRAWINGS;
IT REFLECTS THE FEELINGS OF A CHARACTER, WHICH IN TURN EXPRESSES
THE MOOD AND NARRATIVE OF YOUR ART.

*Draw all structure lines faintly, so they can be erased later.*

*The top quarter goes down to the hairline.*

*Your vampire's features will vary depending on the emotion being expressed – see Gothic Expressions on pages 64–65.*

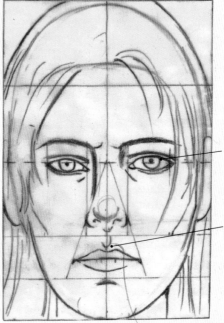

*The width of each eye is similar to the distance between the eyes.*

*The tops of the irises are slightly hidden under the eyelids.*

*To establish the width of the mouth, draw lines from the top of the nose to the outer edges of its base.*

*The central groove of the mouth follows the shape of the vertical groove (philtrum) above.*

### Structure

1 *Viewed from the front, the head's width is about two-thirds of its height, so begin by sketching a rectangle to these proportions.*

2 *Within this rectangle draw an oval that is wider at the top.*

3 *Now draw a vertical line that divides the face into two separate halves – this will help with symmetry.*

4 *Then divide horizontally into four, as above.*

5 *Divide the central horizontal line into five equal parts to establish the width and position of the eyes.*

6 *The third quarter contains the nose – its base is almost at the bottom of this quarter and its width is similar to the position between the eyes.*

7 *Divide the bottom quarter of the face horizontally. The mouth is positioned in the middle of the top half of this bottom quarter, while the chin fills the lower half.*

8 *The ears begin just above the centre horizontal line and end at the base of the nose.*

### Features

1 *Start by sketching the shape of the eyes. Draw the upper and lower edges as arched lines meeting at the positions established on your structural diagram.*

2 *For the irises, draw circles in the centres, with dots in the middle for the pupils.*

3 *Form the upper eyelids by drawing arched lines above the top edge of each eye. Above these, sketch in the eyebrows.*

4 *Sketch the tip of the nose as a sphere and the outer edges as semicircles. Draw the nostrils so that their inner edges continue down into the central ridge. Sketch in the vertical groove (philtrum) below the nose.*

5 *Now draw in the upper lip as an extended 'M' shape. Finish the mouth by defining the shape of the central line and drawing an arched line for the lower lip.*

6 *Finally, create the chin with an oval, and sketch in the character's hair.*

To create convincing faces, you should have a basic knowledge of the structure of the skull and the muscles that lie beneath. Study the illustrations here and on the following pages in order to gain a fundamental understanding of the human head. Practise drawing faces from life by asking friends and family to sit for you, or use a mirror to draw yourself.

*Where the shadows fall on the face will depend on the light source.*

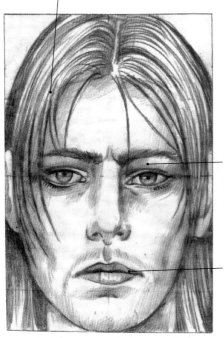

*Add shadow above the eyelids and towards the nose.*

*The lips should be darkest at the mouth.*

### Three-dimensional form

**1** *You are now ready to add shading. Erase the structure lines that marked out the proportions, leaving the features drawn in the previous stage.*

**2** *Artists often begin with the eyes, as these express the nature and emotions of the character. Use pencils to shade the edges of the eyeballs so that they appear spherical and add tone to the pupils.*

**3** *Create a graduating shade across the eyelids so that they appear rounded like the eyeballs beneath. Shade down the sides and the base of the nose. Add some shadow to create the groove of the philtrum.*

**4** *Shade in the upper lip, making it darker towards the line of the mouth. The lower lip should be shaded more at the bottom edge to give the rounded shape.*

**5** *Add shadow beneath the lower lip to build up the chin. Define the shape and structure of the jaw, cheekbones and forehead with shading.*

**6** *Finally, add eyelashes and detail to the hair.*

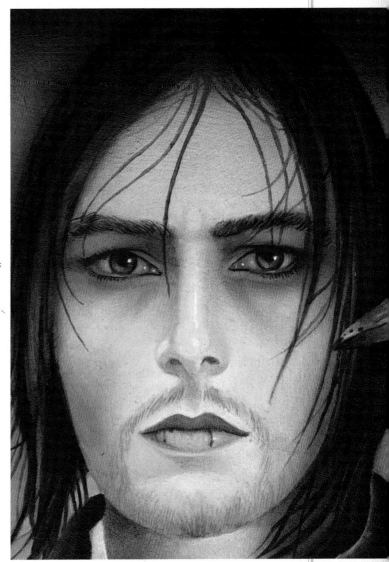

### Rendering

*You have now completed the front-view drawing of your male face. Next you can transfer it to a painting surface and render it in your chosen medium. Turn to the chosen paint technique in Chapter 1 (pages 10–27) to transform your drawing into a finished piece.*

# THE MALE FACE
## SIDE VIEW

HERE, YOU WILL LEARN TO DRAW THE MALE HEAD VIEWED FROM THE SIDE – BEGINNING BY BUILDING A FRAMEWORK, AS WITH THE FRONT VIEW.

*The central horizontal line is the level of the eyes, shown here as a broken line.*

*The circle is the guide for the forehead and the top and back of the head.*

*This line will give you the width of the mouth.*

*As the final stage, draw in the detail of the ear and hair.*

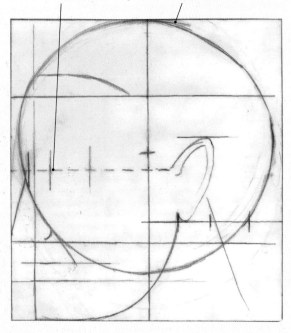

### Structure

**1** *From the side, the width of the human head is approximately seven-eighths its height. Draw a rectangle to these dimensions.*

**2** *Draw a vertical line through the centre. Divide the rectangle with horizontal lines into quarters.*

**3** *Divide the bottom quarter of the face horizontally. Starting at the halfway line in this quarter, draw a circle that runs close to the sides of the rectangle and touches the top.*

**4** *Draw a short line halfway between the central vertical line and the forward edge of the circle. The front of the eye sits halfway between this mark and the front of the rectangle.*

**5** *Draw a vertical line in front of the eye, running down the rectangle. In front of this, where the circle meets the horizontal eye line, is the top of the nose. Sketch a line from here to where the bottom of the third quarter meets the edge of the rectangle.*

**6** *Starting behind the central vertical line, draw the ear. Then draw a curving line from the earlobe to the front of the chin, for the jawline.*

### Features

**1** *Start by sketching the shape of the eyes. Draw the upper and lower edges as lines meeting at the back corner, as marked on your structural diagram.*

**2** *For the iris, draw an oval at the front of the eye, then another smaller oval for the pupil. Create the upper eyelids by drawing a line above the top edge of the eye. Above the eye, sketch in the eyebrow.*

**3** *Round off the tip of the nose and draw the outer edges of the nostril as a semicircle.*

**4** *Next, draw a diagonal line from the top of the nose to the outer edges of the nostril, continuing to the position of the mouth. To draw the mouth, make a small line that curves from the bottom of the nose, then inwards to form the top lip. Continue this line downwards to form the swell of the bottom lip.*

**5** *Bring this curving line in under the mouth and then out to create the structure of the chin.*

When creating the heads of your vampires, think of them as solid, three-dimensional objects. By breaking down the surfaces and features into simple forms, you will gradually be able to visualize and construct them from many different angles – by combining the front- and side-view structural drawings. Details such as the facial muscles can be added later; initially it is most important to construct the basic proportions and placement of the various shapes.

*Create shadow around the eye to indicate the hollow of the eye socket.*

*Fill in the detail of the ear and hair to complete the drawing.*

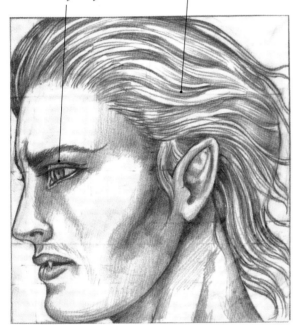

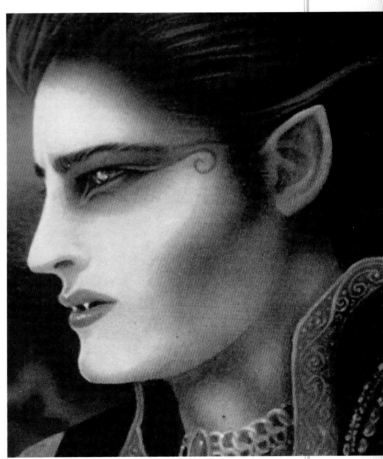

### Three-dimensional form

1 *Use the shading technique explained on page 49. The temples should be shaded, as they form a flat surface that blends into the curve of the forehead.*

2 *Add shadow beneath the eyebrow, making it darker towards the front of the eye and along the eyelid.*

3 *Give the eye a spherical appearance by shading into the corners.*

4 *Add shade down the side of the nose and the front of the cheekbone, and shadow under the nose around the nostril.*

5 *Form the shape of the mouth by creating shadow along the lower edges of the lips.*

6 *Beneath the mouth add more shade to define the chin, and darken the area on the side of the face to emphasize the cheekbone.*

7 *Strengthen the jawline by creating shadow beneath it, darkening below the ear.*

### Rendering

*You have now completed the side-view drawing of your male face. Next you can transfer it to a painting surface and render it in your chosen medium. Turn to the chosen paint technique in Chapter 1 (pages 16–27) to transform your drawing into a finished piece.*

# THE FEMALE FACE
## FRONT VIEW

THE FEMALE FACE IS CREATED IN A SIMILAR WAY TO THE MALE FACE,
BUT WITH SOME IMPORTANT DIFFERENCES.

*Draw all structure lines faintly, so they can be erased later.*

*The top quarter goes down to the hairline.*

*Your vampire's features will vary depending on the emotion being expressed – see Gothic Expressions on pages 64–65.*

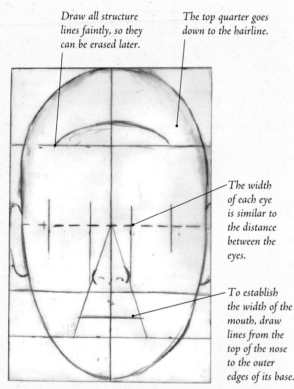

*The width of each eye is similar to the distance between the eyes.*

*To establish the width of the mouth, draw lines from the top of the nose to the outer edges of its base.*

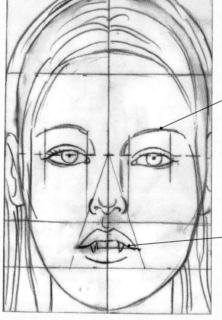

*Draw the eyebrows high and arched for a sensual look; for a sinister feel, draw them straight or slanted.*

*The central groove of the mouth follows the shape of the vertical groove (philtrum) above.*

### Structure

**1** *Viewed from the front, the head's width is about two-thirds of its height, so begin by sketching a rectangle to these proportions.*

**2** *Within this rectangle draw an oval that is wider at the top.*

**3** *Now draw a vertical line that divides the face into two separate halves – this will help with symmetry.*

**4** *Then divide horizontally into four, as above.*

**5** *Divide the central horizontal line into five equal parts to establish the width and position of the eyes.*

**6** *The third quarter contains the nose – its base is almost at the bottom of this quarter and its width is similar to the position between the eyes.*

**7** *Divide the bottom quarter of the face horizontally. The mouth is positioned in the middle of the top half of this bottom quarter, while the chin fills the lower half.*

**8** *The ears begin just above the centre horizontal line and end at the base of the nose.*

### Features

**1** *Start by sketching the shape of the eyes. Draw the upper and lower edges as arched lines meeting at the positions established on your structural diagram.*

**2** *For the irises, draw circles in the centres, with dots in the middle for the pupils.*

**3** *Form the upper eyelids by drawing arched lines above the top edge of each eye. Above these, sketch in the eyebrows.*

**4** *Sketch the tip of the nose as a sphere and the outer edges as semicircles. Draw the nostrils so that their inner edges continue down into the central ridge. Sketch in the vertical groove (philtrum) below the nose.*

**5** *Now draw in the upper lip as an extended 'M' shape. If the mouth is closed, define the shape of the central line and draw an arched line for the lower lip. Part the lips slightly to reveal fangs.*

**6** *Lastly, create the chin with an oval, and sketch in the luxurious hair.*

The following stages explain how to structure the proportions, position and draw the features, and give your female vampire faces form and emotion. Remember to refer to the illustrations of the human skull and muscles illustrated in this section to help give your faces a good anatomical foundation. Generally, female heads are slightly smaller than their male counterparts. The jaw is softer and narrower, while the forehead is more rounded. Eyes and lips tend to be fuller and larger in proportion to the face, and the nose is often smaller.

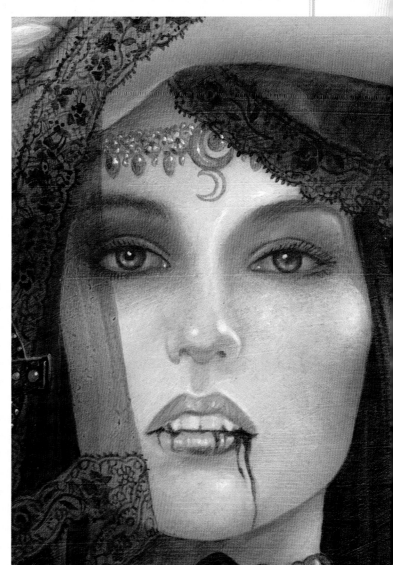

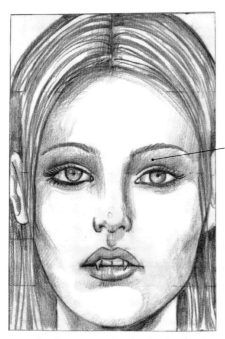

*Create shadow above the eyelids and shading towards the nose.*

### Three-dimensional form

**1** *You are now ready to add shading. Erase the structure lines that marked out the proportions, leaving the features drawn in the previous stage.*

**2** *Often artists begin with the eyes, as these express the nature and emotions of the character. Use pencils to shade the edges of the eyeballs so that they appear spherical and add tone to the pupils.*

**3** *Create a graduating shade across the eyelids so that they appear rounded like the eyeballs beneath. Shade down the sides and at the base of the nose. Add some shadow to create the groove of the philtrum.*

**4** *Shade in the upper lip, making it darker towards the opening of the mouth. The lower lip should be shaded more at the bottom edge to give it its rounded shape.*

**5** *Add shadow beneath the lower lip to build up the chin. Define the shape and structure of the jaw, cheekbones and forehead with shading.*

**6** *Finally, add eyelashes and detail to the hair.*

### Rendering

You have now completed the front view drawing of your female face. Next you can transfer it to a painting surface and render it in your chosen medium. Turn to the chosen paint technique in Chapter 1 (pages 16–27) to transform your drawing into a finished piece.

# THE FEMALE FACE
## SIDE VIEW

A GOOD UNDERSTANDING OF THE SHAPE AND STRUCTURE OF THE SKULL
WILL HELP YOU CONSTRUCT CONVINCING HUMAN HEADS AND FACES.

*This circle represents the forehead, and the top and back of the head.*

*Starting in front of the eye, draw the nose, which, in the female face, protrudes to about the position of the forehead.*

*The style of hair you choose will give your character her own personal identity.*

*The tip of the nose is rounded off to give it a more feminine shape.*

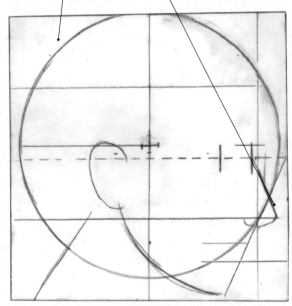

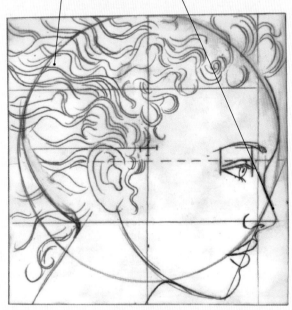

### Structure

**1** *From the side, the width of the human head is approximately seven-eighths its height. Draw a rectangle to these dimensions.*

**2** *Draw a vertical line through the centre. Divide the rectangle with horizontal lines into quarters.*

**3** *Divide the bottom quarter of the face horizontally. Starting at the halfway line in this quarter, draw a circle that runs close to the sides of the rectangle and touches the top.*

**4** *Draw a short line halfway between the central vertical line and the forward edge of the circle. The front of the eye sits halfway between this mark and the front of the rectangle.*

**5** *Draw a vertical line in front of the eye, running down the rectangle. In front of this, where the circle meets the horizontal eye line, is the top of the nose. Sketch a line from here to where the bottom of the third quarter meets the edge of the rectangle.*

**6** *Starting behind the central vertical line, draw the ear. Then draw a curving line from the earlobe to the front of the chin, for the jawline.*

### Features

**1** *Start by sketching the shape of the eyes. Draw the upper and lower edges as lines meeting at the back corner, as marked on your structural diagram.*

**2** *The eyes of the female vampire are larger than those of the male. For the iris, draw an oval at the front of the eye, then another smaller oval for the pupil. Create the upper eyelids by drawing a line above the top edge of the eye. Above the eye, draw in the arched eyebrow.*

**3** *Round off the tip of the nose and draw the outer edges of the nostril as a semicircle.*

**4** *To create the mouth, make a small line that curves from the bottom of the nose, then inwards to form the top lip. Continue this line to where it meets the circle to establish the width of the mouth. Draw a downwards curve to form the swell of the bottom lip, then inwards under the mouth and out to create the shape of the chin.*

**5** *Finally, draw in the ear and flowing hair.*

Your drawings do not need to be anatomically perfect – a basic knowledge of the forms that lie beneath the skin is enough to create convincing artwork. With practise you will be able to draw out your faces without measuring the proportions in such detail, and in time you will be able to draw faces from any angle by employing these guidelines instinctively. Draw from life whenever possible, as this will heighten your skills of observation and drawing.

*Adding light shading around the sides of the face creates a three-dimensional feel.*

*Add some shadow around the eye to suggest the hollow of the socket.*

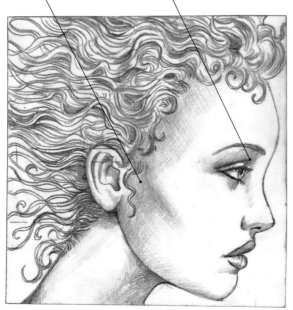

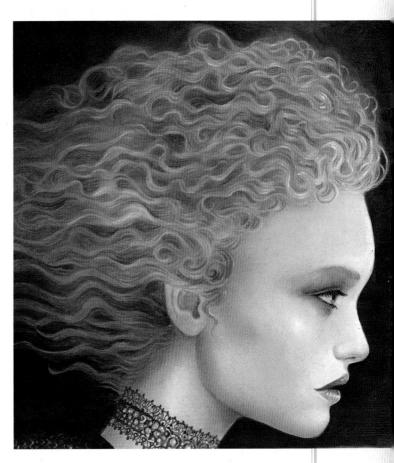

### Three-dimensional form

**1** *As with the front view, this stage creates the appearance of a three-dimensional structure. By employing the shading technique explained on page 49, you can give form to the head.*

**2** *Erase all the construction lines. Study the skull illustration on the previous pages to gain a clear understanding of the structure of the human head.*

**3** *Shade the temples. Create shade under the eyebrow, making it darker towards the front and along the top of the eyelid. Add some shadow around the eye to suggest the hollow of the socket, and give the eye a spherical shape by shading into the corners.*

**4** *Add shade down the sides and base of the nose around the nostril.*

**5** *Emphasize the swell of the lips by creating shadow along their lower edges. Beneath the mouth add shadow to define the chin, and darken the area on the side of the face to indicate the cheekbone.*

**6** *Strengthen the jawline by creating shadow beneath it, darkening below the ear. Add long eyelashes and detail to the ear and hair to complete the drawing.*

### Rendering

*You have now completed the side-view drawing of your female face. Next you can transfer it to a painting surface and render it in your chosen medium. Turn to the chosen paint technique in Chapter 1 (pages 16–27) to transform your drawing into a finished piece.*

# Swipe File:
# GOTHIC EXPRESSIONS

THE FEATURES AND EXPRESSIONS YOU CREATE WILL GIVE YOUR GOTHIC CHARACTERS UNIQUE PERSONAS, INFUSING THEM WITH EMOTION.

The face is the most expressive aspect of the body. It can reveal thoughts, feelings, spirit, energy and inner depths. By firmly establishing an expression, you enhance the overall mood and narrative of your painting.

Facial features convey a character's nature, disposition and personal characteristics. Features that are strong and balanced give the face a look of power and authority. Broad, heavyset features portray strength, whereas delicate or narrow features add an air of subtlety and grace. Face shape, hair colour and style, skin tone, eye colour and the shape of the mouth all help to reinforce personality.

## DRAWING OUT EXPRESSION

- What is the general disposition of your characters?
- What drives or animates them?
- How are they reacting to the situation or environment?
- How are they engaging with the experience expressed in the painting?
- What emotions are they feeling?
- How can portraying a character's emotions enhance the narrative?
- What deeper underlying emotions seethe beneath the surface?
- Are the characters attempting to hide emotions?
- How can you draw out unique personality traits, history or culture?

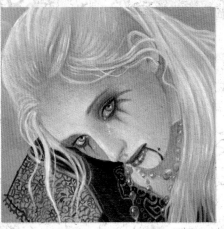

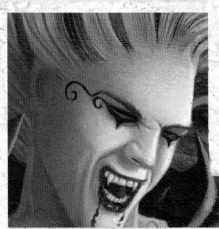

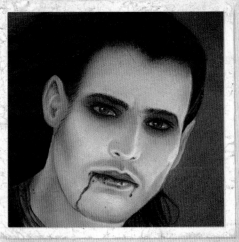

### ▲ Mania
*Portraying madness or mania stems from a crazed look in the eyes – make the eyes wild or bizarre in some way, perhaps glowing red, slanted and sinister, or staring out at the viewer. The hair could also be wild, or strange in colour and/or style. The mouth should reflect the demented nature of the character, perhaps wide and open in a hysterical laugh, a deranged snarl or a sadistic evil grin.*

### ▲ Sorrow
*To express emotions of deep sorrow, try giving the character a thin face or sunken cheeks, a white or pallid skin tone, and a washed-out look. Hair should be straight, limp or ghostly-looking to add to the mood of grief and desolation. The eyebrows should be angled up towards the centre of the forehead, and the eyes wet with tears. You can intensify the emotion by adding a pink hue to the whites and outer edges of the eyes. The mouth should be down-turned and the lips thin and tight.*

### ▲ Assertive
*A firm jawline and broad forehead give a sense of strength and authority. Intense eyes that hold the viewer's gaze convey confidence and power. Making the eyes a dynamic colour, such as fiery red or icy blue, enhances the intensity of the gaze. Small pupils portray cold intensity; large pupils portray emotional depth. Full lips give a straightforward, assertive look; thin lips denote cunning or subtlety. Features like straight eyebrows or a strong nose and cheekbones create a determined and commanding expression.*

### Seductive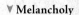

By having the character look up alluringly at the viewer, an emotional attraction is established – enhanced by large eyes with full pupils and lashes. Full and shapely lips add a sensual element, heightened by a subtle seductive smile. The face looks confident with refined but strong features, such as narrow cheekbones and chin.

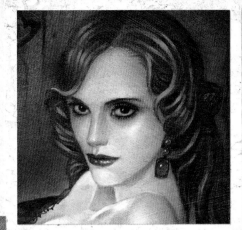

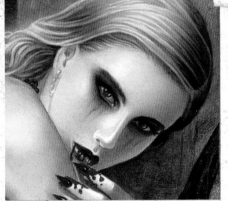

### ▲ Bestial

For a primeval animalistic look – whether the figure is human, bestial or half-human, such as a werewolf – try making the face wide and the forehead low. The head should be set low into the shoulders, with the nose and mouth protruding. The eyes should be wide apart, deeply slanted or round in shape.

### ▼ Melancholy

You can express loss, sadness and hopelessness with an expression of childlike innocence. Use wide, staring oval eyes and wide-set straight eyebrows. Add white highlights around the edge of the eyes so that they look moist and tearful. The mouth should be thin and straight or turned down at the corners. Make the bottom lip protrude to create a pout. Tip the head to one side to create a mood of detached musing.

### ▲ Cunning

Fine or narrow features give the face shrewdness and intelligence. Narrow or slanted eyes add a wicked or sinister element. Small pupils convey ingenuity and cold guile, enhanced by a hooded gaze. A pink blush around the eyes suggests intense inner emotion (in this case it brings an element of spitefulness). A small mouth or thin lips add a secretive feel, implying hidden plans and a clever, calculating disposition.

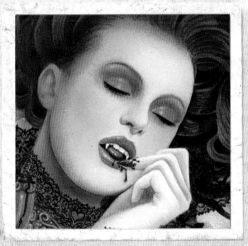

### ◄ Vehement

Create a dramatic intensity of emotion, the head thrust forwards or thrown back, and the mouth open wide to reveal deadly fangs. Eyes should be impassioned – glazed over to express blind frenzy, or fiery and furious. Knit the eyebrows together and angle them away from the eyes. Make the lips snarl, showing sharp or bloody teeth. To increase the sense of violence or hunger, add a trickle or smear of blood around the lips.

### ▲ Sensual

A delicate face and luxurious hair with soft features, glowing skin and blushed cheeks, give your character a look of sensuality. Closed eyes and long lashes support an inner satisfaction, with eyes or eyelids large and full, and the eyebrows arched. You need to establish a mood of thirst being quenched and hunger being satiated. Shapely pink lips and a mouth that is glistening or perhaps opened slightly will heighten the effect.

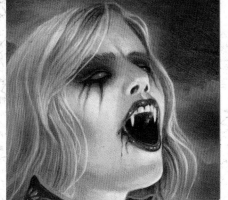

# FIGURE DRAWING

LEARN TO DRAW VAMPIRE FIGURES USING SIMPLE FRAMEWORK
DRAWINGS FOR THEIR STRUCTURE AND THEN
ADD MUSCLES TO GIVE FORM.

Once you have learned the basic human proportions, you can create any number of Gothic poses. The best way to learn how to draw the human form is to use life models – ask friends and family to pose for you or join a life drawing class to develop your skills. These simple guidelines will help you to accurately structure your vampire's anatomy and will later allow you to devise poses from your own imagination. For some traditional vampire poses and examples, see pages 78–81.

## Muscles ➤

*Now that your framework figure is sketched out, you can add muscles to give it form. A general understanding of the major muscles is sufficient to get you started. As you develop your drawing and painting, you may like to learn more about muscles in the future. Study these illustrations and other references you research to get a general grounding in the larger muscles, such as those in the chest, shoulders, biceps, lower arms and legs.*

These illustrations show the muscle structure from the front and side views.

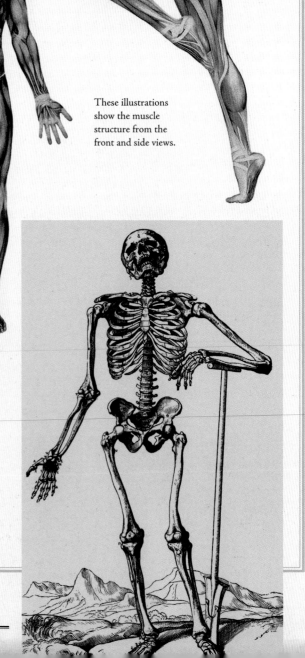

## THE SKELETON ➤

The foundation of any figure is the skeleton, so a basic understanding of the human skeleton is essential. The whole structure is comprised of 206 bones that together create a very strong but light and flexible framework. It isn't necessary to memorize all the bones or their names to get started but rather to have an understanding of the skeleton's basic structure and the proportions and positions of the skull, rib cage, limbs and vertebral column. You may then like to study the human skeleton in more detail as you practise your figure-drawing skills.

## PROPORTIONS

In figure drawing, the basic unit of measurement is the head, specifically the distance from the top of the head to the chin. This unit of measurement has long been used by artists to establish the proportions of the human figure. Most adults are around seven and a half heads high, but for practical and aesthetic reasons, figure drawings are generally eight heads in height. Use this guide to establish the proportions of the various body parts of your figures, whatever their posture may be.

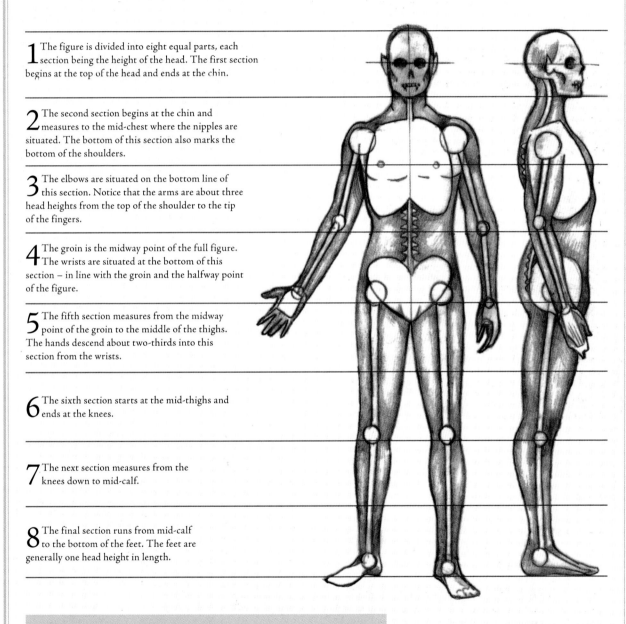

**1** The figure is divided into eight equal parts, each section being the height of the head. The first section begins at the top of the head and ends at the chin.

**2** The second section begins at the chin and measures to the mid-chest where the nipples are situated. The bottom of this section also marks the bottom of the shoulders.

**3** The elbows are situated on the bottom line of this section. Notice that the arms are about three head heights from the top of the shoulder to the tip of the fingers.

**4** The groin is the midway point of the full figure. The wrists are situated at the bottom of this section – in line with the groin and the halfway point of the figure.

**5** The fifth section measures from the midway point of the groin to the middle of the thighs. The hands descend about two-thirds into this section from the wrists.

**6** The sixth section starts at the mid-thighs and ends at the knees.

**7** The next section measures from the knees down to mid-calf.

**8** The final section runs from mid-calf to the bottom of the feet. The feet are generally one head height in length.

## STUDIES

To increase your knowledge and understanding of human muscles, study anatomical books and drawings. Drawing from life will increase your anatomical accuracy and insight into the muscle structure of various body parts.

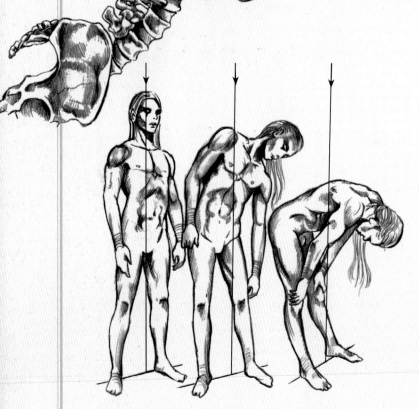

◄ **Flexing**

The most important support structure of the skeleton is the vertebral column, or spine. A firm muscular system maintains the curved but upright stance of the vertebral column, allowing for flexing and bending of the body. The strong yet flexible links of the spine and the stable support of the pelvis are the essence of any pose. Pay attention to the curve and flexure of the spine, which will be the structural foundation for your figure's posture. The positions of the head, rib cage, pelvis and limbs are all dependent on it.

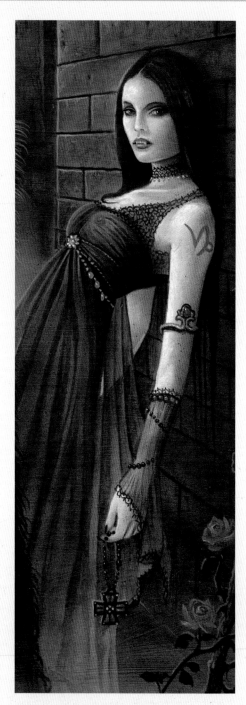

**Weight and balance** ▲

In order for figures to stand upright, their weight must be distributed evenly on each side of their central line of gravity. When standing straight with weight evenly distributed on both feet, the centre line of gravity falls directly between the feet and runs in a straight line up through the centre of the head. If the weight of the figure is mainly supported by one leg, then the foot taking the weight is nearer to the central line of gravity. Think carefully about how your vampire's weight is distributed and where his or her centre of balance is.

**Supported recline** ▲

Here, the vampire is reclining against a wall, so some of her weight is supported from behind. As her legs are also supporting her from below, the central line of gravity passes between these two supports and directly upwards through her chest. Notice how gravity causes her arms and hair to hang down.

**HEAD HEIGHT**

Using the head height as a measurement helps to establish other anatomical proportions:

The width of the shoulders is about two head heights for a male, and one and three-quarters for a female.

The distance between the fingertips of the outstretched arms is equal to the length of the body.

The arms from the top of the shoulder to the tips of the extended fingers are about three and a half heads long.

The navel is positioned roughly halfway between the bottom of the rib cage and the top of the pelvis.

The legs are approximately four head heights long, from hips to feet.

## MOVEMENT AND RHYTHM

Within the proportion diagram figures, you will see a simplified structure of the human skeleton. By drawing your framework figures to the correct proportions and measurements, you can devise their poses with anatomical accuracy. You also need to think about foreshortening: Body parts that are closer to, or farther away from, the viewer appear shorter. Those that are closer also appear larger, while those that are further away appear smaller. Notice how the arms in this framework figure look shorter, because the right arm is closer to the viewer and the left is angled away.

**1** Draw an oval for the head and sketch the curve of the spine – which is about three head heights in length.

**2** Add the simplified rib cage and pelvis shapes to the correct proportions, the rib cage being one and a half head heights and the pelvis one head height.

**3** Add circles for the shoulders and attach the arms. The upper arms should be about one and a half heads in length, while the lower should be two head heights long.

**4** Draw the circles where the legs attach to the pelvis. From here the upper legs are two heads in length and the lower legs another two head heights long to the feet.

# DRAWING MALE VAMPIRES

LEARN HOW TO DRAW MALE VAMPIRES BY FOLLOWING A SERIES OF STAGES.

Find out how to create convincing figures by drawing a basic framework, then adding muscles, form, shading and detail. You can use these techniques when creating vampires from your imagination or as a guide when drawing from life models. Using framework figures as the foundation of your vampires allows you to position them in any pose you choose. By employing the correct proportions for your figures' body parts your characters will remain anatomically accurate, whatever their posture may be.

## FRONT VIEW

### FIRST STAGE ➤
**The framework**
*Begin by sketching the oval of the head. Mark a faint line where the centre of the face will be – this also shows which way the head is turned. Draw a horizontal line halfway down the head for the position of the eyes. Draw the neck, then the top of the chest just under a half head length below the chin. A full head length marks the centre of the chest, which you can now sketch as a simple barrel shape, indented at the bottom.*

### SECOND STAGE ➤
**Adding limbs**
*Draw two circles for the shoulders and the top sections of the arms – which should be one head in length. Draw circles for the positions of the elbows, then sketch the lower arms, these being about one head in length. You can now draw circles for the hip joints and the thigh 'bones' – each is two heads long. Now sketch in the knees and the lower legs, which are also two heads long. Complete the framework figure by drawing simple shapes for the hands and feet.*

Including the shoulders, your figure should be two head heights wide.

The chest is about one and a half heads high.

Indicate the centre of the chest for the position the figure is facing. Now draw the curve of the spine, approximately three head lengths long.

Draw a heart shape for the pelvis – its top indent is about one head length from the bottom indent of the chest. The bottom point of the heart is at the centre of the body.

It is a good idea to mark where the centre of balance lies, shown here as a vertical dashed line.

### Adding muscles to the arms

*To give your skeleton framework more form, sketch in the features of the face (see pages 56–59). Draw the form of the neck (about the same width as the head), and the shoulder muscles. Draw the biceps and the shape of the arms – refer to the muscle illustrations on page 66 until you remember the particular muscles.*

### Shading

*Erase the framework figure you sketched to create the structure of the vampire. Next, enhance the forms of the muscles by shading them on the opposite side to the light source (see pages 48–49). Add more details to the figure, draw his hair and features, and give him the character and expression you desire (see pages 64–65).*

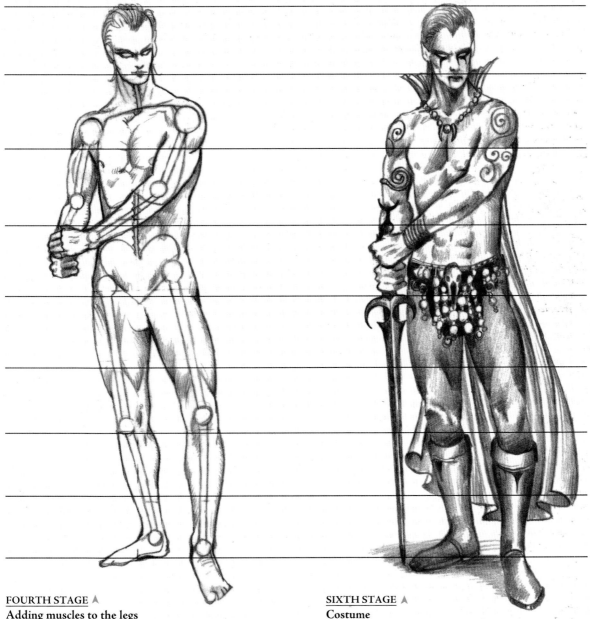

### Adding muscles to the legs

*Sketch the chest muscles and body form, the waist being about three head lengths down from the top of the figure. Draw the forms of the leg muscles as you did with the arms, then draw the hands and feet.*

### Costume

*The final stage can be the most fun. Add your vampire's attire or costume and any Gothic artefacts to enhance your vampire's cultural identity. You can gather inspiration from any number of sources, from costume museums and antique clothes shops, films, books and magazines.*

## SIDE VIEW

### FIRST STAGE ➤
### The framework

*Start by drawing an oval for the head as you did for the front view, sketching the eye line and the centre line where the front of the face will be. This could be in profile, so it may be on the right- or left-hand edge. Sketch in the neck and the top of the chest. The chest should be about one and a half heads high.*

You may like to divide the figure up into eight sections to get the proportions right, as shown on page 67.

A full head length marks the centre of the chest, which you can now sketch as a larger oval tilted towards the shoulders. Next, sketch the curve of the backbone – this should be about three head heights in length.

Draw a tilted oval for the pelvis, tapering towards the front. This should be a little smaller than the head, its centre being the halfway point of the figure.

### SECOND STAGE ➤
### Adding limbs

*Draw a circle about halfway down the second section for the shoulder. Now sketch in the upper and lower arms – both approximately one head height long. These are jointed at the elbow so they can be positioned at the desired angle. Next, draw a circle for the hip joint at the centre of the pelvis. Sketch the upper legs (about two heads in length). Mark the positions of your figure's knees with small circles, followed by the lower leg bones – two heads in length. Finish the framework figure by drawing the shapes of the hands and feet.*

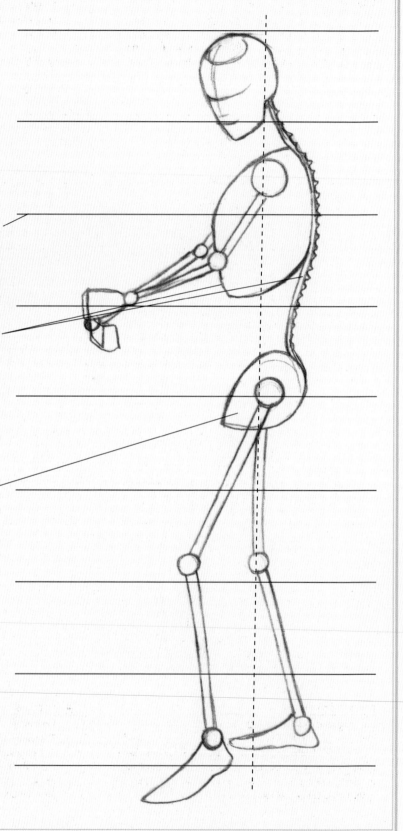

**THIRD STAGE** ▽
## Adding muscles to the arms

*Draw in the features of the face (see pages 56–59). Sketch the neck and the shoulder muscles around the circle you drew for the shoulder. Next, draw the biceps and the form of the arms – you can refer to the diagrams of muscles on the previous pages.*

**FIFTH STAGE** ▽
## Shading

*Erase the framework figure you sketched to create the structure of the vampire. Next, enhance the forms of the muscles by shading them on the opposite side to the light source (see pages 48–49). Add more details to the figure, draw his hair and features, and give him the character and expression you desire (see pages 64–65).*

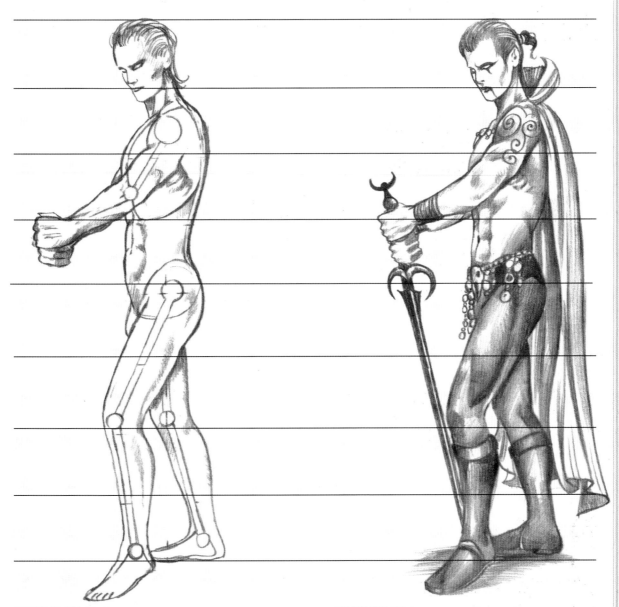

**FOURTH STAGE** △
## Adding muscles to the legs

*Draw the swell of the chest muscles and the shape of the body using your skeletal frame as a guide. Now build up the shapes of the legs, paying particular attention to the large muscles of the thighs and at the back of the lower legs. Sketch the shape of the hands and feet in more detail.*

**SIXTH STAGE** △
## Costume

*Lastly, you will want to design your vampire's clothing. Draw in his apparel and trappings to enhance his character and cultural background. You may want to give him a very Gothic costume, a romantic one or a tribal look – see pages 78–81 for inspiration.*

# DRAWING FEMALE VAMPIRES

LEARN HOW TO DRAW FEMALE VAMPIRES BY FOLLOWING A SERIES OF STAGES.

The female vampire has a few important differences from the male. The eyes should be slightly larger and the jawline narrower and softer. The neck, shoulders and chest should be narrower, the waist smaller and the hips larger. Try to draw from life as much as possible, as this will give you a deeper understanding of figure drawing and the effects of weight and balance. The technique for drawing both front- and side-view female figures is explained here – this allows you to conceive your vampire from any angle by combining the two views; simply imagine the framework figure as a three-dimensional object.

## FRONT VIEW

### FIRST STAGE ➤
**The framework**

*First draw an oval for the head as you did for the male vampire. Mark where the eye line falls – halfway down the head. Next, draw the centre line where the front of the face will be. These lines will create a cross at the centre of her face. Draw the neck and the top of the chest. The chest should be about one and a half heads high and two heads wide. A full head length marks the centre of the chest, which you can now draw as a barrel shape with an indent at the bottom as shown. Indicate the way the chest is facing with a centre line down its front.*

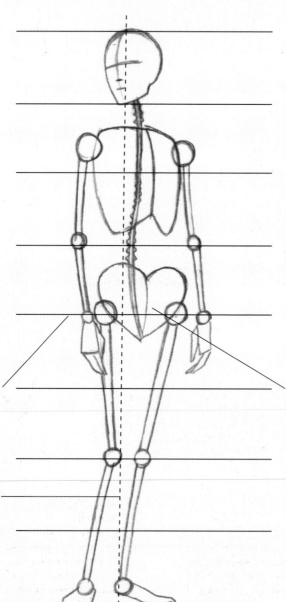

You could divide the figure up into eight sections as shown on page 67 in order to get the proportions correct.

Mark the centre of balance with a vertical dashed line. Sketch the sweep of the backbone about three head heights long. The shoulders of your female vampire should be just under two head widths wide.

### ◄ SECOND STAGE
**Adding limbs**

*Draw two circles about halfway down the second section for the shoulders. The female shoulders are narrower than those of the male. Draw the upper and lower arms in your desired pose. Both the upper and lower arms are one head height in length – connected by small circles for the elbows. Next, sketch circles for the hip joints, positioned wider than the male's hips so that the legs taper inwards more. Draw the thigh bones two heads long, then the knees and lower legs, also two heads long. Finish your framework figure by drawing simple shapes for the hands and feet.*

Draw the heart-shaped pelvis; its top indent should be about one head length from the bottom indent of the chest. The female pelvis is wider than the male's. Remember, the bottom of the heart marks the centre of the figure.

With practice you will gain a good knowledge of the relative lengths of the body parts and be able to draw any pose using these framework skeletons.

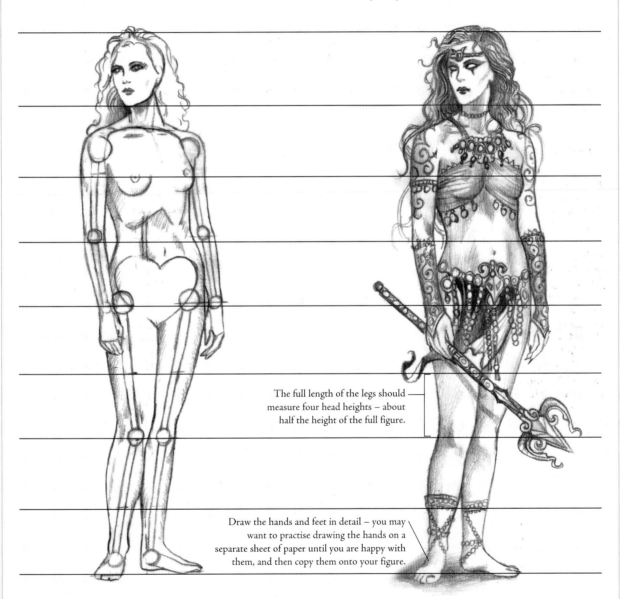

THIRD STAGE ▼

## Adding muscles to the arms

*Sketch in the features of the face (see pages 60–63). Draw the curve of the neck and rounded shoulders using your framework as a guide. Draw the biceps and the shape of the arms – refer to the muscle illustrations on the previous pages until you remember how to draw them.*

FIFTH STAGE ▼

## Shading

*Erase the framework drawing and any structural lines. Next, you must decide which direction the light source is coming from. Begin shading on the shadow side of your vampire until you build up the form of the body and limbs. Then you can add the facial features and the hair detail.*

The full length of the legs should measure four head heights – about half the height of the full figure.

Draw the hands and feet in detail – you may want to practise drawing the hands on a separate sheet of paper until you are happy with them, and then copy them onto your figure.

FOURTH STAGE ▲

## Adding muscles to the legs

*Next, draw the chest and torso. Follow the shape of the rib cage down and in at the waist, then out around the hips, following the curve of the pelvis. In the female vampire, the thighs will be fuller and taper inwards to the knees. At the knees, sketch the rounded form of the lower legs, making them narrower towards the feet. Sketch the hands and feet.*

SIXTH STAGE ▲

## Costume

*Decide what sort of cultural look you want, whether it is be ceremonial, pagan or elegant, for instance. (See the following pages for some examples.) You may like to add jewellery, tattoos and artefacts to enhance the Gothic look of your vampire. You can design these separately if you want, then transfer them onto your finished drawing.*

## SIDE VIEW

### FIRST STAGE ➤
### The framework

*If your female vampire is standing upright, you can divide her full height into eight equal parts in order to measure out the proportions. If she is in a different pose, measure the various body parts in relation to each other using the dimensions shown. Begin by drawing an oval for the head, indicating where the centre of the face will be. One head height below this oval marks the centre of the chest, which you can now sketch as a larger oval tilted towards the shoulders.*

### SECOND STAGE ➤
### Adding limbs

*Sketch a circle halfway down the second section, touching the spine for the shoulder. From this, draw the upper arm bones about one head height long. Another head height measures the length of the lower arms, starting at the elbows. Next, draw the thigh bones, beginning at the hip joint, in whatever position you desire. Maybe one leg is resting or raised onto a step, or perhaps the figure is in motion. The lower leg should also be two head heights in length, beginning at the knee joint and ending at the ankle.*

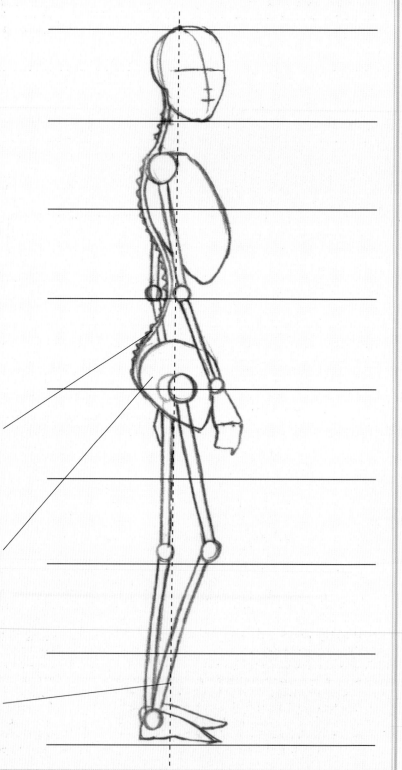

Draw the spine running down from the curve of the neck and out at the back, then sweeping in to the waist and out behind the pelvis.

Draw an oval for the pelvis, tilted and tapering towards the front. The centre of the pelvis, where the hip joint can be placed, will be at the halfway height of your full figure.

You may want to draw a vertical dashed line to indicate the figure's centre of balance.

### THIRD STAGE ▽
**Adding muscles to the arms**

*Sketch in the features of the face (see pages 60–63). Sketch in the neck and the shoulder muscles, continuing the lines down to form the shape of the arm; at the elbow, begin tapering the lower arm until it meets the wrist. You may need to refer to the muscle diagrams on the previous pages.*

### FIFTH STAGE ▽
**Shading**

*Erase the framework figure you sketched to create the structure of the vampire. Next, enhance the forms of the muscles by shading them on the opposite side to the light source (see pages 48–49). Add more details to the figure, draw her hair and features, and give her the character and expression you desire (see pages 64–65).*

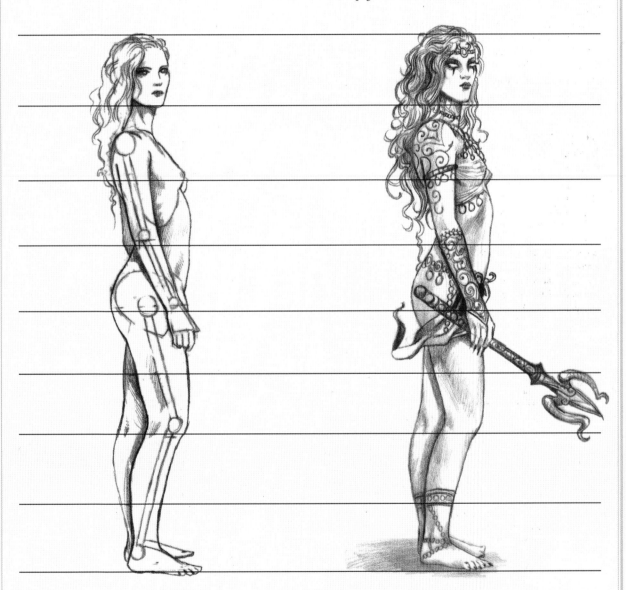

### FOURTH STAGE △
**Adding muscles to the legs**

*Draw the chest and the swell of the breasts. Add form to the torso using your framework figure as a guide. Draw the stomach, slanting towards the pelvis from the bottom of the rib cage. Next, sketch the line of the back sweeping out and around over the pelvis. Now draw the forms of the leg muscles as you did with the arms, then complete this stage by drawing the hands and feet in more detail.*

### SIXTH STAGE △
**Costume**

*You are now ready to clothe your vampire. Here, you can create a costume, jewellery and objects or weapons for her. Create a personal or cultural identity for your vampire by dressing her in a strange and wonderful costume drawn from your imagination. Find inspiration in anything from a piece of antique lace, to old jewellery, fashion magazines, museums, leaf skeletons, crystals and feathers.*

Swipe File:

# GOTHIC POSES AND COSTUMES

THESE TYPICAL VAMPIRE POSES AND COSTUMES ARE
USEFUL AS REFERENCE WHEN DRAWING AND PAINTING
YOUR OWN FIGURES.

To create a pose for your figure, begin by drawing the framework figure
(see pages 66–69), keeping the proportions accurate. Mark the angle
of the chest and hips to help establish the posture of the figure. Think
about balance and rhythm when sketching your figures – where is the
weight distributed? Where is the centre of gravity? Next, fill the body
out and sketch in muscles using the framework as a guide.

When you have drawn your pose you will want to clothe your
vampire. Look to Gothic art, films, historical costume and your own
imagination for inspiration (see pages 30–31). Here is a selection of
some of the most common poses and styles of vampire costume to help
you with your own designs.

### ▼ Costume: Sensual

*The traditional idea of the vampire as a
femme fatale or seductive killer can be
expressed in your figure's costume. This
is the classic 'vamp' costume: sleek,
glamorous and sensual. Use velvet, satin
or leather fabrics. Add a lace collar or
cuffs and a long dress to enhance the
feeling of Gothic romance.*

### ▲ Costume: Tribal

*This type of costume is inspired by gypsy, pagan and Gothic
dancer influences. Add ethnic elements such as lace, gauzes
or chiffon fabrics, and tribal jewellery, trinkets or talismans.
Veils, waist scarves and coin belts enhance the look.*

### ◄ Pose: Enticing

*To create an enticing vampire,
give her a sensual posture in
which the body shape follows a
soft, seductive rhythm. The
figure should appear relaxed
and confident.*

### ▼ Pose: Reclining

When drawing a reclining vampire, give her a relaxed demeanour and a feeling of self-confidence. Pay particular attention to the weight distribution. The limbs should be relaxed and the posture casual.

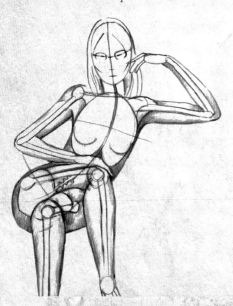

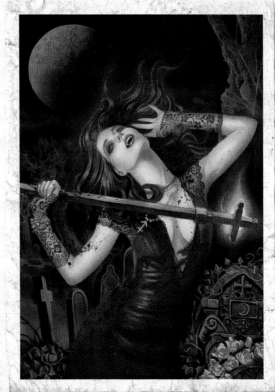

### ▼ Pose: Awakening

The line of the spine here creates a sensuous rhythm. This type of pose is useful when depicting a vampire rising from her deathly sleep – rejuvenation – or one energized by emotion, power or lust. The head is drawn back and the arms are raised, implying heightened emotion or exhilaration.

### ▲ Costume: Victorian

Victorian costumes often use rich fabrics such as silk, satin or velvet. Colours tend to be either vibrant – such as deep emerald green or flaming red – or layers of pure black material. Include embroidery, plenty of lace, ruffled dresses and gloves or hats.

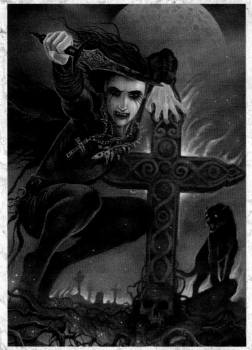

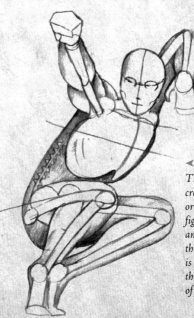

### ◄ Pose: Crouching

The vampire may need to be crouching in your drawing. In order to remain balanced, the figure's back should be arched and the legs tucked underneath the body. Here, the right hand is thrust towards the viewer, so the framework follows the rules of foreshortening (see page 39).

### ▲ Costume: Gothic

This costume is inspired by Gothic clothing and culture. Create close-fitting fabrics of soft leather or velvet, using lots of black or dark colours. Add Gothic elements such as religious artefacts, bones, buckles and lace.

# THE VAMPIRES

### ➤ Pose: Attacking

When showing vampires attacking, try to depict them with explosive, concentrated energy. Be sure to give the figures a powerful sense of momentum and rhythm. Notice here how the rhythm of this figure implies that all the energy is contained within the shoulders, and how the momentum enhances the power of the attack.

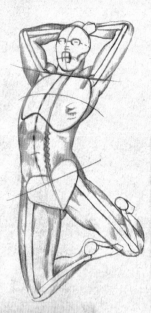

### ▼ Costume: Pagan

You may want to give your character a primitive or pagan appearance. Do this by dressing him in tattered cloaks, furs, leather or bound cloth. Also, go for the semi-naked or bare-chested look, with pagan tattoos. Adorn your character with bones, totems or primitive jewellery.

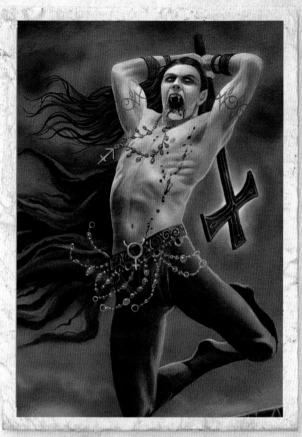

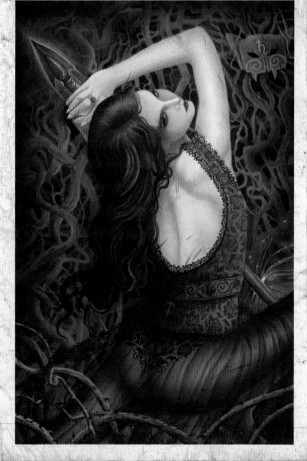

### ◀ Pose: Dynamic

You will need to create dramatic poses if you want to inject energy into your drawings and paintings. When working out a dramatic pose, consider the movement and tension of the body. Draw poses that are unusual and animated – whether you want to express power, defiance, exuberance or vivacity.

### ▲ Costume: Glamour

There is a certain glamour attached to the vampire myth, so designing dazzling and extravagant costumes and dresses will give them individuality. Use silk, chiffon, gossamer lace and shimmering fabrics in golds, reds, oranges and purples.

▼ **Costume: Elegant**

To create elegant and exquisite costumes for your figures, be sure to include fine details such as lace cuffs, lush fabrics and lavish embroidery. Design exquisite dresses, capes or loose shirts. This type of rich costume works well in pale cream colours or rich greens and blues – perfect for either a virginal victim or a debonair aristocrat.

▼ **Pose: Swooning**

Don't forget the vampire's victims. Here is a pose that shows a swooning and languid figure. When fainting, the weight of the figure is often held by another – perhaps around the waist – or in this case, by the wrist. The figure's limp body is supported from above. For a swooning pose, let the body and limbs hang lifelessly.

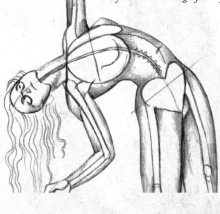

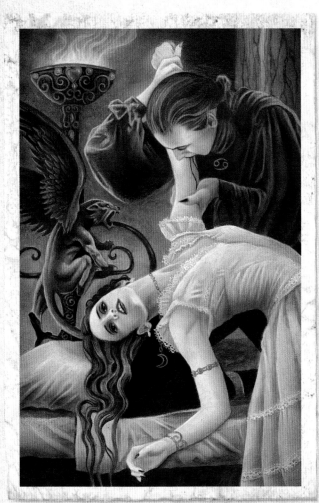

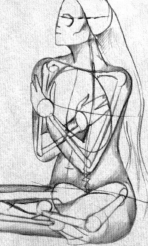

▶ **Pose: Ritualistic**

This type of pose shows a vampire in a ritual act, often in a symmetrical pose or performing ritualistic gestures. As here, the vampire may even be meditating. Create a pose that instills a mood of mystery; perhaps the figure is conjuring a spell or is deep in trance.

▲ **Costume: Ceremonial**

The religious aspect to the vampire myth means that at times you will need to design ceremonial or religious costumes. The most common styles involve cloaks, hooded robes or a pagan look, as shown here.

# ARISTOCRATIC VAMPIRE

THE ARISTOCRATIC VAMPIRE, OR THE VAMPIRE NOBLE, IS ONE IMAGE
FROM VAMPIRE MYTH THAT IS DEEPLY INGRAINED IN OUR CULTURE.

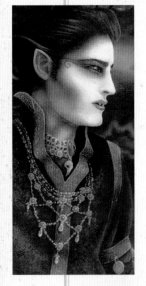

When Bram Stoker's *Dracula* was published in 1897, the
Aristocratic Vampire made his appearance as Count Dracula.
Stoker's character is thought to have been based on Vlad Tepes
(more commonly known as Vlad the Impaler), who was a prince
of Wallachia in Romania. Many modern books and films have
built on these concepts of the Vampire Noble, or Count: finely
dressed, decadent and with an air of sinister aloofness.

### FINISHED PAINTING

Once you have your detailed drawings worked out, transfer
them to the painting surface as the foundation for the actual
painting. Velvet greens and rich golds were used for the
costume, over a tonal underpainting of raw umber. The skin
tones were painted over the dry underpainting, allowing for
the detail beneath to remain visible. When this second layer
is dry, finer details were added – for example, the face, costume,
adornments and artefacts.

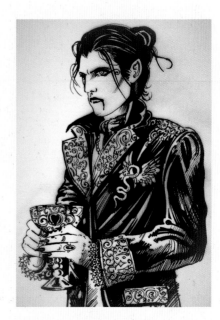

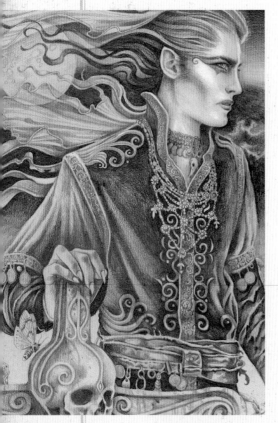

### ◄ FIRST STAGE
**Key elements**

*It can be helpful to make a list of
key elements for your character or
painting. These will include all the
aspects, features and expressions
that enhance the credibility of your
character. So, for example, your
Aristocratic Vampire could include
the following:*

+ *A look of decadence and aloofness*
+ *An expression of assertiveness
  (see Gothic Expressions, page 64)*
+ *Rich and elegant garments*
+ *Jewellery and adornments*
+ *Decorative artefacts*

### SECOND STAGE ▲
**Pen and ink sketch**

*Instead of using pencils for your sketches and
studies, try using pen and ink (see page 15).
In addition to being bolder, pen and ink
drawings help establish darks and lights more
fully. This drawing was created as the basis for
the finished painting.*

### THIRD STAGE ►
**Artefacts**

*Design elaborate artefacts, either in pencil
or paint. Find inspiration in antiques,
or create your own designs, reflecting the
nature of your character. This chalice was
painted for the Aristocratic Vampire and
is featured in the finished painting.*

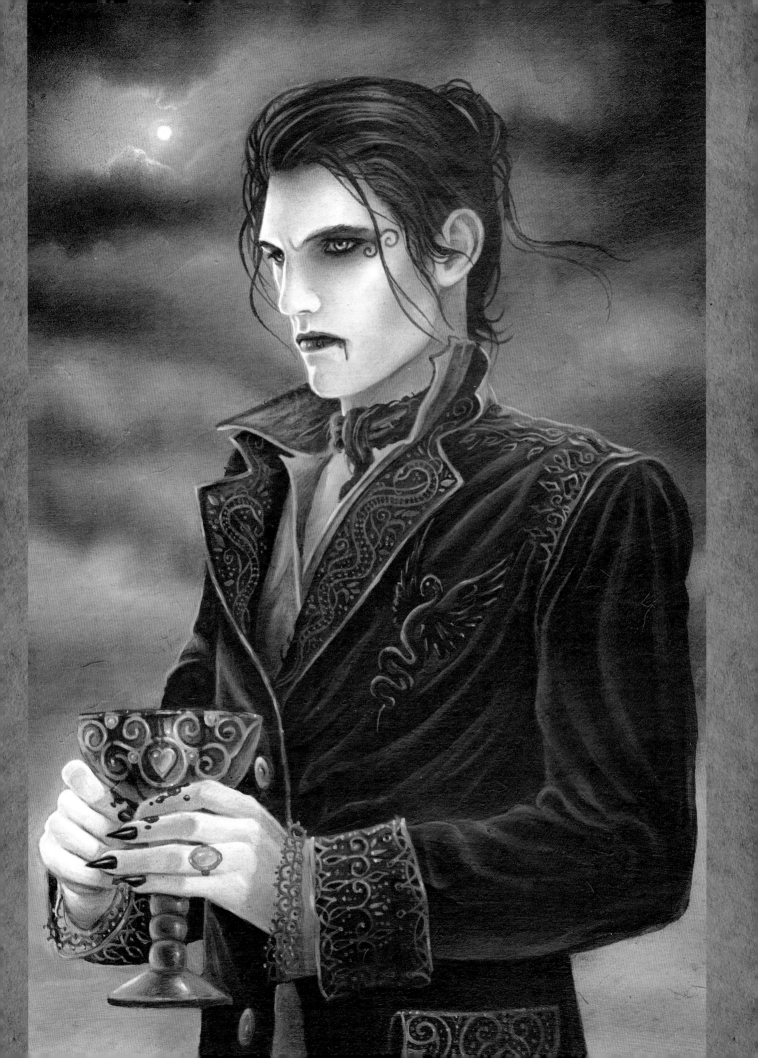

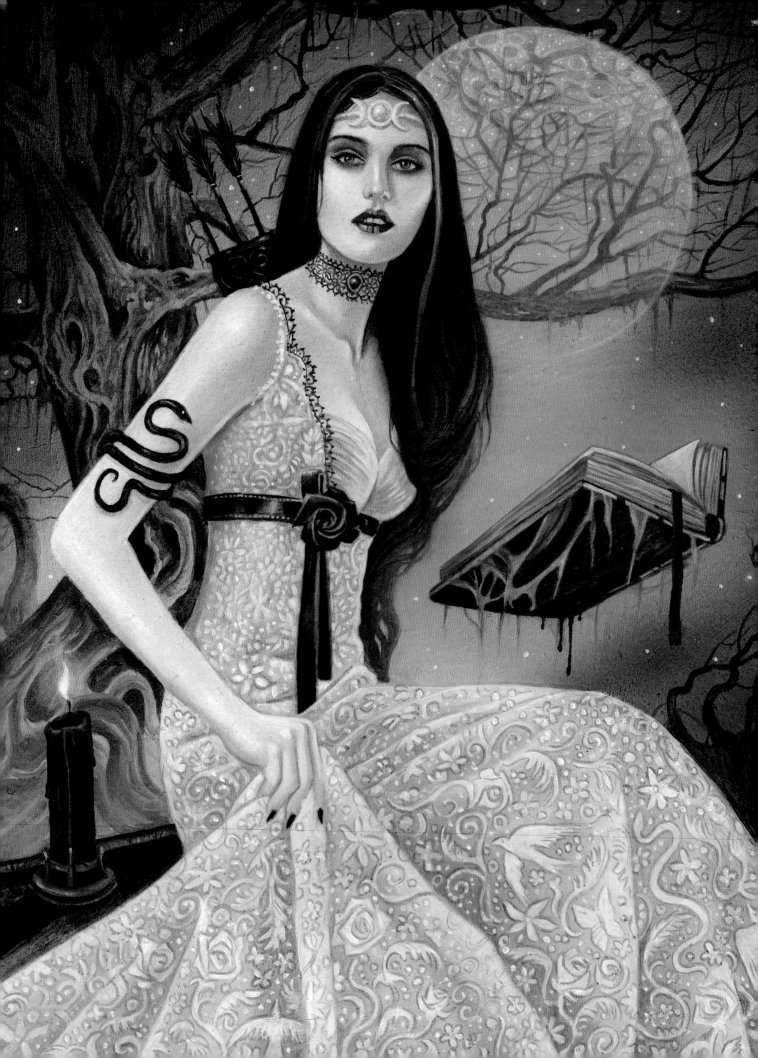

# VAMPIRE PRIESTESS

BLOOD-DRINKING PRIESTESSES ARE RECORDED IN
A NUMBER OF CULTURES AS SPIRITUAL ORACLES.

In ancient Greece, the priestess was believed to be inspired to divination through her drinking of the blood of animals and becoming possessed by the gods. Archaeological evidence of the Moche civilization in northern Peru tells of the ceremonial bleeding of bound males and the drinking of their blood. The only female among the elite participants in this ritual was the priestess, who was deeply connected to an ancient cult of moon worship.

### FINISHED PAINTING

The Vampire Priestess was painted in oils using the process explained in Oils on pages 26–27, and The Gothic Vampire on page 78. First, the sketch was transferred to the stretched and colour-washed paper. A tonal underpainting in raw umber was painted over this and was left to dry. The basic areas of colour were then painted in, transparent enough for the tonal underpainting to be seen beneath. Once dry, the figure and background were painted in more detail using the still-visible tonal underpainting as a guide.

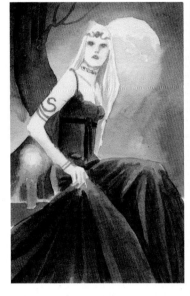

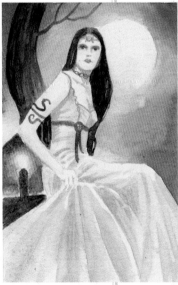

### SECOND STAGE ⏶
**Colour sketches**

*Once you have your pencil sketch worked out for the painting, you may want to experiment with colours. Refer to Understanding Colour, on page 44, for a guide to the mood effects of different colours. Use watercolours to create simple sketches in order to decide on the colour scheme for the final painting. Here, warm red, pink and purple were used in the initial sketch, but it was decided that cool greens and blues would give a more haunting effect to the painting.*

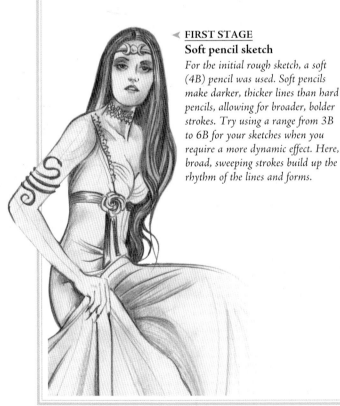

### ◄ FIRST STAGE
**Soft pencil sketch**

*For the initial rough sketch, a soft (4B) pencil was used. Soft pencils make darker, thicker lines than hard pencils, allowing for broader, bolder strokes. Try using a range from 3B to 6B for your sketches when you require a more dynamic effect. Here, broad, sweeping strokes build up the rhythm of the lines and forms.*

### THIRD STAGE ➤
**Fabric designs**

*Creating fabric designs for your characters' costumes will help to establish their cultural ambience while adding richness to your paintings. Create designs with pencils or paints on a separate piece of paper before transferring them to the final rendering. Designs should be painted over the dry, underpainted cloths or fabric. To create a sense of depth, darken the design in the folds of the fabric and add highlights in the raised areas.*

# VAMPIRE BRIDE

THIS PICTURE FOCUSES ON A POPULAR THEME IN VAMPIRE MYTHOLOGY: LOVE AND LOSS.

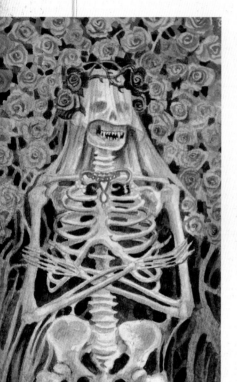

Trapped eternally between life and death, the vampire bride can never rekindle lost love – neither can she forget it. The roses, symbolic of life and love, are brightest the further they are from the figure; this suggests that the skeleton is gradually sucking life from the roses, illustrating the parasitic nature of the undead vampire. Vampires who fall in love with humans are faced with a choice between denying their love or consigning their lover to a shared fate.

## FINISHED PAINTING

Your finished painting should retain both the conceptual vision and emotional mood of your initial inspiration. In addition to rendering the details aesthetically, it is important to capture the energy and rhythm of the sketches. Colour is extremely important – here, greyish browns and muted greens give a sense of decay, contrasting strongly with the vibrant colours of the roses, further highlighting the polarity of life and death. The black roses enhance the notion of stealing life (see conceptual study, below). The black heart pendant at her throat is a reference to love and death, and to sleeping beauty (see fine detail, below). The skull carved into the tomb is added as a Gothic symbol of death. The black blood of the vampire's eternal curse bleeds from her haunted eyes.

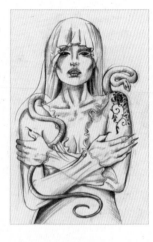

**FIRST STAGE** ▲
**Sketch**
*Use bold strokes to give your sketches energy and rhythm. Establish the shape and structure of the figure, without being too concerned about finer details. Develop one or two sketches as shown to decide the overall tone, composition and conceptual story you want to convey.*

**FOURTH STAGE** ▲
**Conceptual study**
*This watercolour explores concepts of life and death. Alternative perspectives illustrate how you can use dual perceptions or ambiguity to create intrigue.*

**THIRD STAGE** ▶
**Fine detail**
*Use your drawings to establish details and to make decisions about particular aspects. Here, another composition view is tried, with lots of fine details added, such as richly patterned clothes, roses and a necklace, to help establish the final darkly romantic tone.*

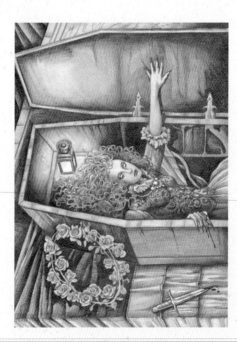

**SECOND STAGE** ▲
**Explore an alternative view**
*By drawing the figure from another angle, you will gain a better understanding of its anatomy. Exploring alternative viewpoints also helps decide what works best to convey concepts and emotions, perfecting the composition before you add colour.*

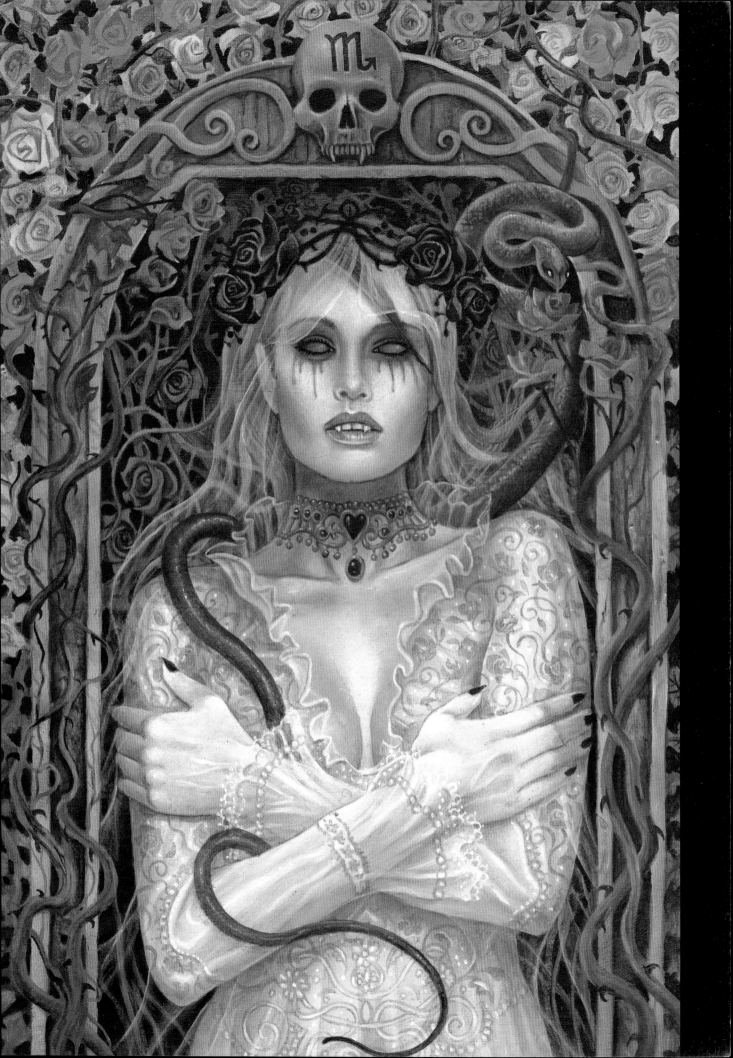

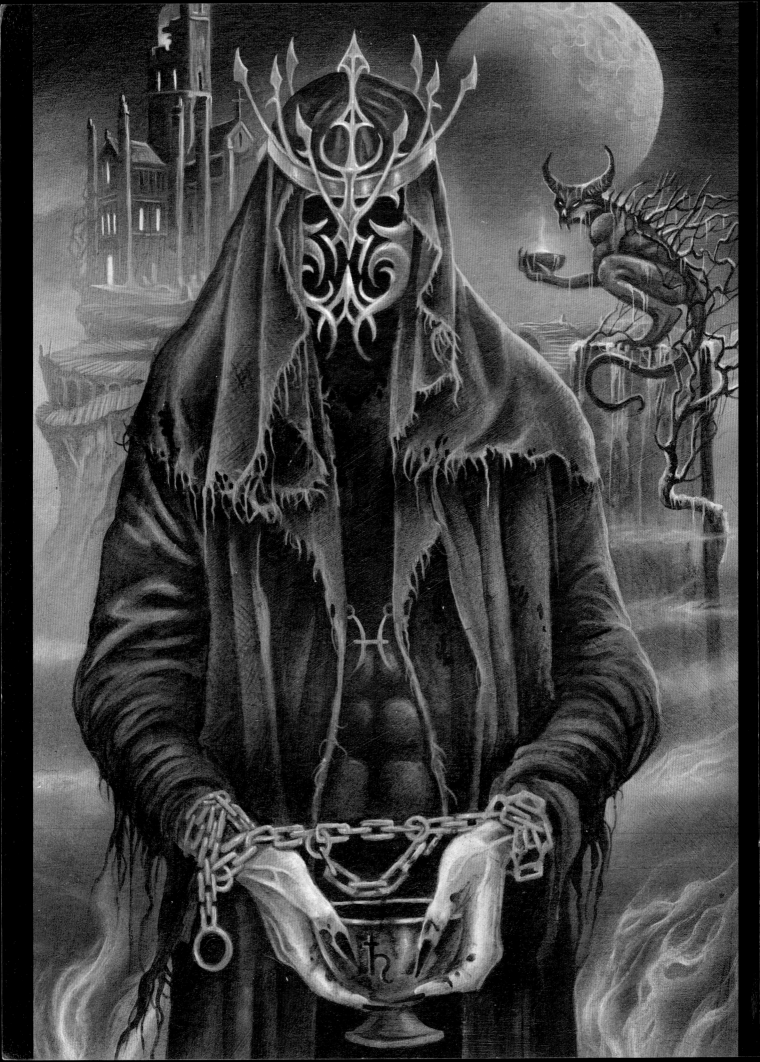

# VAMPIRE PHANTOM

THE IDEA OF PHANTOMS AND GHOSTS RETURNING TO THE
WORLD OF THE LIVING TO SATE THEIR THIRST FOR BLOOD
AND WREAK VENGEANCE IS A POPULAR ONE.

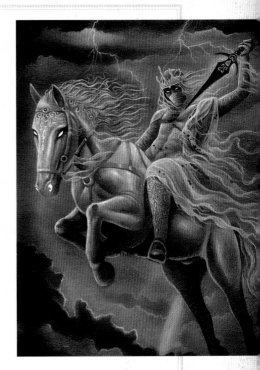

Norse beliefs tell of spirits of the dead in some form of limbo. Many of these 'dead' behaved as if they were alive, rising from their tombs to seek out those who had wronged them and to quench their bloodlust. Usually, the Assyrian dead descended into the 'House of Darkness', but there were those who were forced to prowl forever through the living world…

**FINISHED PAINTING**

The finished piece was painted in poisonous green oils to reflect the nature of the character and create the desired mood (see page 104). Lurid yellow and acid green depict toxic vapours and lights in the distant cathedral – adding a feeling of creeping dread. For the painting techniques used here, see Oil Paints on pages 24–27.

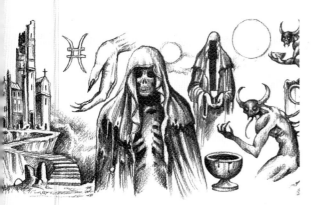

**FIRST STAGE** ▲

**Preliminary drawings**

*Get into the habit of doing preliminary drawings. These can be rough sketches or detailed drawings, and they will help you to develop your ideas and establish the different elements within your painting.*

**THIRD STAGE** ➤

**Creating a story**

*As the viewer engages with these meanings and symbolism, a narrative unfolds. The colour is often the starting point, fixing the mood. The composition and setting follow, building up a background story. Notice how the different components work together to tell a story: The clothing and pose make the figure look destitute, while the crown hints at lost glory. The rune around his neck adds a religious aspect. The bowl suggests that he is a beggar and the chains deepen the story by revealing that he is a prisoner.*

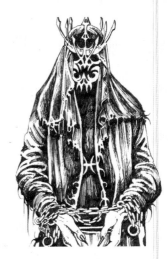

**SECOND STAGE** ➤

**Developing characters**

*Here, you can see how the character developed. The cup became a begging bowl, and different views were explored. It was decided that empty darkness where the skull had been would create a more mysterious, ghostly effect. A crown was added to develop the narrative, and the rune was incorporated from the preliminary drawings. Finally, a mask was added and the crown was enhanced.*

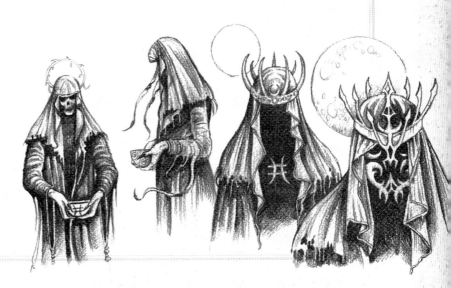

# VAMPIRE LOVERS

THE THEMES OF LOVE AND DEATH PLAY
A CENTRAL ROLE IN THE VAMPIRE MYTH.

The idea of the vampire has come to address two of the most basic urges of the human psyche: the desire for immortality and the need for love. The image of the ageless, beautiful individual as portrayed by the vampire appeals to something deep within us. The vampire's immortality is assured by drinking the blood of another and drawing on the life force. Gothic romance is an important aspect of the vampire myth, so be sure to imbue your work with beauty – even if in a dark and haunted form.

### FINISHED PAINTING

The drawing was transferred to the painting surface (see pages 42–43), and an underpainting in raw umber painted over it. Once the underpainting was dry, the overpainting was built up in layers and glazes of oil paints. (If you prefer watercolour, refer to pages 16–19 for techniques.) The flaming skull in the background was later added as a symbol of the characters' mythical union (love and death). Other additions include the female's crown and tattoo – giving her an air of nobility and elegance and building up the narrative. The roses add a sense of romance to the finished painting.

### FIRST STAGES ▽

**Framework and skeletal sketches**

*The painting was started by making a framework sketch (see Figure Drawing, pages 66–69) to establish proportions and poses. When two figures are featured, it is important to create an interesting interaction between them: consider the negative space. To help establish this, a more detailed 'skeletal' sketch was created. This does not need to be anatomically accurate; its purpose is to establish the figures in more detail.*

### SECOND STAGE ▽

**Creating a drawing from framework sketches**

*A pencil drawing was created from the framework sketches. A good way to create the full figure from a framework sketch is to lay tracing paper over the sketch and build up the forms using the framework as a guide. This drawing can then be transferred to paper to be worked on in more detail.*

### THIRD STAGE △

**Watercolour sketch**

*You may want to produce a quick watercolour sketch before starting work on your actual painting. Transfer your drawing or pencil sketch onto watercolour paper, then use washes to build up the layers of colours and tones (see Watercolours, page 19). This will help to establish the colour and mood of your finished painting. At this stage, ideas are still evolving, so feel free to develop them further. For example, in this case it was decided that making the male figure horned and demonic would create much deeper intrigue, especially if he also appeared to be the willing victim of the female.*

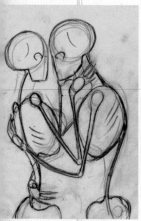

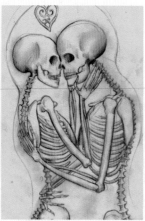

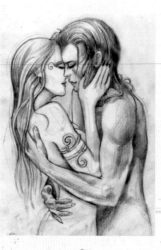

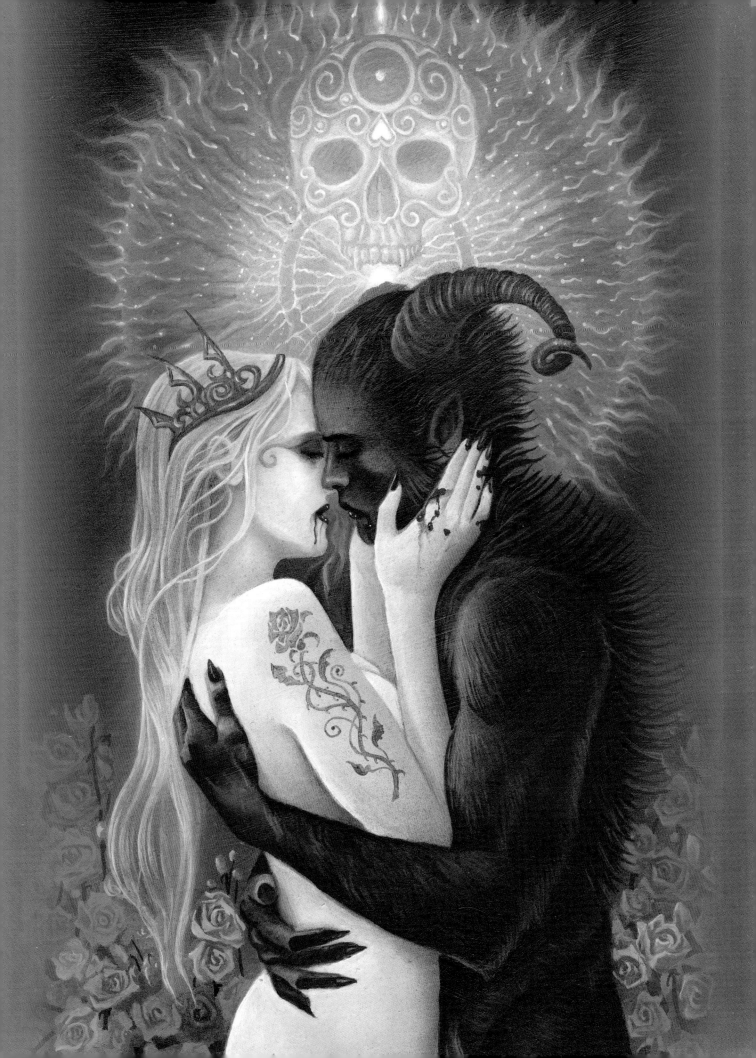

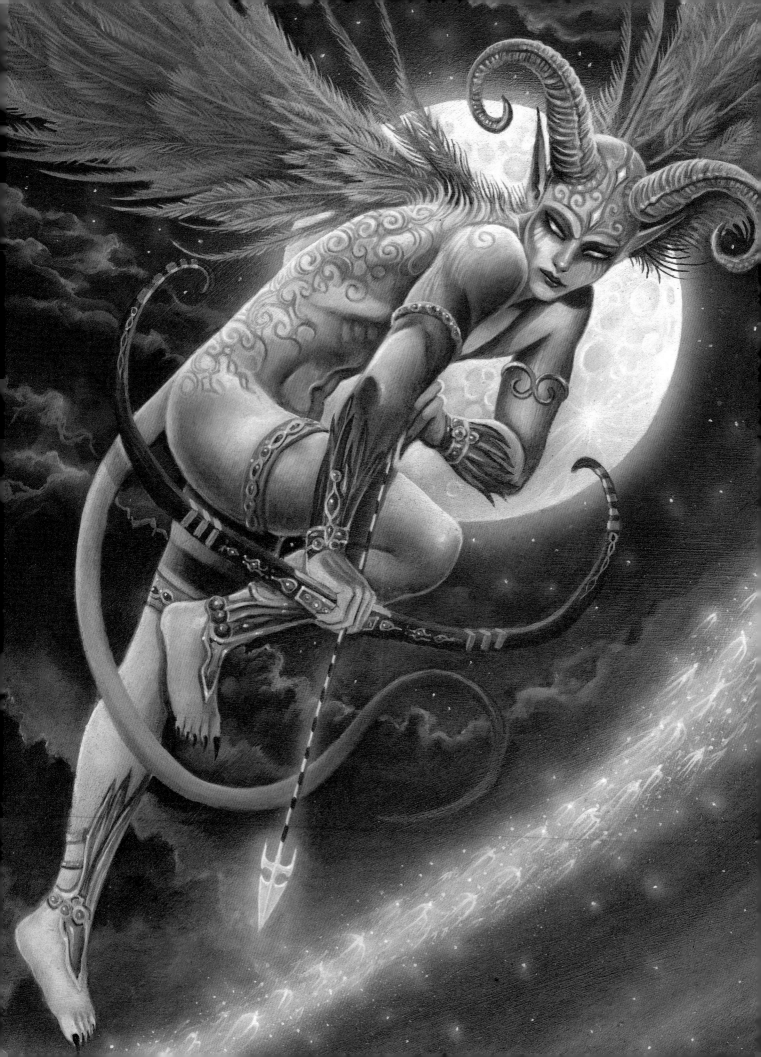

# VAMPIRE DEMON

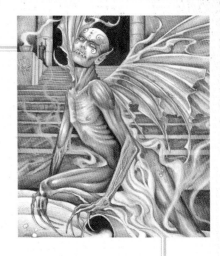

DEMONS ARE GENERALLY CONSIDERED TO BE ANGELS WHO HAVE FALLEN FROM GRACE BY REBELLING AGAINST GOD.

In religion and mythology the word 'demon' has various meanings. For instance, the Greek *daemon* meant something different than the later medieval notion of demons as evil spirits. The Greek word meant 'spirit' or 'divine power', much like the Latin *genius*. These demons were thought of as supernatural beings, neither benevolent nor malevolent, and were simply the spirits that inhabited a particular place or accompanied a person. Other myths describe them as nature spirits related to particular elements.

**FINISHED PAINTING**

The paper was stretched and primed for oil paints, then a colour wash was laid down. When the wash was dry the drawing was scaled up (see Transferring Imagery, pages 42–43) and transferred onto the prepared paper. An underpainting of burnt umber established the tones, forms and shadows. When the underpainting was dry, the painting was worked up in layers, using the underpainting as a guide. Storm clouds were painted into the background to increase the Gothic mood, and the full moon was used to frame the figure. Multicoloured feathered wings enhance the fairy-like enchantment.

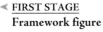
**FIRST STAGE**
**Framework figure**

*It was decided that this painting should incorporate both the nature spirit, or fairy, aspect as well as more traditional demon characteristics. This was achieved by merging elements from both. In fairy tradition, these beings kill their victims by firing 'elf bolts' from magical bows, so this figure was sketched as if drawing a bow. To capture a sense of cunning and stealth, the figure's back was arched and it is looking over its shoulder with sinister intent.*

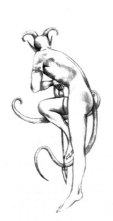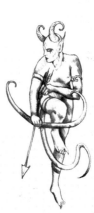

**SECOND STAGE** ▶
**Portrait study**

*Try creating colour sketches of the face in order to build up a cultural identity. This will help you to establish the overall feel of the character and give it a unique personality. Experiment with different colour combinations until you capture the mood you desire. Here, the Vampire Demon was given an elf-like face and elaborate designs to enhance the fairy feel, while traditional demonic elements were also included, such as horns and slanted, glowing eyes.*

**THIRD STAGE** ▲
**Figure rotation**

*Using the framework figure as a foundation, a series of drawings were drawn up in greater detail. These showed the character from different angles and helped to establish the form and pose. Draw a few figure rotations when creating any character to help you decide on the angle that best suits your composition. Here, the bow was added and the anatomical details were built up. The right-hand drawing was selected as a base for the painting.*

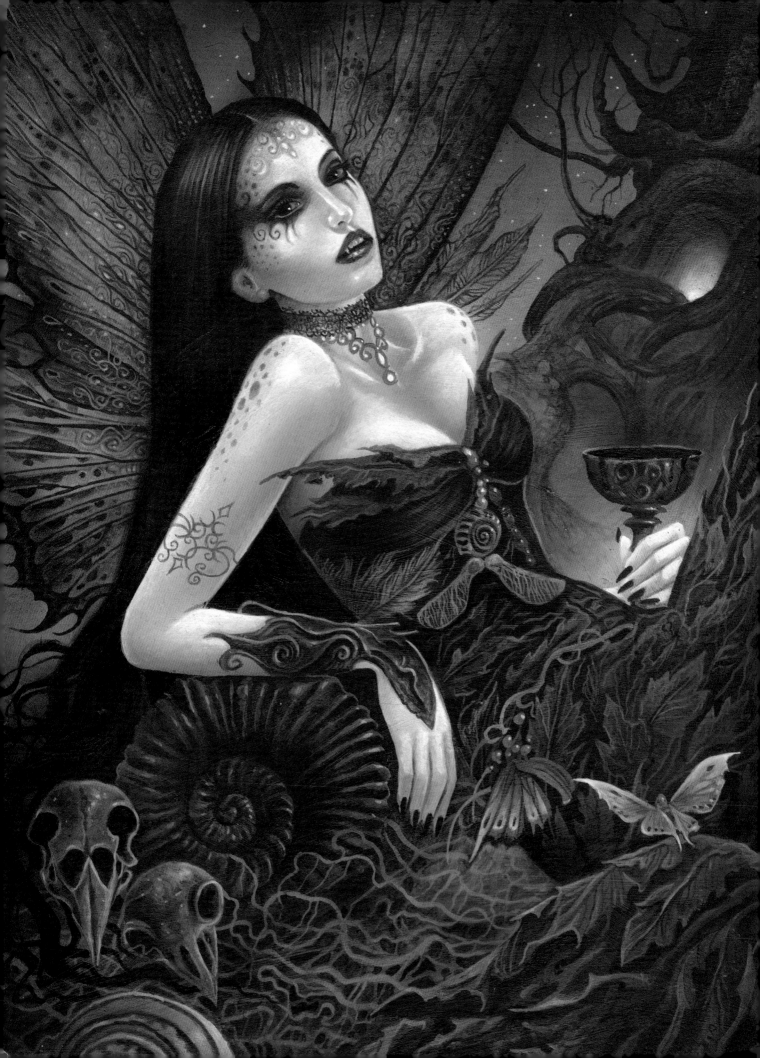

# FAIRY VAMPIRE

THE TRADITIONAL CONCEPT OF FAIRIES AS DELIGHTFUL BEINGS WHO FLITTER ABOUT ON GOSSAMER WINGS IS OFTEN FAR REMOVED FROM MORE ANCIENT MYTHS ABOUT THEM.

In ancient myths, fairies are portrayed as evil spirits who live off the blood of their human victims. Tales tell of seductive female fairies luring travellers to their deaths on dark and lonely forest trails, and of strange, cave-dwelling beings with tree roots for hair and small, sharp teeth, hungry in their bloodlust. Celtic myths speak of a massive fortress known as the 'Castle of the Blood Visage', which was home to a clan of bloodthirsty fairy vampires.

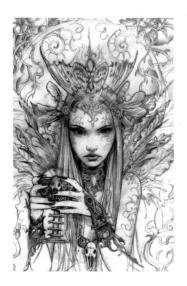

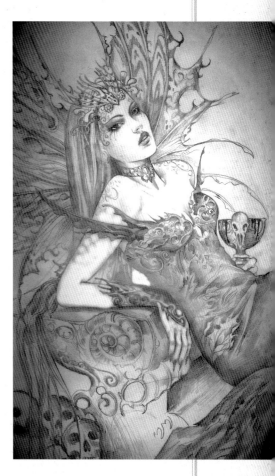

### FINISHED PAINTING
For the background, a deep, dusky night sky enhances the haunted feel. For a narrative element, a huge tree serves as an entrance into the fairy realm. The inner light from this hollow creates mystery and magic (see Gothic Settings, pages 104–105). Earthy colours, such as muted browns and hints of green, along with misty greys and reddish purples, give an overall impression of twilight (see Gothic Palettes, pages 50–53). The crimson of the fairy vampire's wings enhances her fiery disposition and power. The earlier idea of a headpiece was developed further; her forehead is decorated with curious designs to portray her mystical aspect. The bloody cup she holds suggests an underlying Gothic horror.

### FIRST STAGE ▲
**Portrait sketch**

*An initial drawing was created to help develop the cultural feel and desired elements. Since fairies are predominately 'nature spirits', it is important to include natural aspects, such as leaves, seeds and shells – and bird skulls add a darker element. Collect your references from nature or take a sketchbook out with you to make drawings of these details. Here, a look of childlike innocence combined with alien slanted eyes result in a sinister appearance.*

### SECOND STAGE ▲
**Framework figure**

*Sketch a framework figure to establish the anatomical proportions and pose of your character. It was decided that the figure here would recline, giving her a look of sensual seduction and arrogance. At this stage it is important to lay the foundations of the figure: consider weight distribution and balance. Her weight is on her right elbow, drawing her shoulders up and forwards. The relaxed gesture of the wrist and the tilt of her head add a feeling of haughty seduction.*

### THIRD STAGE ▲
**Detailed drawing**

*Here, the figure is filled out and the face is drawn in detail. Her dress and wings are also sketched in. For the dress, leaf-design textures were built up, to be worked on later in more detail. Her wings were inspired by those of a butterfly but were given a spiny, tattered look to convey her dark nature. Elements from the initial portrait sketch were used in the headpiece that, along with her necklace, give her an air of rich elegance.*

# VAMPIRE MONSTER

THE FLESH-EATING LIVING DEAD, IN THE FORM OF MONSTERS AND VAMPIRES, HAVE BEEN EVIDENT IN MYTHOLOGY FROM EARLY TIMES.

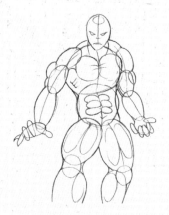

**Oval framework sketch**
*Using a series of ovals and circles to build up your framework figure works well for muscular characters, such as werewolves and monsters. This basic structure can be outlined and used for the next stage.*

In the Epic of Gilgamesh, dating to about 1,000 BC, vampire creatures were controlled by the goddess Ishtar. She threatened to raise the dead and have them devour the people. Tales of zombies originated in the Afro-Caribbean spiritual belief system of Voodoo, and *Frankenstein* by Mary Shelley portrays the resurrection of the dead as a scientific process rather than a mystical one.

## FINISHED PAINTING

This painting was inspired by the scientist's laboratory in *Frankenstein*. The detail was painted in over the whole painting using soft fan brushes to blend the colours and fine brushes for the smaller details. Allow the first layer to dry before adding more detail, such as patterns, highlights and reflections. As shown here, you may decide to blend dark shadows into the top of the painting. Notice how vertical perspective (see page 38) creates drama, and how the foreshortened tanks create a sense of depth.

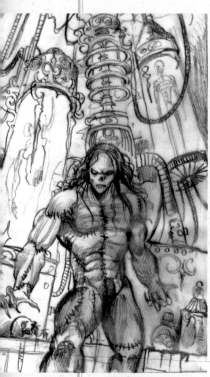

**FIRST STAGE** ▲
**Rough drawing**
*A rough drawing was made based on the framework figure, including details and a sketch of the background.*

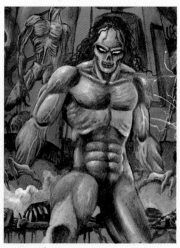

**SECOND STAGE** ▲
**Underpainting**
*A more detailed drawing was built up using tracing paper overlaid on the rough drawing. The painting surface was prepared with a thin layer of paint in the predominant colour. When dry, the detailed drawing was transferred to the painting surface and underpainted in monotone using raw umber and titanium white. If you are using watercolours, the underpainting should not include white, as these areas are left unpainted at this stage; build up your underpainting in raw umber or in any translucent colours that are dominant in the picture.*

**THIRD STAGE** ➤
**Work in progress**
*Once dry, further glazes were applied over the underpainting using a large, soft brush – fan brushes work particularly well. Build up and blend colours that will form the foundation of the painting, using the underpainting as a guide. Don't worry about keeping the colours within their specific areas; it is more important to create a blend. The underpainting can still be seen beneath this layer of paint.*

**FOURTH STAGE** ➤
**Adding detail**
*When the foundation colours are dry, begin to work in the details using fine brushes. The underpainting was used as a blueprint for the structure and to guide the tonal values.*

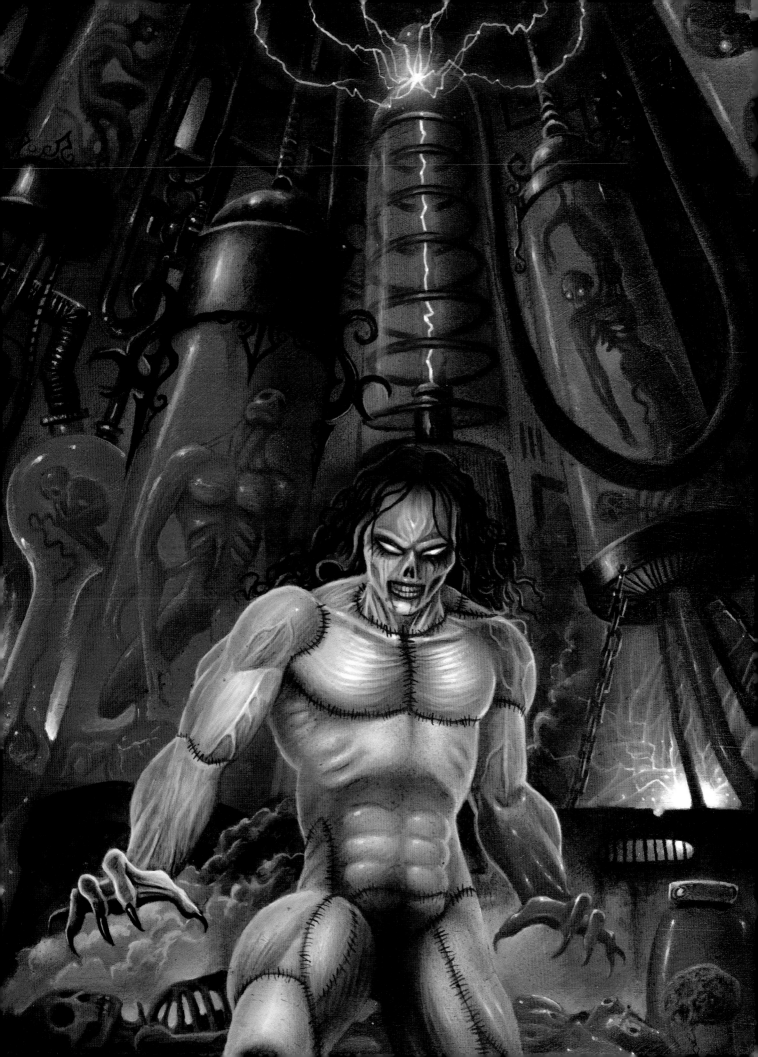

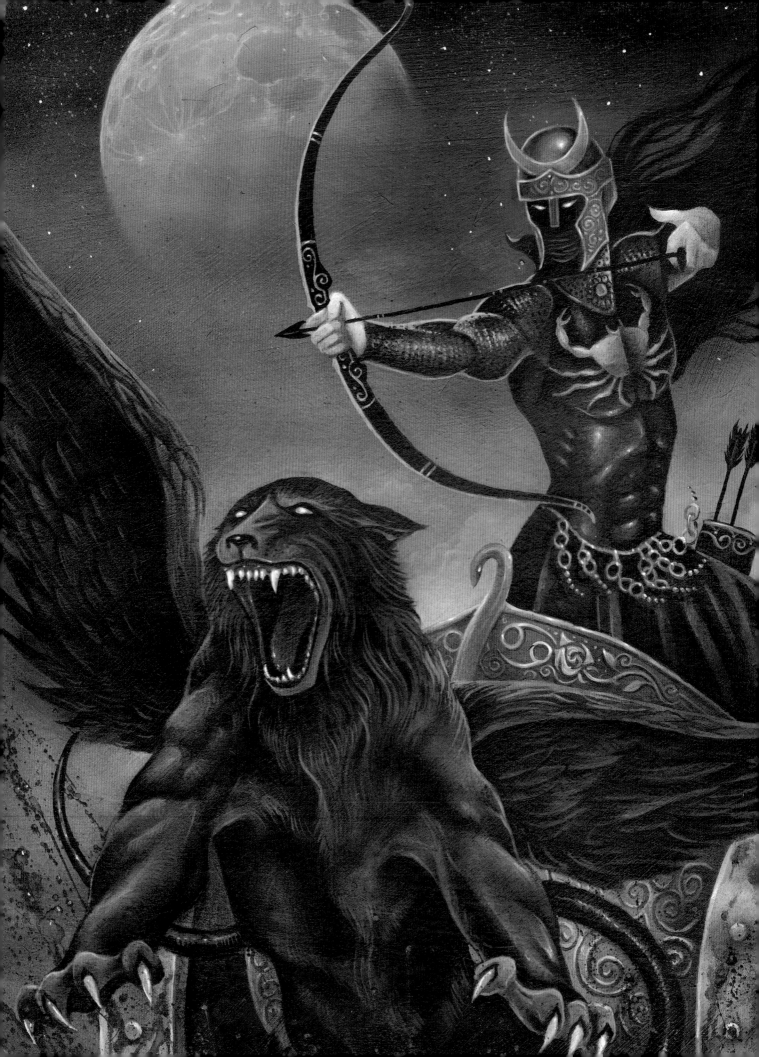

# VAMPIRE WARRIOR

MANY AGREE THAT BRAM STOKER'S CHARACTER, DRACULA, WAS BASED
ON VLAD TEPES, A REAL HISTORICAL FIGURE WHO RULED AN AREA
OF THE BALKANS IN THE MID-FIFTEENTH CENTURY.

Vlad Tepes was known as Vlad the Impaler because of his propensity to
punish victims by impaling them on stakes, then displaying them publicly
to frighten his enemies. An old legend tells of a Celtic warlord named
Abhartach, who rose from the grave demanding a basin filled with the
blood of his subjects in order to sustain his undead corpse. Vampire
warriors known as 'draugr' were said to emerge from ancient burial
chambers wreaking bloody revenge.

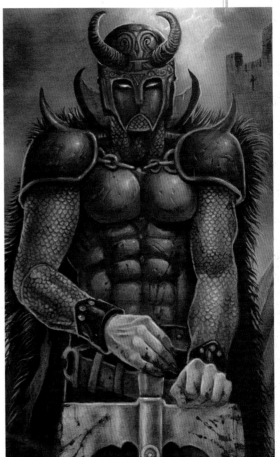

### FINISHED PAINTING
An underpainting in raw umber was painted as a foundation and left
to dry. Adding thin layers of colour, called 'glazes', over this allowed the
underpainting to remain visible as a guide to the finished painting. The
moon was created by merging lighter colour onto the dry-painted sky, either
with soft brushes or an airbrush. Details such as moon craters were added
after the graduated base colour was completely dry. Further elements were
added as the painting developed, such as the panther's wings and the
emblem on the Vampire Warrior's breastplate.

### SECOND STAGE ▽
**Detailed drawing**
*The right-hand thumbnail was used to create
this detailed drawing. A bow was chosen for
this Vampire Warrior's weapon. The chariot
and panther were worked up from thumbnails
in a similar way to the figure, then scaled up
and incorporated into this drawing.*

### FIRST STAGE △
**Thumbnail sketches**
*As an alternative to creating
framework figures, you can
develop your figures using quick
thumbnail sketches. Use a soft
pencil or fibre-tip pen to create
simple doodles. Work freely
and speedily, concentrating on
capturing both the simple forms
and the darks and shadows (see
Light and Shadow, page 48).
From your thumbnails you
can select the most desirable
figure and work it up into a
detailed drawing.*

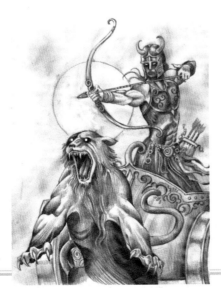

### THIRD STAGE △
**Armour**
*Authentic-looking armour will enhance the
impact of your Vampire Warrior. Evoke chain-
mail armour by painting a series of small circles
or scales over dry, underpainted arms, torso and
skirt. The underpainting should be the colour
of the armour, perhaps silvery grey or bronze.
Breastplates and metal body armour can be
enhanced by deepening the shadows and lifting
the highlights of the muscles beneath. Give the
armour a battle-stressed feel by adding small
dents or scratches. Add spikes for a more Gothic
look or elaborate designs to enrich the effect.*

# VAMPIRE HYBRID

MYTHS FEATURING HALF-HUMAN, HALF-ANIMAL, BLOOD-DRINKING
CREATURES ABOUND IN FOLKLORE AND LEGEND.

Myths can be a fantastic source of inspiration for your vampire figures. In order to make your Vampire Hybrids believable, try to merge the different human/animal elements. You can achieve this by making the colours of each element the same or very similar, or by carrying aspects such as the body markings, designs and textures like fur and scales of one element across to the other.

### ILLUSTRATING A WRITTEN DESCRIPTION

Working from a given text or description can be very inspiring. Rather than limiting the possibilities, it can aid in structuring your ideas and create wonderful results. Compare the descriptions here with the artwork, then try to create your own painting drawn from a vampire myth or description.

**Dark satyr ➤**

*In Greek mythology, the satyr is a lustful, drunken, woodland creature that is half-man, half-beast. Satyrs are characterized by pointed ears, horns and a tail, and they attended to the god of wine, Dionysus. This spiritual intoxication is related mythically to drinking from the Holy Grail. Christ offered the grail, containing wine to signify his blood, to his disciples and directed them to drink it. This parallel between the Eucharist and vampire legends suggests that the consumption of blood is an act intended to obtain divine vitality.*

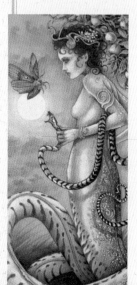

**◄ Lamia**

*One of the earliest malignant hybrid creatures that displayed vampiric tendencies was the lamia. Her victims were usually sleeping infants, which she stole from their cradles and took to her lair where she drank their blood. She is described as having the upper body of a beautiful woman and the lower body of a serpent.*

**Baobhan Sith ▼**

*The baobhan sith of Celtic folklore was a cross between a ghost, a fairy and a vampire. It is often described as a beautiful woman with the hindquarters and feet of a goat. At night, these beings would appear at remote dwellings where shepherds lodged, in the guise of a loved one. Returning to their true form, they would then attack the shepherds and drink their blood.*

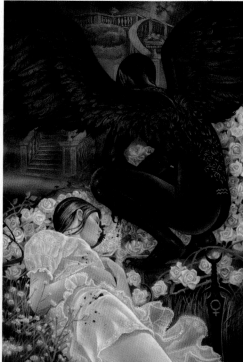

**◄ Werewolf**

*The werewolf has come to symbolize the ancient beast that lurks within the human psyche, ready to reassert itself under the baleful influence of the moon. This concept is so deeply ingrained in our culture that the prefix 'were-' is generally suggestive of a human who transforms himself or herself into a ferocious, bloodthirsty animal.*

**Winged vampire ▲**

*In many ancient cultures, the distinction between vampires and demons was extremely blurred. Winged demons were believed to be fallen angels who subsisted on human blood. Their lust for blood enticed them from the shadowy underworlds.*

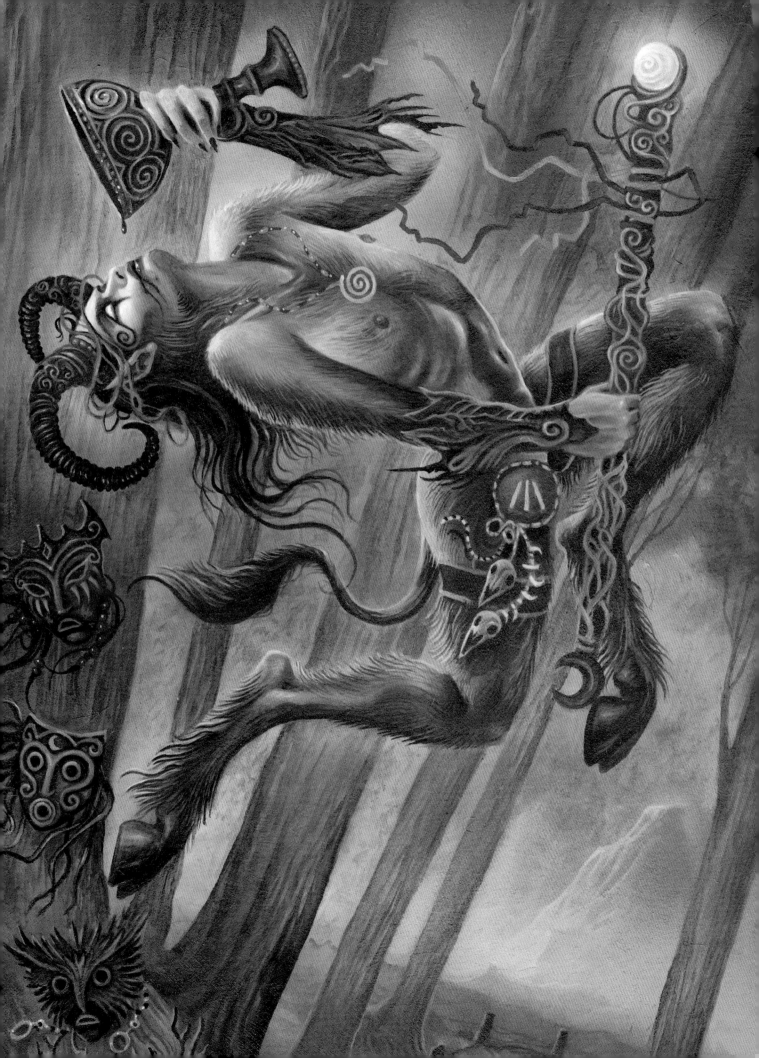

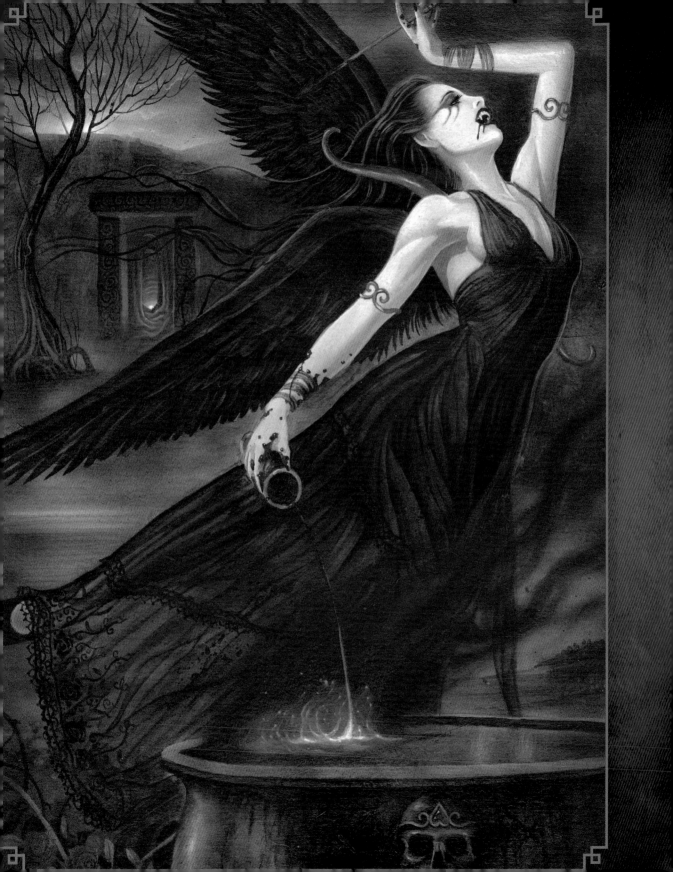

# CHAPTER 3

# GOTHIC ENVIRONMENTS

THIS CHAPTER TAKES A LOOK AT SOME OF THE
TRADITIONAL SETTINGS ASSOCIATED WITH THESE
CREATURES OF THE NIGHT. EXPLORE THEIR DARK
WORLDS, AND USE YOUR IMAGINATION TO
CONJURE UP SOME SINISTER SCENES.

# GOTHIC SETTINGS

THE ENVIRONMENTS AND LANDSCAPES THAT YOU CREATE FOR YOUR VAMPIRES AND GOTHIC CHARACTERS WILL ENHANCE THE MOOD OF YOUR ARTWORK, AND ADD STORY LINES AND A SENSE OF MYSTERY.

Environments are created to increase the emotional impact, intrigue and beguiling nature of your work. Draw inspiration from reference and photos to create cryptic plots and epic landscapes. Notice how the background in this painting (right) engenders a sense of terrifying foreboding: the lonely, ramshackle cottage looms over the scene, echoed by the gathering dark clouds, while the root-woven pathway leads the viewer into the haunted woods.

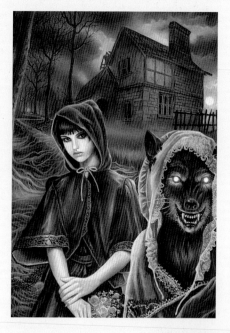

**EXTERIORS**
On the following pages you will learn to recreate various exterior environments including mists, storms, forests and ruins. To set the scene, think about various Gothic moods and aim to reflect them in the environment you design. If the mood is to be eerie and ghostly, dramatic and violent, or dark and creepy, reflect this in your landscape.

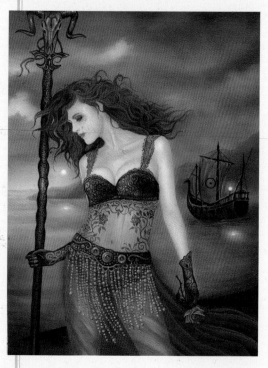

**Narrative** ⌃
*When designing environments and settings, think about the plot. How do the characters relate to, and engage with, the backgrounds? Consider the past, present and future. Think about the landscape, structures and objects, and how they relate to each other. By combining these elements you will create a story. See here how the light on the ship mirrors the rising sun, implying a journey towards the horizon. The vampire holds a staff – is she a priestess? The rose is a symbol of love – is she romantically involved with someone on the ship?*

**Mood and mystery** ➤
*Mood is established through the use of colour, light and shadow, climate, ambience, visual space and composition. Select colours that reflect the mood of the figure itself or the feeling you want to create. In this example, the insipid green creates a feeling of eerie, poisonous fever. The mood is enhanced by the ghostly glow around the vampire pirate, which is reflected in the light emanating from the top of the painting. A feeling of mystery is created through the use of visual space and composition (see page 40); the strange pillars reach up into the unknown, connected by a network of precarious walkways.*

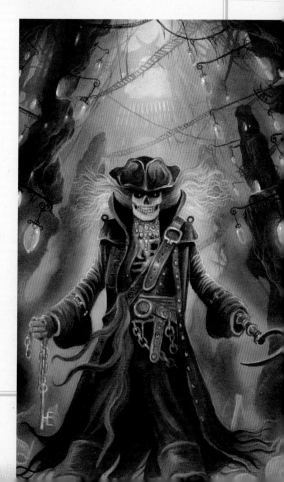

# GOTHIC SETTINGS

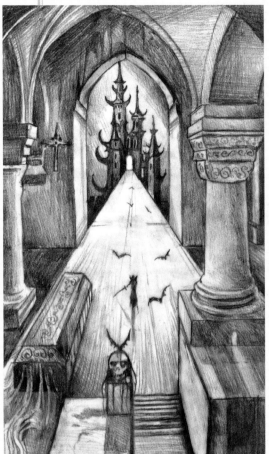

### ◀ Perspective

*Perspective will not only help you to create a believable setting; it can also be used to build a narrative and create drama, intrigue and depth. Note here how the narrative unfolds as the eye is led to the vanishing point at the distant fortress portal. The vampire's head on the pillar leads us to his coffin on the left, then to the swordsman walking away, following the path to the gateway and bridge – and on towards the distant fortress. The vampire bats add to the sense of depth.*

### Colour roughs ▶

*Before adding colour to your artwork, it is a good idea to experiment with different hues and effects. The colours used will greatly affect the mood of your painting, so selecting the right ones is important. You can do a few colour sketches with paints, or add colour to a sketch digitally, as shown here. By scanning your drawing into a computer you can use a graphics program to add, edit and merge various colours until you are happy with the result, then recreate them with your paint box.*

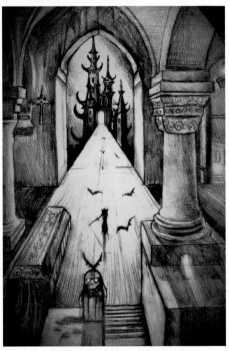

### Interiors ▲

*If your scene is to feature an interior, create a mood of seclusion, imprisonment, dankness, gloom or awe-inspiring vastness – depending on the narrative and atmosphere you want to recreate. Instill a sense of mystery and interest in the interior, allowing the viewer to imagine what lurks around a corner or through a doorway: Where does a passageway lead? What lies beyond a Gothic window or archway? Include cryptic clues, such as a pool of blood, a locked door, a key or other interesting items, such as masks or knives.*

# MISTS

By CREATING GHOSTLY MISTS, YOU CAN ADD A
MYSTERIOUS, HAUNTED MOOD TO YOUR PAINTINGS.

There are a number of mist effects that you can employ to enhance the Gothic atmosphere of your paintings. In your landscapes, paint low-lying fogs by adding a pale hue at the horizon; this graduated tint should become more opaque as it meets the horizon. Notice how objects become lighter the further away they are from the viewer. You can also add smaller wisps of mist to the landscape to haunting effect. Add fog and mist to distant hills and a ghostly luminous haze in the sky, especially around the moon.

**Low, creeping mists ➤**

*To create low, creeping mists, make your tones lighter towards the horizon and decrease the tonal contrast of distant objects. Notice how the distant tree roots are lighter than those close to the viewer; exploiting this idea will create atmospheric depth. A ghostly fog hangs in the hollows of the landscape, obscuring objects and details such as the grasses, tree roots and gravestones. Once you have established the tonal qualities of the environment, begin to add colour. You could include a distant ruin (see page 112) to emphasize the ghostly mood.*

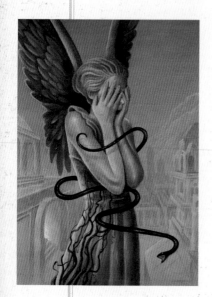

**◄ Atmospherics**

*Mist is a phenomenon consisting of small droplets suspended in the air, creating a low-level cloud that diffuses light; this effect increases with distance. To recreate this atmospheric effect in paint, decrease the contrasts in tones and mute the colours of objects the further away they are. Make distant objects more hazy and closer ones more defined. Adding cold colours, such as blue and cool green, will make distant objects retreat even further into the background.*

**FINISHED PAINTING ➤**

Notice how the roots further back at the bottom have less colour and tone, while those in front of the mist are darker and more defined. The horse's rear legs fade in tone the closer they are to the ground, where the mists are thickest. You can either paint the graduated mist tones directly, or apply them as an opaque glaze over a dry underpainting, using a soft fan brush or an airbrush (see Oil Paints, page 24). You may want to create a misty glow around your character in the same colour as the low fogs to give it an eerie, phantom-like presence. Here, the flaming orange contrasts with the cool mists, making them appear even colder and more ethereal.

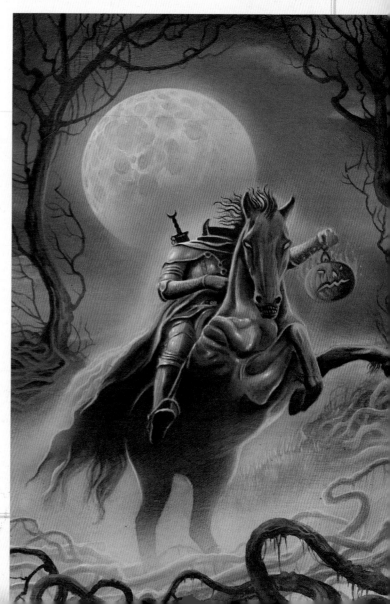

# STORMS

DARK, BILLOWING STORM CLOUDS WILL GIVE YOUR
ART A BROODING, FOREBODING FEELING.

The image of a gathering storm, of bellowing thunder and lashing lightning, is the very essence of Gothic atmospherics. The landscapes that lie beneath the storms play an important role in enhancing the sense of foreboding. You may want to include a distant building to dramatize the Gothic effect (see Buildings, page 111). Include areas cast in shadow and reflect the colours of the sky in your landscape. Illuminate the landscape where rays of escaping light part the menacing clouds.

**FINISHED PAINTING** ▽

Use a cool, silvery hue for the areas of light and the moon's or sun's rays, highlighting the edges of the clouds. For the mid-tones, mix up deeper grey and silver tones and combine them with golds and rich browns. The dark areas of the storm should be very dark; use deep browns, greys and black to build up the billowing, shadowy forms.

**Cloud formations** ▷

*When sketching cloud formations, build up the forms in darkening layers. Notice how the edges of the clouds catch the light, and how the forms are lit from the direction of the light source. When sketching storm clouds use bold, dynamic strokes to capture their energy, or make more detailed studies, observing the subtle effects of light and vapour. To recreate rays of sunlight or moonlight breaking through the clouds, draw converging straight lines meeting towards the light source, widening some to create beams of light.*

**Lightning** ▽

*To create bolts of lightning use white, painted with a very small hint of cool blue or yellow. Paint the lightning from the top, onto dry paint, forking it several times as you descend. Use the same colour to highlight the area of cloud at the lightning's source. Once dry, apply a translucent light glaze (see Acrylics, page 20) using a soft brush or an airbrush to give the lightning an electric glow.*

**Sunlight and moonlight** △

*The sun or moon emerging from a cloud lightens the colours around it. As sunlight penetrates, an aura of richer hues should be added, such as gold and bronze. The aura of moonlight generates opalescent colours and silvery blues. Create a light haze around the sun or moon using glazes of opaque white or cream.*

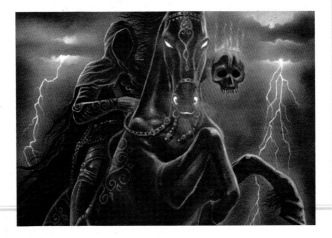

# GRAVEYARDS

THE GRAVEYARD IS ONE OF THE MOST TRADITIONAL SETTINGS FOR VAMPIRES. THESE UNDEAD BEINGS LURK IN THE DEEP SHADOWS OF CHURCHYARDS AWAITING THE OPPORTUNITY TO ATTACK THE LIVING.

Painting a full moon or a dark storm (see page 107) as a backdrop will enhance the feeling of eerie, spine-tingling terror. Include different types of gravestones to create interest – such as vertical headstones, crosses and flat tombstones. You could decorate them with lettering, ornate designs, runes or carved skulls and faces. Age the stone by adding chips and cracks, and add moss and roots to enhance the decaying effect.

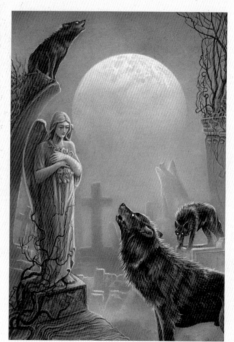

**◄ Statues**
*To increase interest in your graveyard paintings, add Gothic statues or gargoyles. Create these as you would living figures (see Chapter 2), but paint them the colour of stone and age them to match the gravestones. Statues can be a fantastic way of developing the narrative of your Gothic paintings; by giving them specific poses and emotional references you can add layers of meaning to your compositions. Notice here how the fog blurs objects as they recede into the background (see Atmospherics, page 106).*

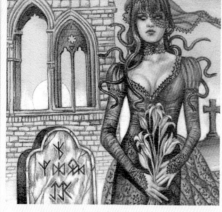

**▲ Architectural details**
*Take your sketchbook with you to churches and graveyards, and make some drawings of architectural details and gravestones (see How to Gather Inspiration, page 30). Keep in mind the composition of your final artwork.*

**Darks and shadows ►**
*To enhance the eerie mood of your graveyards, you may want to shroud the scene in creepy shadows. Notice here how the shadows of the trees create interesting pools of darkness. Use darks and shadows to help structure your composition (see page 48 for help with this).*

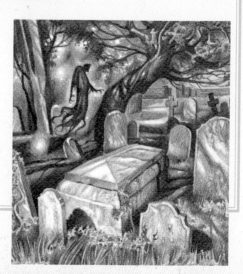

# FORESTS

PAINT CHILLING, DEEP FORESTS AS A
BACKDROP TO YOUR GOTHIC ART.

A dark, forest environment will imbue your paintings
with an atmosphere of fear and apprehension of sinister
creatures that may lurk there. Include deep shadows and
ghostly low mists to further enhance the mood. Take
photographs and make sketches of trees and woodland,
concentrating on details such as twisted trees and
branches, fallen leaves and creeping roots.

### ▼ FINISHED PAINTING

Your Gothic forests will probably be set in autumn or deep
winter. Here, burnt oranges and golds are used to create
a pathway. The trees are bare and threatening, creating a
tunnel that leads towards an eerie, insipid mist. Transfer
your drawing to the painting surface and make an
underpainting in raw umber. Once dry, you can build
up the low and mid-tones, allowing your underpainting
to show through. Finally, work up the detail and sharper
focus of objects at the front of the picture.

**Misty forest pathways ➤**

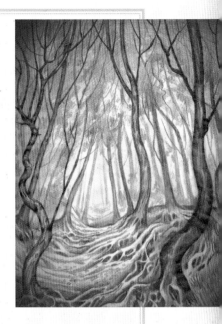

*Begin by making a detailed drawing,
using the sketches and photos you
have gathered. This will act as
a tonal guide for your finished
painting, establishing where the areas
of light and shadow fall. At this stage
you can also draw in some of the
details, such as twisting tree roots
and leaves.*

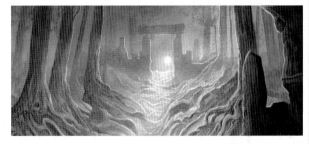

**▲ Creating depth**

*It is important to draw the viewer into your paintings or drawings.
Try to compose your pictures in such a way that they lead the eye
towards a focal point of interest. Here, the moonlit pathway leads
the viewer deeper into the painting towards the ruined gateway,
adding a layer of narrative to the picture. You could include the
entrance to a tomb for added intrigue (see Tombs, page 110).
Note how the trees and objects become less defined as they recede,
creating a sense of mystery and anticipation of what lies beyond.*

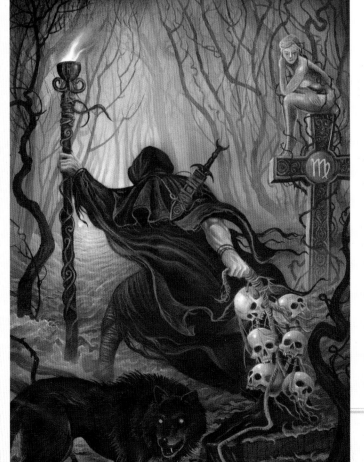

**◀ Perspective**

*You can give your forests
a greater sense of majesty
by having the trees
towering overhead. Create
a sense of height by having
the trees converge towards
a vanishing point above
the picture. The horizon
line should be towards
the bottom of the picture,
giving a low viewpoint
(see Perspective, page 36).*

# TOMBS

A TOMB IS PERHAPS THE MOST TRADITIONAL
DWELLING PLACE FOR A VAMPIRE.

Vampires rest in deathly sleep during the hours of day,
emerging rejuvenated at dusk to seek their unsuspecting
victims. Give your pictures narrative depth by designing
sinister tomb entrances, leading into burial mounds or
crypts. Learn to create ancient overgrown tombs and
evoke a deep feeling of mystery and intrigue.

### FINISHED PAINTING ➤

Once you have transferred your drawing to paper or canvas,
you can start to add colour. To create an atmosphere of ancient
horror use bleak, muted colours for the main features of your
painting. Dull greens, greys and browns will give an archaic
pagan feel, while adding mists and dark areas of shadow will
suggest even deeper mystery. Create intrigue by adding ghostly
glows, perhaps at the horizon or within the depths of the tomb
entrance. The colours you choose here will depend on the mood
you want to evoke – see Understanding Colour on page 44.

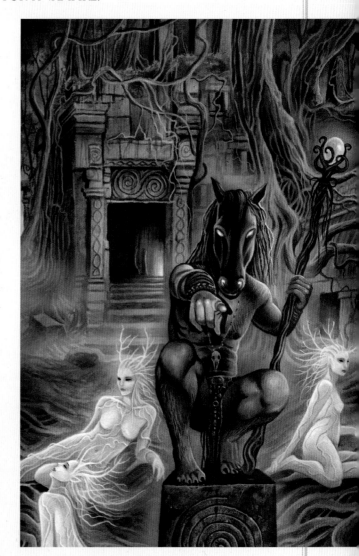

### ◄ Ancient tombs

*Give your tombs and crypts a feeling
of antiquity by covering them in vines
and overgrown vegetation. Ruined and
crumbling walls covered in moss or tree roots
will give an air of foreboding and intrigue.
Draw unusual designs or runes on the stones
to give a building an occult appearance. The
drawing shown here was inspired by the
photograph on page 109; the huge, coiling
roots growing through the crumbling walls
create a perfect Gothic environment. Take
your own photos for reference when you are
out and about for later use in your artwork.*

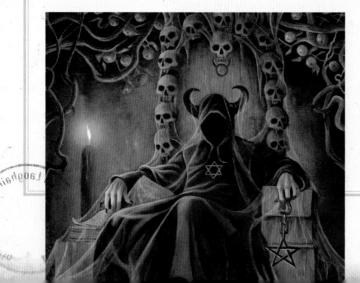

### ◄ Tomb interiors

*If your painting is set within a tomb or chamber, you can
include certain elements guaranteed to give an ancient Gothic
atmosphere. Make your painting dark around the edges to
draw the eye into the centre – enhance this effect by including
a focal point of light, such as a candle or doorway. Give the
walls or stone a distressed look by adding cracks and texture.
You may choose to create furnishings, such as coffins or
thrones – adorn these with Gothic imagery, ancient designs
or skulls. Cobwebs and roots provide an extra archaic touch.*

# BUILDINGS

GOTHIC CASTLES, TOWERS AND CHURCHES MAKE GREAT
SUBJECTS FOR YOUR BACKGROUNDS AND SETTINGS.

Buildings add narrative to your work and help to enhance the personality of
your characters, giving them a culture and backstory. Design fantasy castles,
crumbling cathedrals or buildings inspired by actual places. This charcoal
drawing shows the castle of Vlad Tepes, the inspiration for Dracula. Notice
how the Gothic atmosphere has been enhanced by the addition of sweeping
rain, mists, skeletal trees and vampire bats.

### ▼ Churches and cathedrals

*Churches and cathedrals play an important
role in vampire myth and legend. They
instill a religious element, reminiscent of the
deeper spiritual issues, such as life, death and
resurrection. Carry a sketchbook with you to
capture church details, or take photographs
for reference. Later, you can use theses studies
as a starting point and develop them. In this
example, see how the cathedral has been covered
in an eerie organic substance as though it were
melting back into the earth. How you light
your Gothic buildings is important too; here,
the greenish light heightens the sinister mood.*

### ◄ Ancient castles

*Pay attention to architectural details such as towers,
spires and windows when you are reproducing Gothic
buildings. They do not need to be perfectly constructed,
but authentic detailing helps to establish grandeur. Add
moss and vines to crumbling edifices for an ancient feel.
Your castles could be empty and ruined (see Haunted
Ruins, page 112) or may have evidence of a resident,
such as an eerie light spilling from a window. You may
also like to include gargoyles or statues (see page 108).
Notice how the statue here conjures up narrative and
intrigue with its bloodstained face.*

### ▼ Towers

*Gothic towers can inject a sense of energy, power
and authority into your pictures. Notice here
how the colours of the tower are reflected in the
sky. Add stone spikes, spires or battlements to
your towers to heighten the Gothic effect. Roots,
vines and mosses can also be added.*

# HAUNTED RUINS

LEARN HOW TO CREATE HAUNTED, CRUMBLING
BUILDINGS AND TUMBLING TEMPLES.

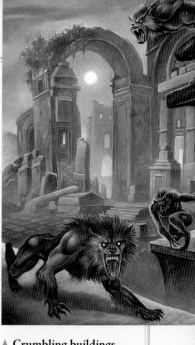

### ▼ Ruined temples

*To make your ruined temples and buildings appear to tower above you, work from a low horizon line with the vanishing point high above the scene (see page 105). By creating vast ruins that loom overhead, you will evoke a feeling of lost grandeur. Your initial drawing will help you work out the placement of the structures as well as establish their forms and shadows. Note how the earth has built up over time, obscuring fallen stones and pillars.*

By filling your ruin with half-hidden doorways, mysterious passages and inviting stairways or arches, you will engage with the viewer, daring them to wonder what lurks around the next corner. Pay special attention to perspective (see pages 38 and 105), as your ruin will probably include many stone surfaces, fallen masonry, paths and passageways. In order for your ruin to be believable you must work from accurate drawings. Include points of interest, such as statues, carvings, broken arches or stairways. Cover your walls in mosses, grass, vines or roots for an extra sense of deterioration.

### ▼ FINISHED PAINTING

Trace your drawing onto the painting surface and paint a monotone underpainting; once this is dry, begin to add colour. With all your Gothic environments you will need to establish the light sources that illuminate your scene. From which direction do they fall, and what colours are they? Are they soft glows or penetrating rays? In this example, there are three sources of light. The strongest is the haunting green light coming from the left, which lights most of the landscape. The second appears from the entrance at the centre; it is brighter than the first, adding a sense of mystery. The final light source comes through the arch on the right. This is a cool, blue hue, highlighting only the pillars and stones.

### ▲ Crumbling buildings

*The extent of the deterioration of your building will depend on your intended narrative. Are the ruins desolate and overgrown with vegetation? Or are they only partially ruined? Is someone, or something, dwelling there? Notice the fallen masonry lying around and sinking into the ground in this image. See how some of the walls lurch precariously, and how the tops of the buildings are overgrown with foliage. To capture the ghostly mood and create a sense of distance, decrease the tonal contrast the further the buildings are from the viewer.*

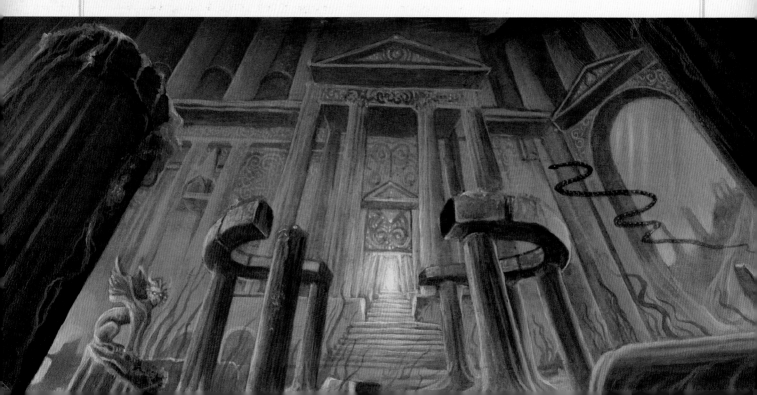

# VAMPIRE DWELLINGS

YOU MAY WANT TO CREATE UNIQUE DWELLINGS FOR YOUR GOTHIC CHARACTERS. TRY CREATING UNDERGROUND CITIES OR CATACOMBS, OR DEVISE YOUR OWN FANTASY DWELLINGS.

For inspiration, look at ancient buildings, Gothic architecture, nature or anything that sparks your imagination. You could combine two or more Gothic environments, such as a ruined tower in a deep forest. You could set your dwelling in a different environment – a swamp, cliff top or cavern, for example. The drawing shown below was inspired by cathedral towers and fossilized bones.

### Gothic cities ➤

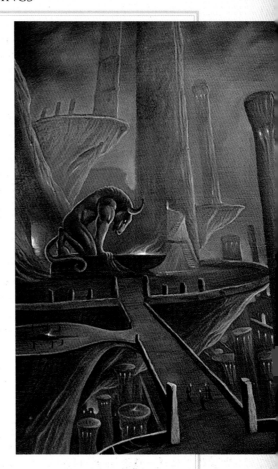

*Where might a clan of vampires dwell? In a metropolis of networked castles? A labyrinth of cathedrals? A vast colony of temples? Let your imagination run wild and create a city worthy of your Gothic characters. This example was inspired by rock formations, with the outcropping platforms creating a forest of pillars. The stone circle, statue and flaming bowl bring a ritualistic element to this dwelling. Notice how the tiny figures in the foreground make the city, pillars and pagan statue seem gigantic.*

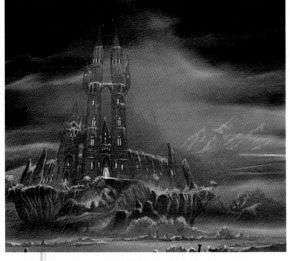

### ▼ Catacombs

*Catacombs are ancient, underground passageways and subterranean chambers or tombs. As places of the dead they become perfect dwellings for gatherings of vampires. Create pillars and structures that seem to have been carved from the stone; a multitude of entrances or windows give the appearance of scattered, flame-lit chambers. Huge walkways connect the pillars, creating a network of subterranean chambers or crypts. Notice how the distant cavern entrance to the right creates interest and a sense of depth.*

### ▲ Fantasy dwellings

*Paint unusual and fantastic dwellings, drawing inspiration from Gothic buildings, such as churches and towers, as well as the natural landscape around you. Rock formations, ancient trees, twisting roots and other natural structures can all be great references for your vampire dwellings. With all of your Gothic dwellings, consider the surrounding landscape and how it could enhance the mood of the buildings. Notice here how the distant mountains create a mysterious backdrop to this island castle. The eerie green lights and strange land formation emerging from the lake evoke a mood of sinister fantasy.*

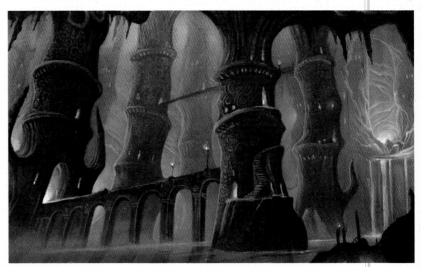

Swipe File:

# GOTHIC CHARACTER TEMPLATES

SCAN OR TRACE THESE CHARACTER TEMPLATES, AND TAKE THE OPPORTUNITY TO EXPERIMENT. A COLOURED-IN VERSION OF THE CHARACTER FEATURES ALONGSIDE THE LINE DRAWING. USE THIS AS GUIDANCE ONLY; YOU CAN PLAY WITH THE LIGHTING AND SHADING, OR CREATE YOUR OWN COLOUR SCHEMES.

## WAKING VAMPIRE

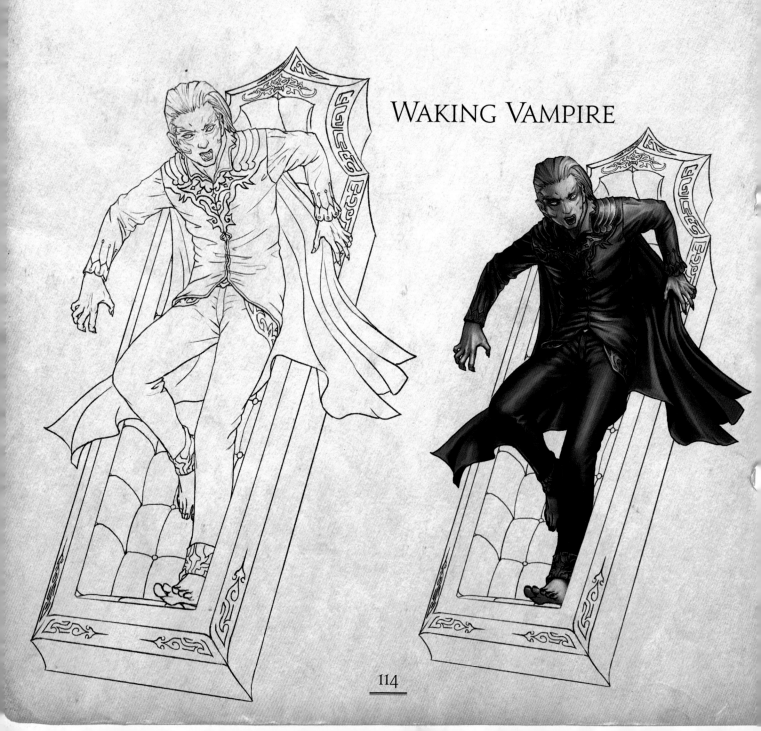

# VAMPIRE SEDUCTRESS

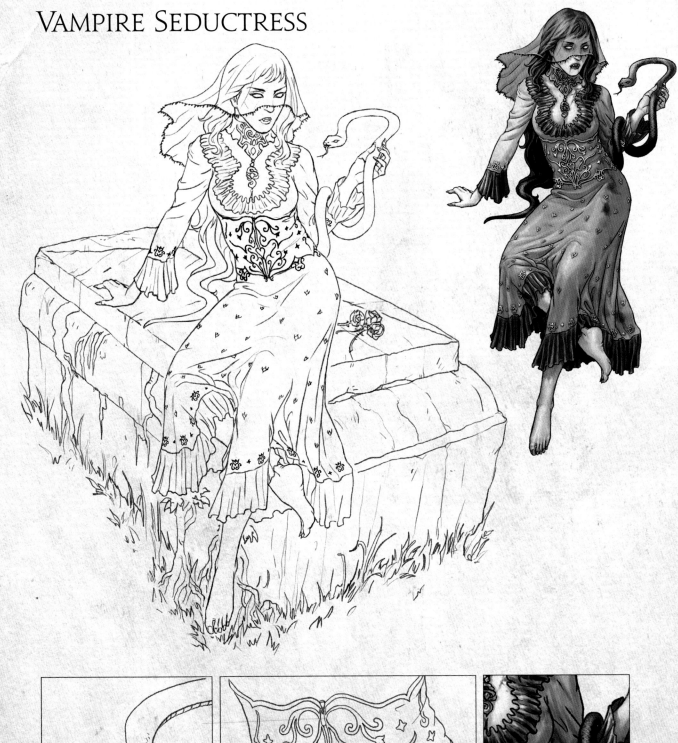

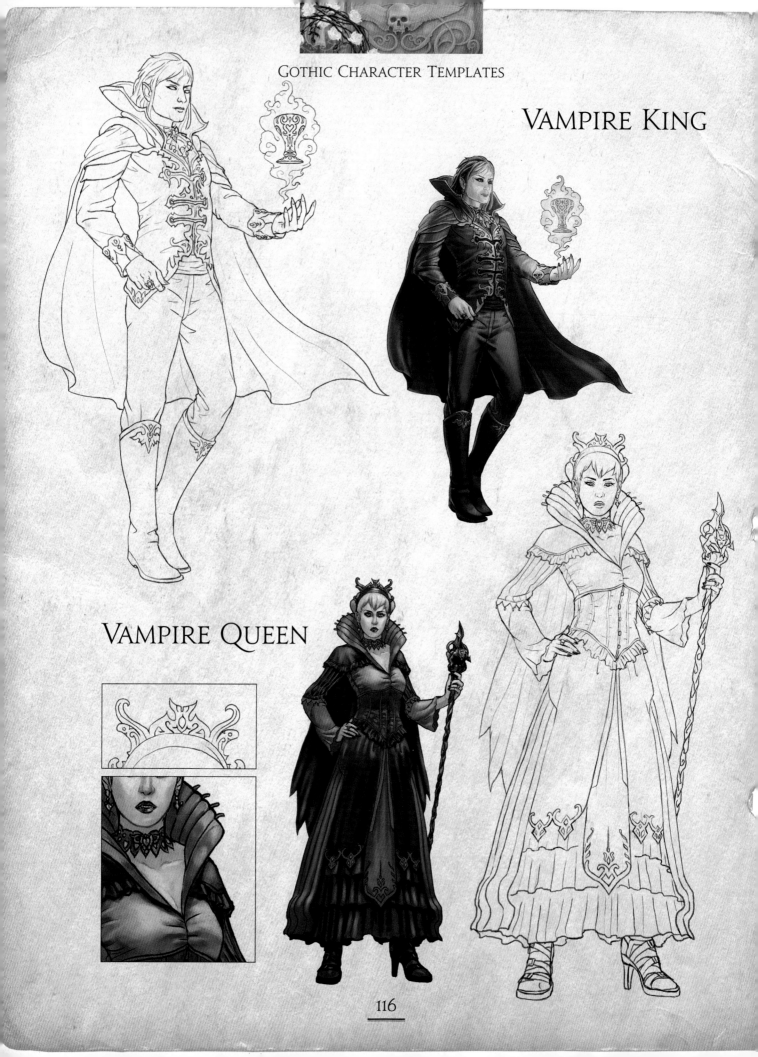

# VAMPIRE KING

# VAMPIRE QUEEN

# Female Vampire

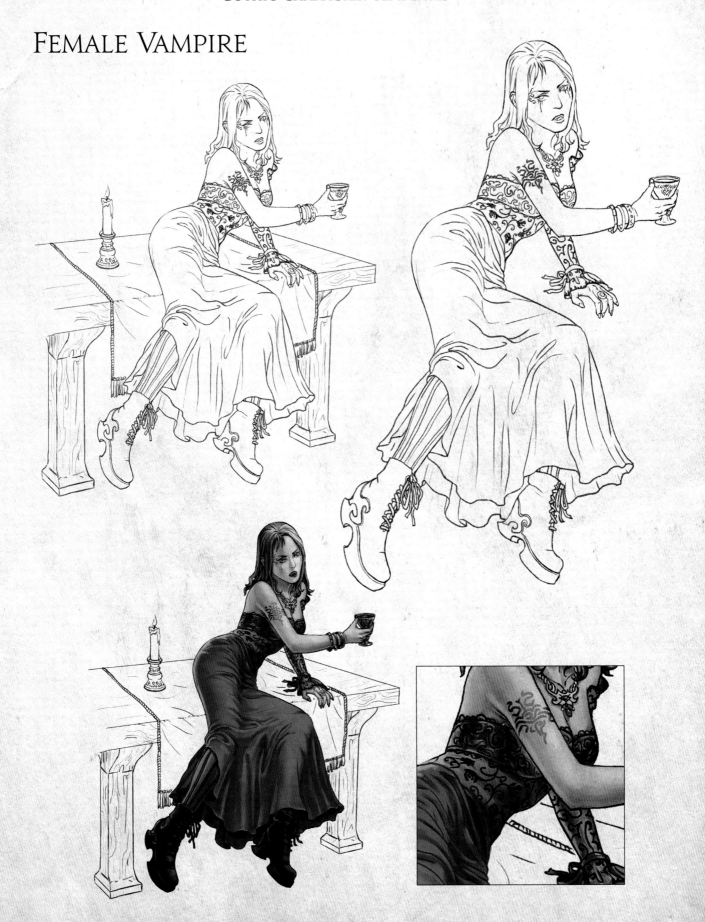

# VAMPIRE PRIESTESS

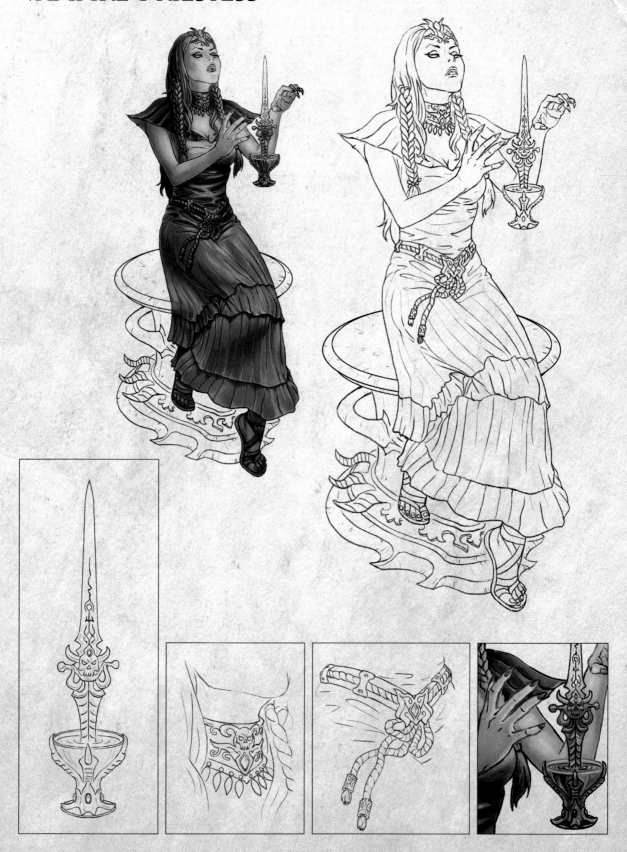

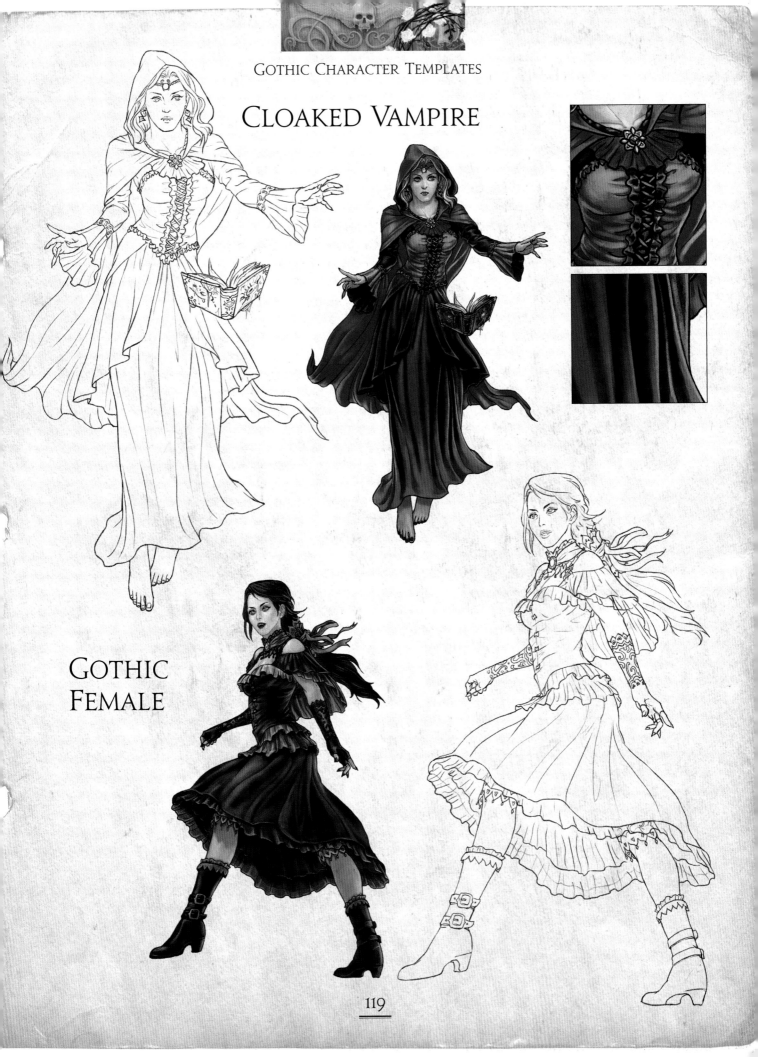

# CLOAKED VAMPIRE

# GOTHIC FEMALE

# DEMON

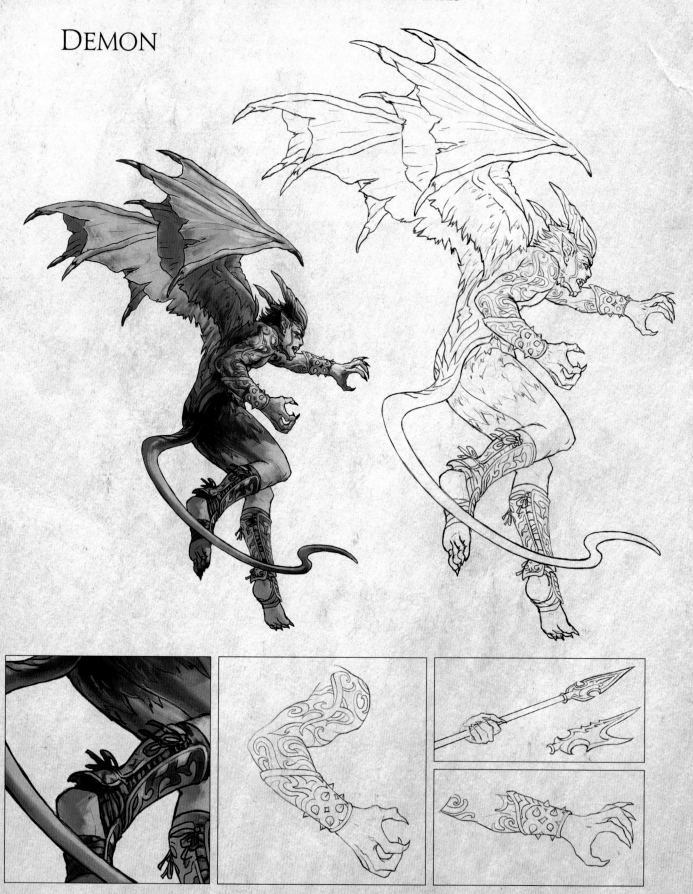

# DEMONESS

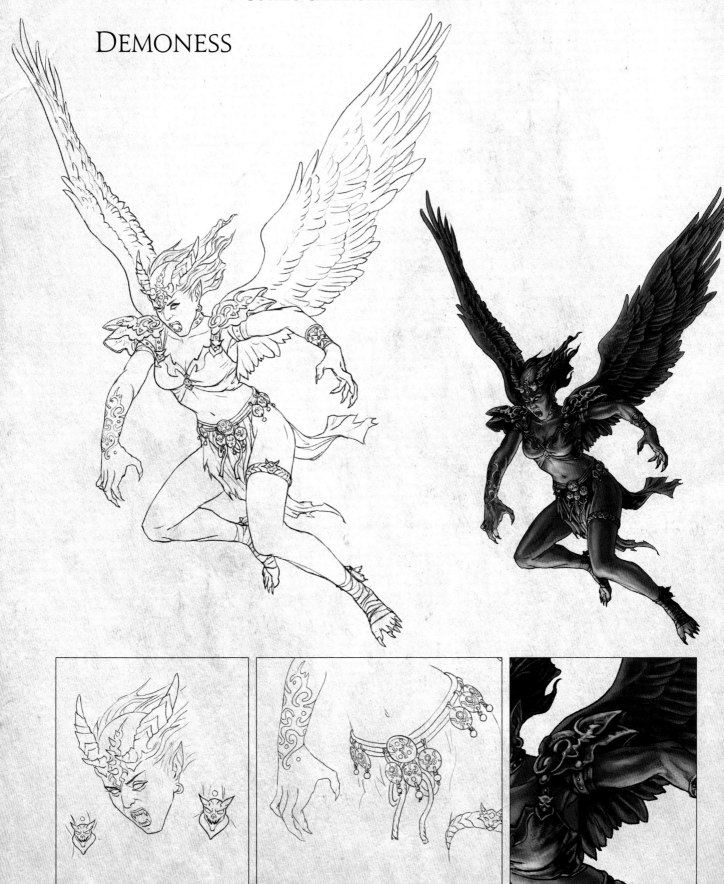

# GOTHIC MALE

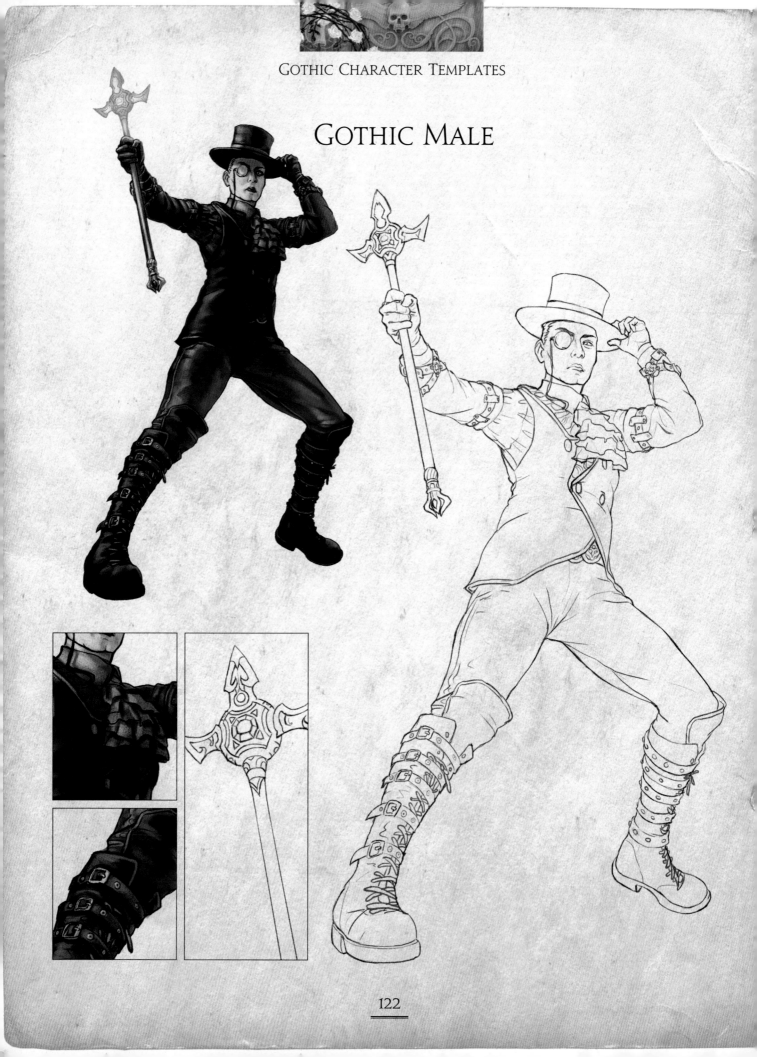

# Aristocratic Vampire

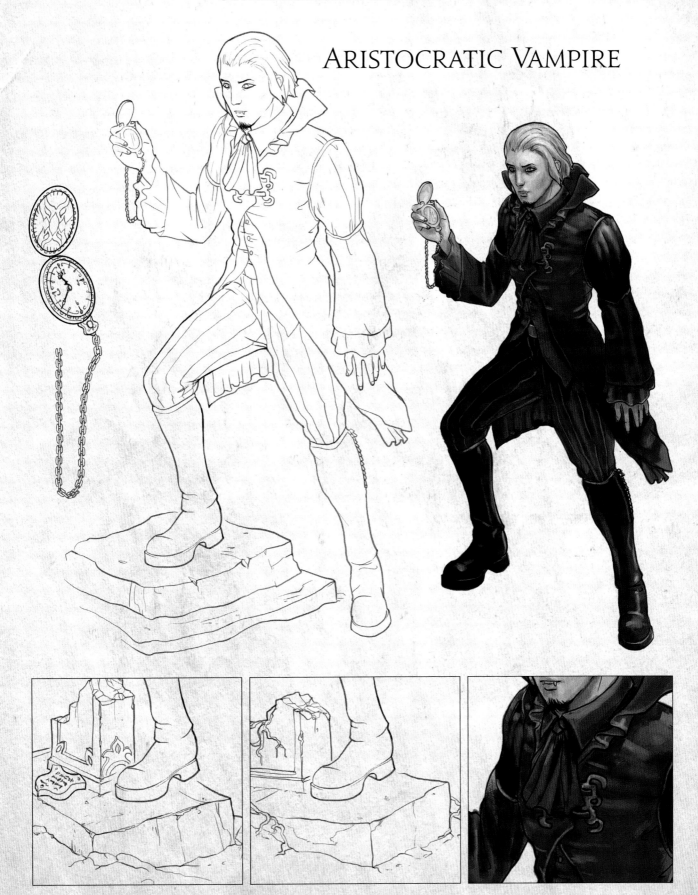

# VAMPIRE WARRIORS

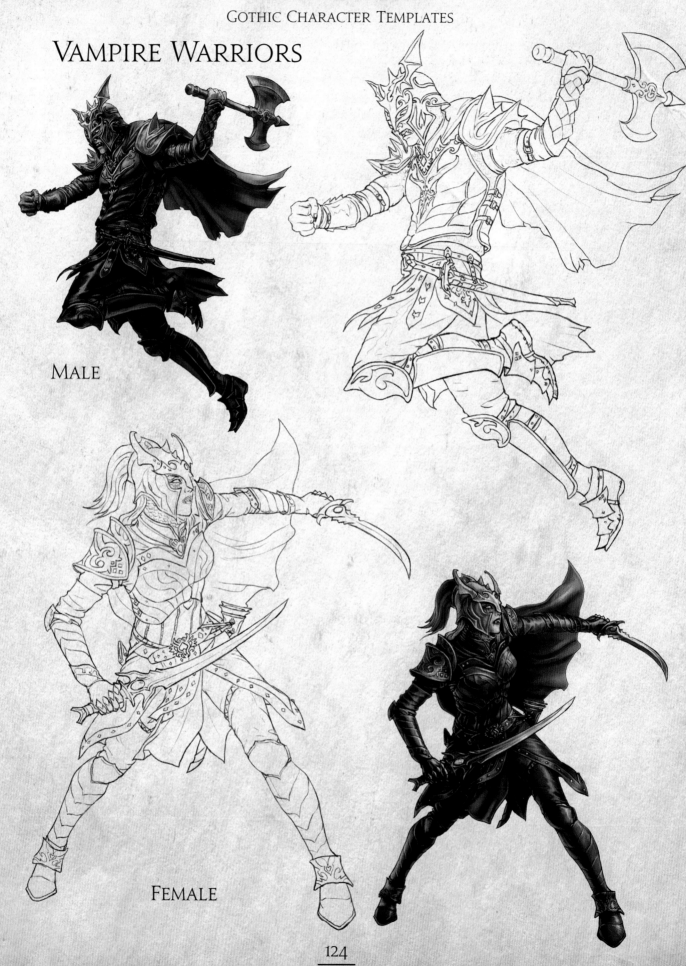

MALE

FEMALE

# VAMPIRE DANCERS

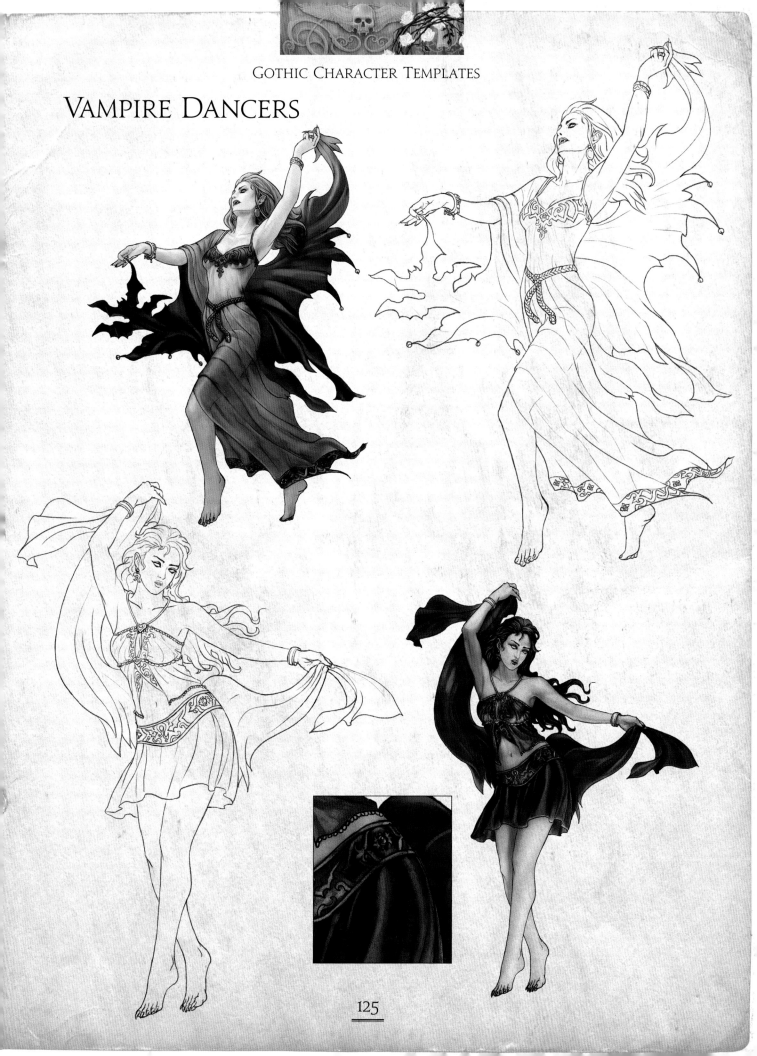

# INDEX

# CREDITS

Author's assistant: Claire Hall

Gothic Character Templates (pages 114–125)
supplied by Rafi Adrian Zulkarnain.

All step-by-step and other images are the
copyright of Quarto Publishing plc. While every
effort has been made to credit contributors,
Quarto would like to apologize should there
have been any omissions or errors, and would be
pleased to make the appropriate correction for
future editions of the book.

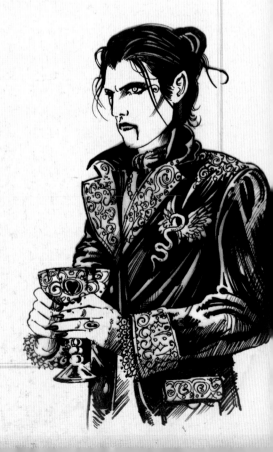